THE ART OF LUKE CHUEH BEARING THE UNBEARABLE

The Art of Luke Chueh
ISBN: 9780857689276

Published by
Titan Books
A division of Titan Publishing Group Ltd.
144 Southwark St.
London SE1 0UP

First edition: June 2012
10 9 8 7 6 5 4 3 2 1

Did you enjoy this book? We love to hear from our readers. Please e-mail us at:
readerfeedback@titanemail.com or write to Reader Feedback at the above address.

Visit our websites:
www.lukechueh.com
www.titanbooks.com
www.nineteeneightyeight.com

A CIP catalogue record for this title is available from the British Library.

Printed and bound in China by C&C Offset Printing Co., Ltd.

THE ART OF LUKE CHUEH BEARING THE UNBEARABLE

TITAN BOOKS · GALLERY 1988

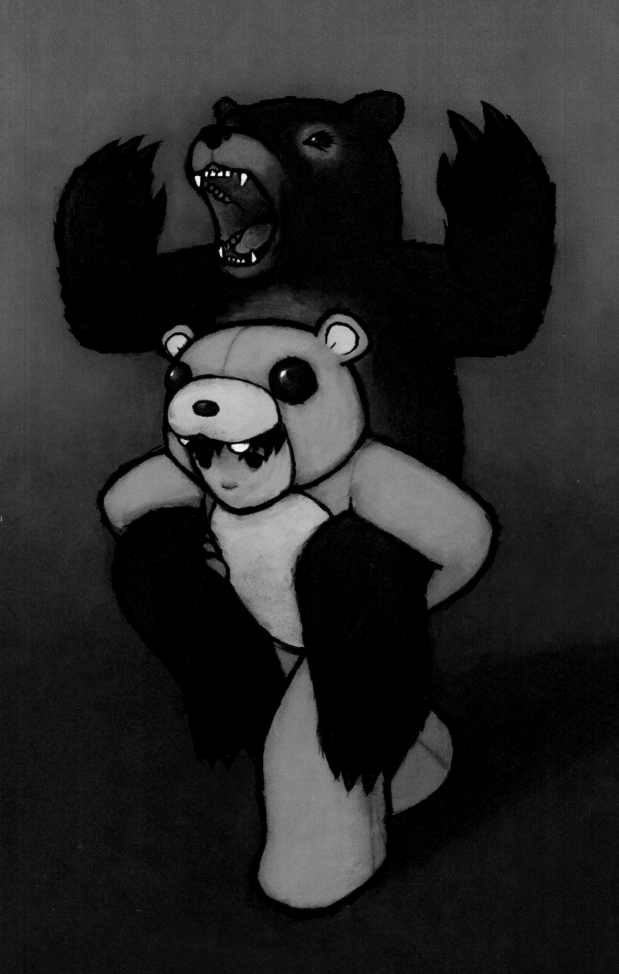

CONTENTS

Fall Out Boy - Folie À Deux
Acrylic and ink, 30 x 30 inches, 2008

INTRODUCTION

The night I met Luke Chueh in 2003 at an art party in downtown Los Angeles, my business partner Katie and I knew he was on the cusp of ending up in one of two different predicaments. It was really a 50/50 coin toss.

1. Dozens of art galleries, including our own, would start selling his pieces effortlessly, even when priced up to $15,000, and we'd be releasing his first art book in less than ten years' time.

Or

2. He'd be dead from multiple gunshot wounds.

Luke Chueh is a gangster and I'm here to tell you why. As we walked up on Luke's dozen or so wonderful paintings that night in 2003, he seemed rattled. A bit jumpy even. I chalked it up to nerves, since the buzz around his work had just started to cause a commotion in the underground LA art scene, almost immediately after he decided to make the jump from graphic designer to fine artist. Maybe he heard that people were buying his new pieces without even asking the price (btw, they were about $300 each in case you weren't mad enough for hearing about him a few years too late). Although these other options were wholeheartedly true and possible, what had him spooked was actually something much more likely to be seen in a John Singleton movie than an art exhibition.

He had just survived a drive-by shooting.

Just moments after the doors opened at this party, an unknown assailant drove by and shot at the venue's window, just inches away from where Luke was standing and his prized paintings hung. Luke was basically the Asian John McClane.

When we walked up to Luke to put faces to our many emails, he shook our hands as if nothing had happened. When we saw the broken glass, shattered into pieces just inches behind him, we weren't quite as reserved with our reactions. We all survived, Luke sold every painting he exhibited and the night set precedence for the next eight years of my professional career, where I would work with Luke more than any other art gallery in the world. Those bullets let me know in advance: A lot of crazy shit is gonna happen to, and around, Luke Chueh, but he's going to stay calm, all because he knows exactly what he's doing and he's painfully brilliant.

We always say that Gallery1988 is "the house that Luke Chueh built," and we're dead serious. Before Luke showed with us, Katie and I had truly no idea what the focus of the gallery would be, nor did we have any real concept of how to run a gallery. Most of our days consisted of wondering what we had gotten ourselves into, while playing an unhealthy amount of online poker. It wasn't until Luke brought emotion, spectacular design and die-hard buyers into the space that we really found our direction and niche.

Now eight years later, we remember Luke as our first sold out show, our first giclée print, our first vinyl toy, our first art directed album cover and our first artist-curated group show (the wildly successful Vivisect Playset). We've done these things since, but nothing compares to our first time.

I always laugh when someone trivializes his process by

calling him "the bear guy," knowing deep down how intensely complex a character Luke truly is. He has battled personal demons throughout our friendship, and most of his struggle, pain and torment are directly represented in his paintings. Yes, he really lives it.

I've celebrated with him, cried with him, yelled at him, visited him in rehab and mourned my father's death with him. He's always been part of my family, through thick and thin. We learned so much together, and without a doubt, from each other.

He's a talent we won't find again, no matter how long Gallery1988 is in business. He has "that thing." That thing where the paintings just sell themselves. That thing where people line up the night before just to get a chance to take something home. That thing where he can metaphorically bleed all over his paintings, place so much sadness onto a canvas, and still have the viewer smirk, or even laugh, at what's depicted. Inside he's a ball of manic stress, outside he's the poster boy for melancholy. That's the intersection of Luke Chueh, and the beauty of his paintings, now beautifully chronicled in this book collecting the images he produced from 2003-2009.

Without Luke Chueh, my first entrepreneurial attempt would've been a major disaster. But I could've been a professional online poker player by now, so who knows? Truth is, he was our catalyst and became our leader for what we barely knew we could become. The gallery is so proud to be associated with his name, work and infectious smile. He's a survivor more than anything. A perfectionist, a true artist and basically bulletproof.
Jensen Karp, Gallery1988

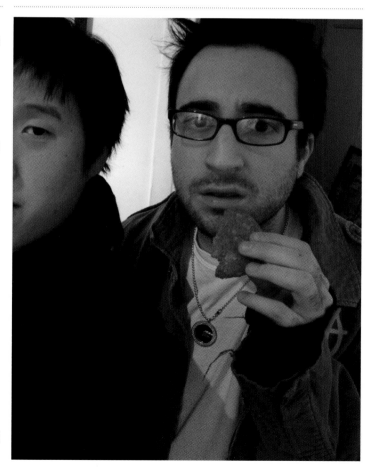

Luke Chueh and I
Photo by Luke Chueh

The Shedio and I
Photo by Jessica DiCicco

2003

Luke Chueh is a complex man. You don't get it right away, looking at his simple woodland creatures, all that empty space, but he's got a lot bubbling underneath. I've called him a trailblazer since he appointed himself my first assistant during his time with Cannibal Flower, and he's lived up to the name, making paths, leaving something scorched but visually beautiful.

That's okay though, 'cause more than anything it's him he leaves behind. Sure, you can say he's one of those artists, defying protocols, a rebellious artist for a rebellious generation, but it's not the sparks he's ignited in other artists that makes him special; it's him. Luke is going to survive, he is going to be legendary, he is going to be irreplaceable, Luke will survive because Luke is one of the few unafraid to dig deep, too deep, and let all his own viscera erupt, right onto his canvas.

That's the thing with Luke – when he paints, he is not just painting cute little creatures; when Luke paints he is writing a diary – he is painting his life, his fears, his vulnerabilities, his loneliness. We shared countless conversations in the time we worked together and it was immediately obvious in his work. The bear too large to exit through the door. The singular characters, so often alone, in all that negative space. It's Luke, always, on that canvas. When Luke came around, he showed Los Angeles that art was for people, plain and simple, even though he's made it obvious now that he's anything but simple. Luke is a complex man.

L. Croskey (Thinkspace/Cannibal Flower)

When I started painting, I was under the impression that real art was big. The bigger, the better. And so, when I did my first Cannibal Flower art show, I contributed a large canvas (3 feet by 4 feet), with a large price tag befitting a painting that size. This was my first show in my new home, Los Angeles, and needless to say, I was excited. Fantasies of what I would say to my first collector, followed with what I would spend that money on, filled my head. After the show, I lugged my unsold painting back home, and walked out with feelings of defeat hanging over me.

A week later, I stopped by the *Giant Robot* Magazine's art gallery where Deth P. Sun was having his first solo exhibition. The walls were filled with small to medium wood panels, each painted somewhat monochromatically. The effect was enchanting. What also struck me were the little red 'sold' dots scattered across the show. When I looked at the price sheet, I was taken aback by how humble his prices were. That was when I realized it wasn't how large the price of the art but rather, the fact that someone believed enough in the work to invest, even if it's a little money, in the art. This is a piece of advice I often share with aspiring artists: It's not about how much you sell the art for, but rather, that you sold the art at all.

I returned to Cannibal Flower the following month with two small paintings and had priced them to sell. "Feeling Blue" was one of those paintings. When they sold that night, my confidence in my art and my ability blossomed, and I never looked back.
Luke Chueh

Feeling Blue
Acrylic and ink, 16 x 20 inches, 2003

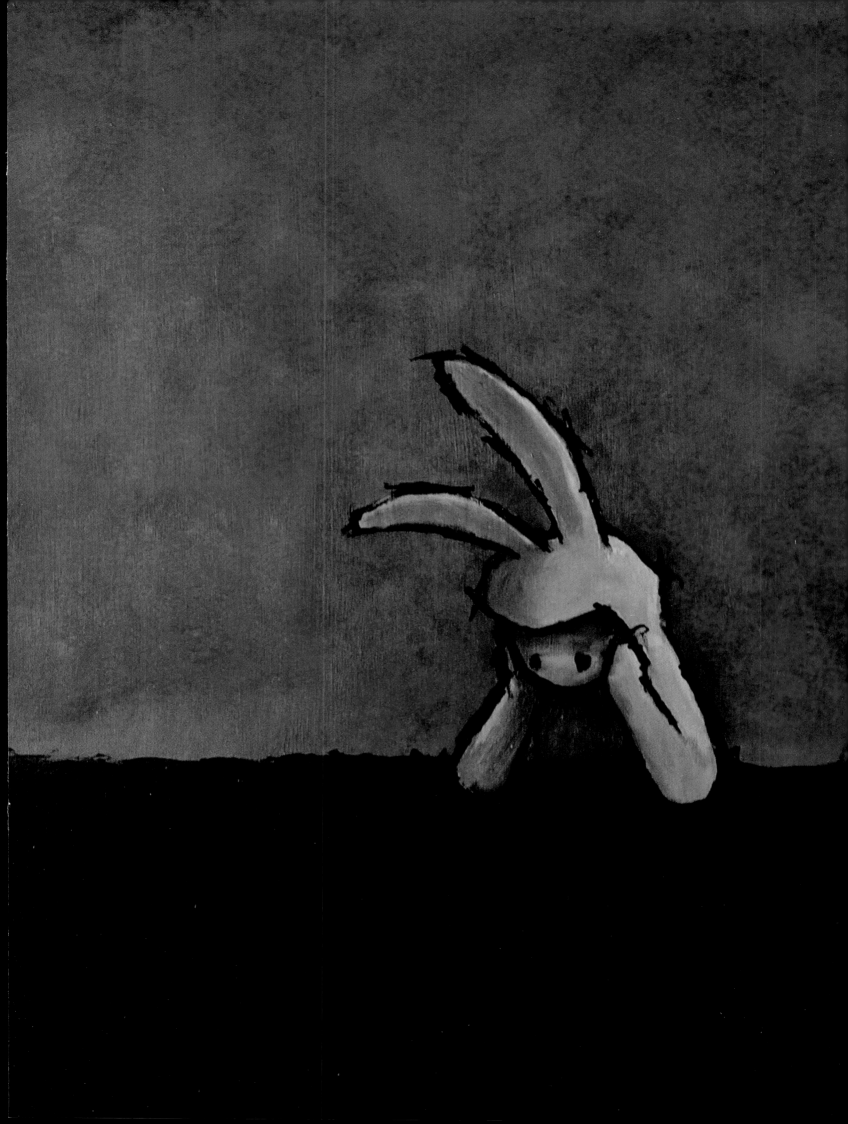

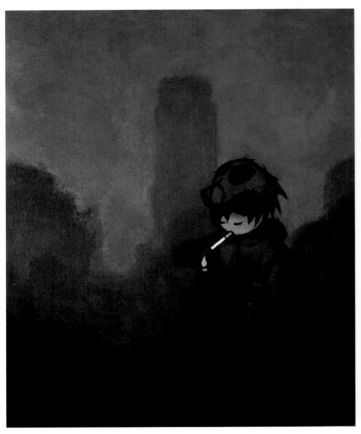

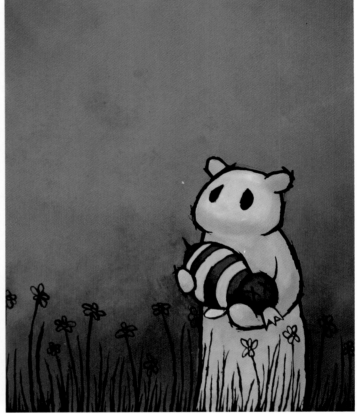

Smoke
Acrylic and ink, 16 x 20 inches, 2003

The Queen is Dead
Acrylic and ink, 16 x 20 inches, 2003

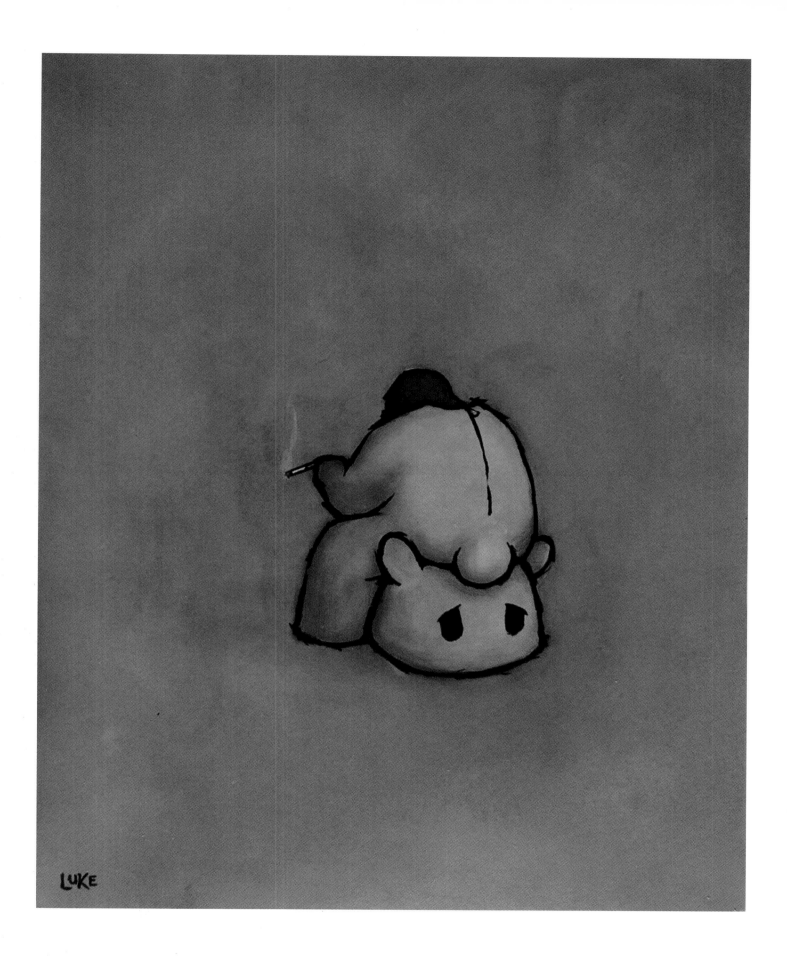

Headrest
Acrylic and ink, 16 x 20 inches, 2003

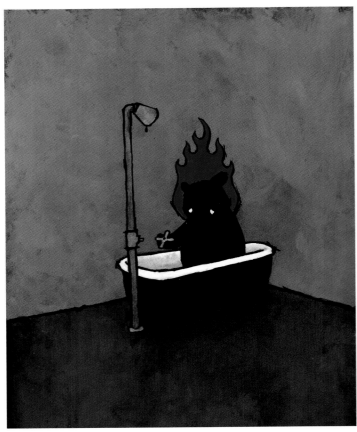

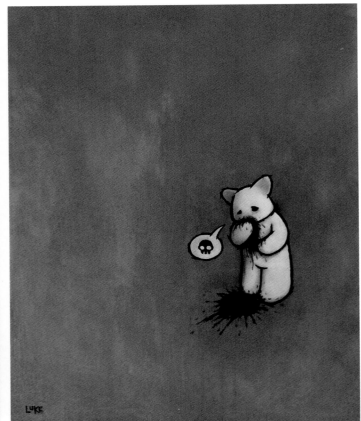

Hope Extinguished
Acrylic and ink, 18 x 24 inches, 2003

Vomito Negra
Acrylic and ink, 16 x 20 inches, 2003

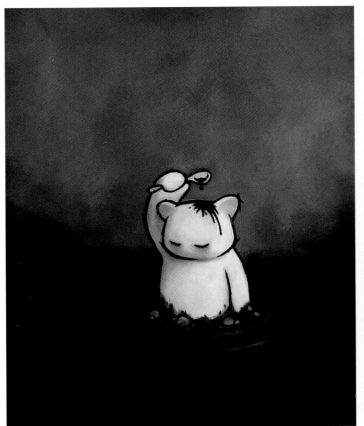

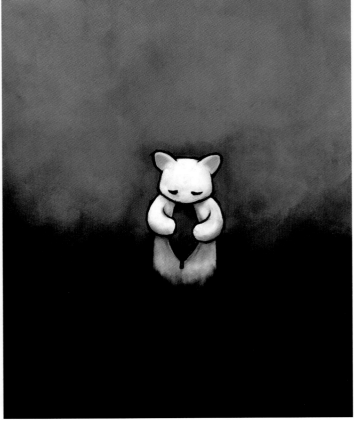

Pour Some Sugar On Me
Acrylic and ink, 16 x 20 inches, 2003

Hollow
Acrylic and ink, 16 x 20 inches, 2003

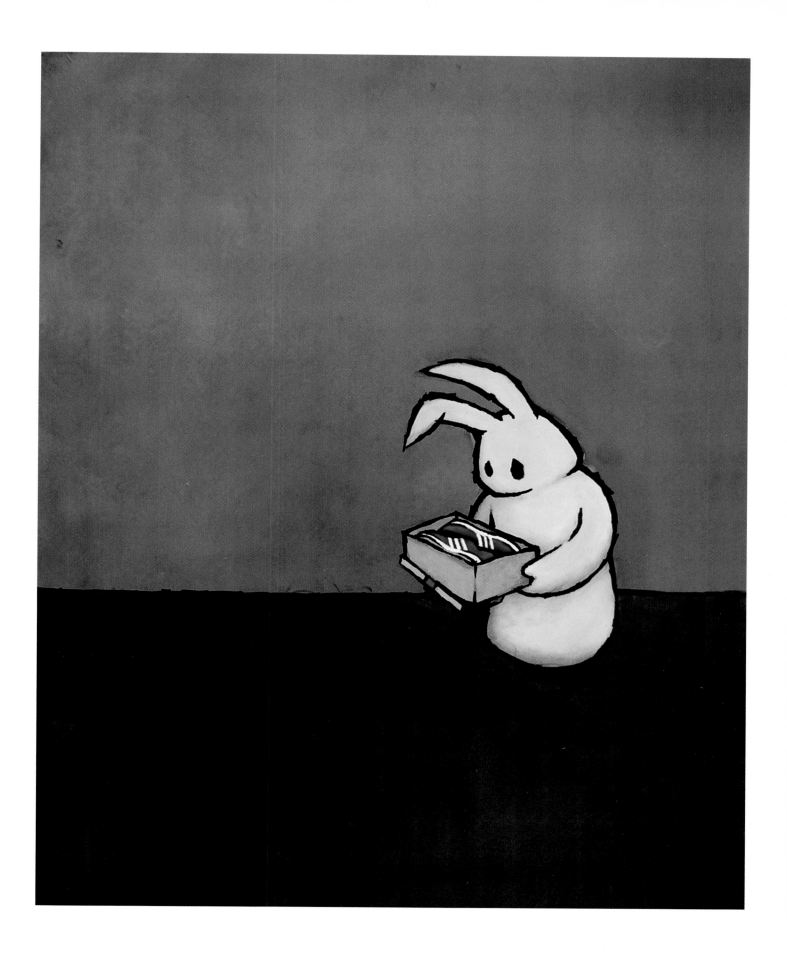

Another Useless Gift
Acrylic and ink, 16 x 20 inches, 2003

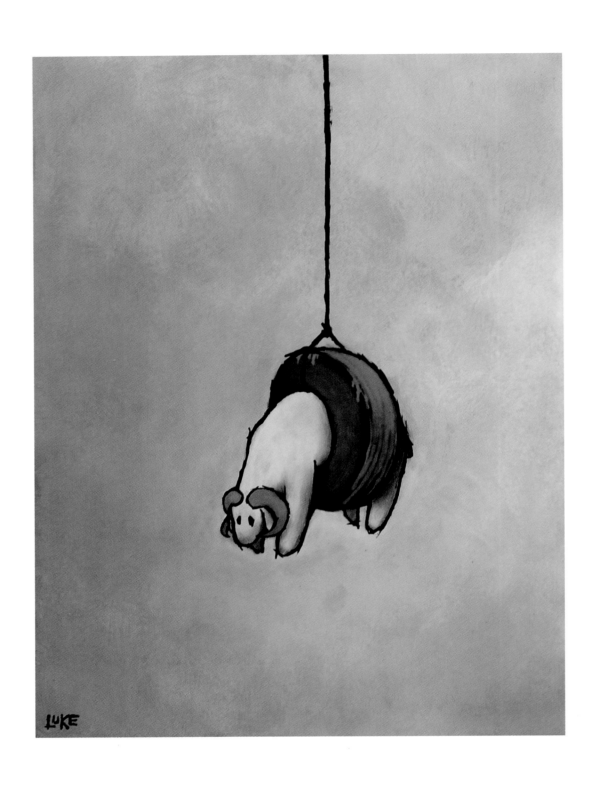

Mono_Ram (Chueh vs. Rauschenberg)
Acrylic and ink, 18 x 24 inches, 2003

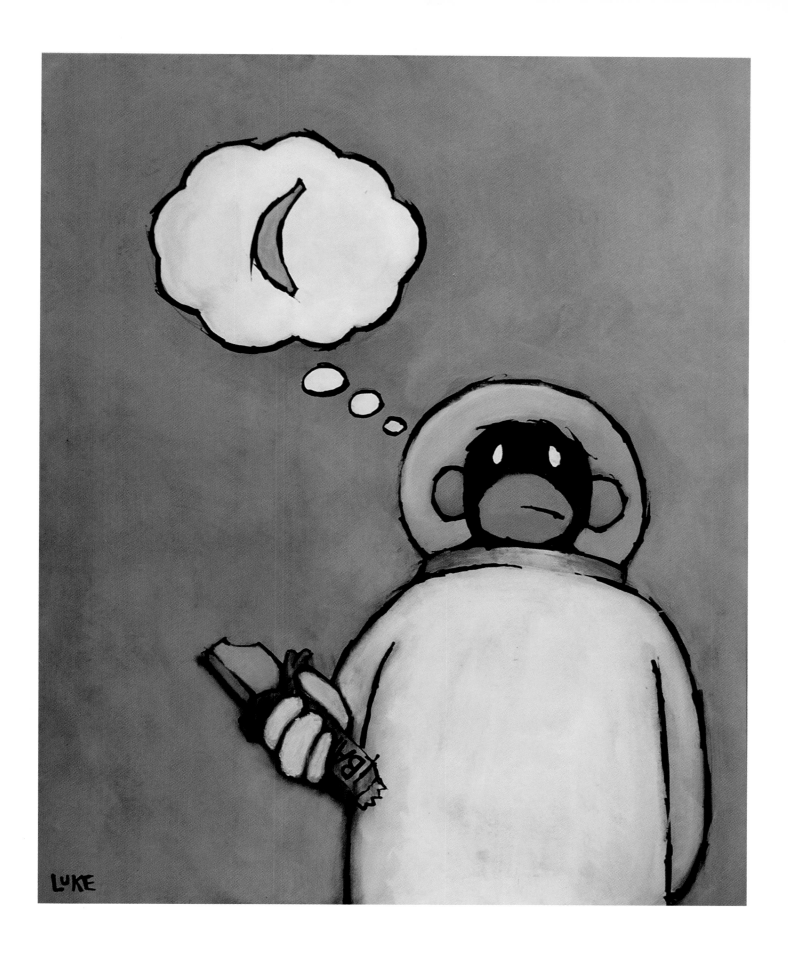

Nostalgia
Acrylic and ink, 16 x 20 inches, 2003

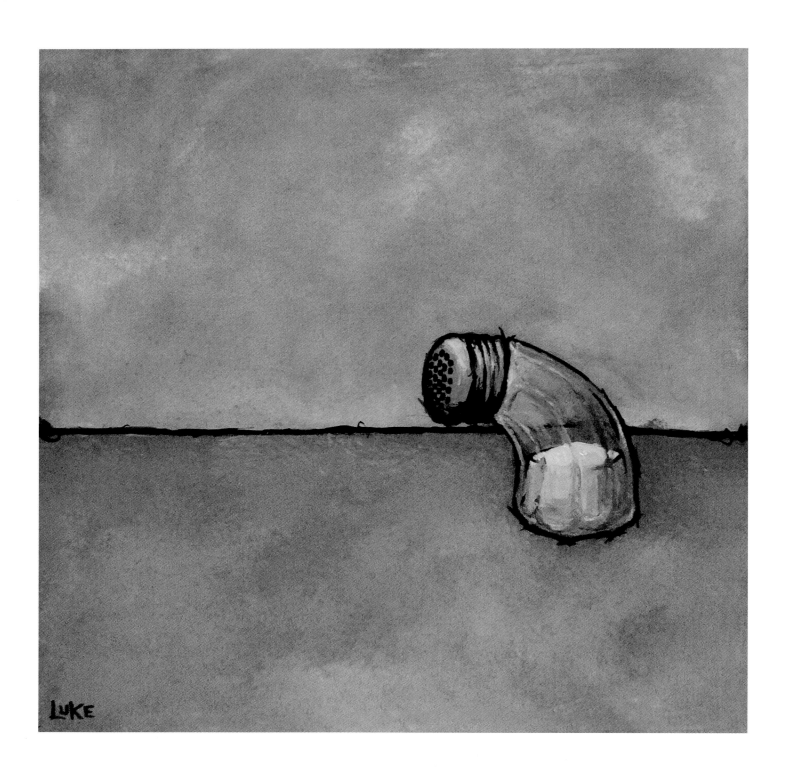

Saltpeter
Acrylic and ink, 12 x 12 inches, 2003

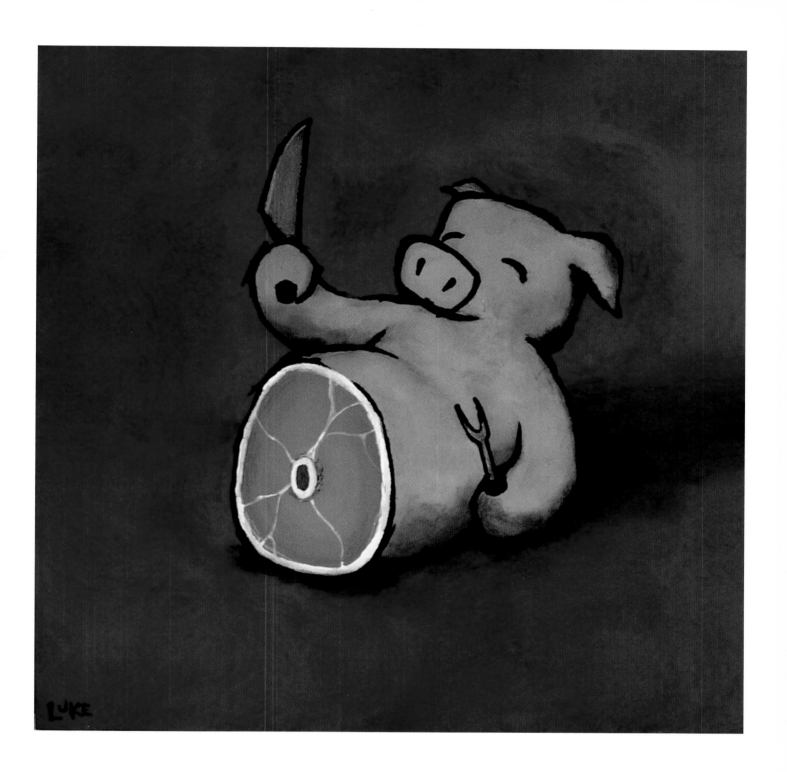

Ham
Acrylic and ink, 12 x 12 inches, 2003

For Cannibal Flower's third year anniversary show, I wanted to incorporate elements of Cannibalism, and Flowers in the work. I wasn't comfortable illustrating the gory, blood-soaked imagery I've painted since then, so the idea of a chicken being served a plate of eggs became the "cannibal" element, while the daisy on the table setting is the "flower".

I'm still shocked by how popular this painting is. But what really kills me is when it was bootlegged onto a t-shirt in Japan. At first I was flattered, but then variations on the idea popped up. A pig with tonkatsu, a cow with steak, a rabbit with a fur jacket, and most recently, a marlin with a fish steak. But being in America, I felt like my hands were tied when it came to compensation or asking them to desist. But what can I say, the shirt looks great. I even have pictures of the lead singer of LCD Soundsystem performing in it. But let it be known, I have plans for how I'm going to handle this, and retribution will be mine, whether it's served sunny side up, or scrambled.

Luke Chueh

I Asked For Scrambled
Acrylic and ink, 16 x 20 inches, 2003

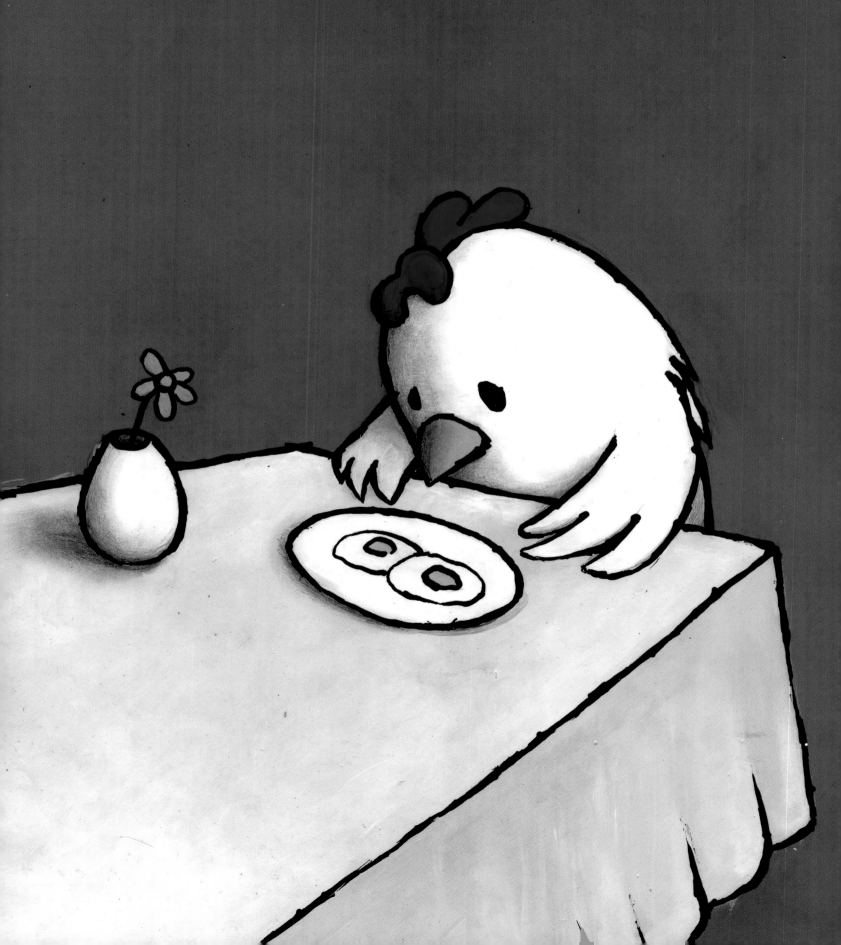

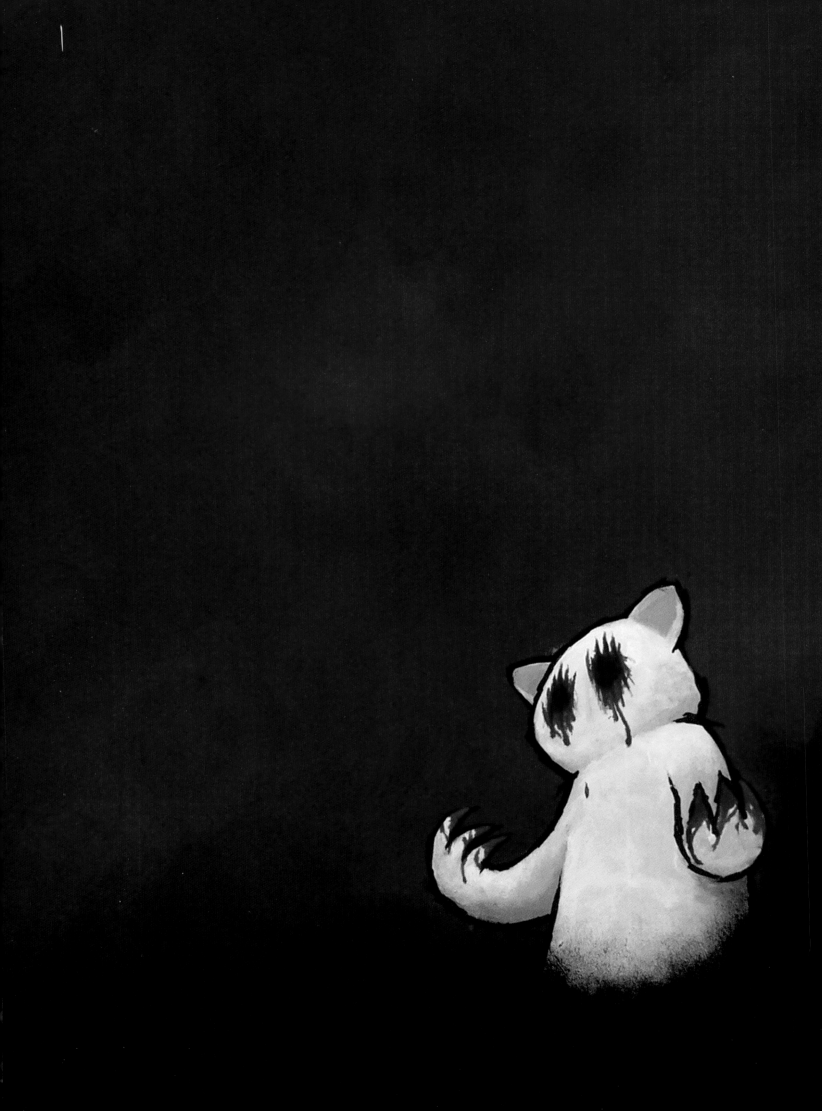

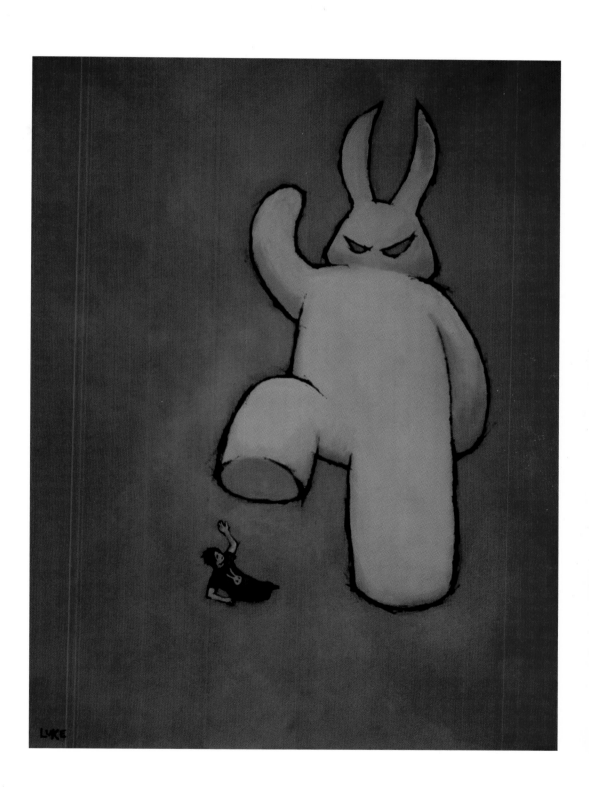

Force Majeure
Acrylic and ink, 16 x 20 inches, 2003

The Things You Love Will Destroy You
Acrylic and ink, 36 x 48 inches, 2003

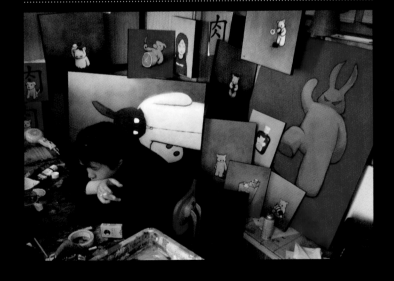

Posing in front of all the paintings from my first solo show
Photo by Wendy Jung

2004

Luke Chueh saved our business. When we opened Gallery1988, we had close to zero knowledge about the art world. We booked artists that we liked, artwork that we ourselves would purchase for our apartments. Our first show with Luke was a small group show featuring Luke and three other young artists: Bob Dob, Jason Sho Green and Chris Cuseo. This was our third show ever, and we titled the exhibit "Down Here It's Our Time" in reference to *The Goonies*. The show postcard was a still shot from the film, we didn't even reference the artists' artwork on the show invitation. You could say we hadn't developed our marketing skills quite yet.

But after seeing the response to Luke's work in "Down Here It's Our Time," we knew Luke was a rising star. Luke was already building a fan base at that point, and people came to the gallery specifically to see his work. He sold every piece, which as young gallery owners, we had never seen before. It was amazing to witness the beginning of something so incredibly special. But that was only the beginning, we had no idea how big Luke was about to become.

As we continued to work with Luke, we began to see the energy and excitement for his work grow and grow. We saw customers fly across the country and wait in line to purchase his art. We watched Luke sell out show after show, and we even had customers inquire about purchasing his paintings sight unseen. Luke's collectors were becoming increasingly competitive and all of a sudden there was this fury and anxious craze to get your hands on one of Luke's paintings. The demand for Luke's work grew unbelievably fast, and he literally became a huge superstar in this underground art scene. It was amazing to be involved in the development of Luke's career, but what was even more amazing than his rise to stardom, was watching Luke remain at the top year after year. The demand for Luke's work has been constant and that is the true testament of his success.

I always say we happened to be in the right place at the right time when opening the gallery. Gallery1988 was able to align itself with a few amazing artists that were just starting their careers, and we learned and grew with them. Luke is without a doubt one of these people that we just happened to meet at the exact right time in our lives. Luke has played a huge role in shaping the gallery, and I can never thank him enough for his involvement and support.
Katie Cromwell, Gallery1988

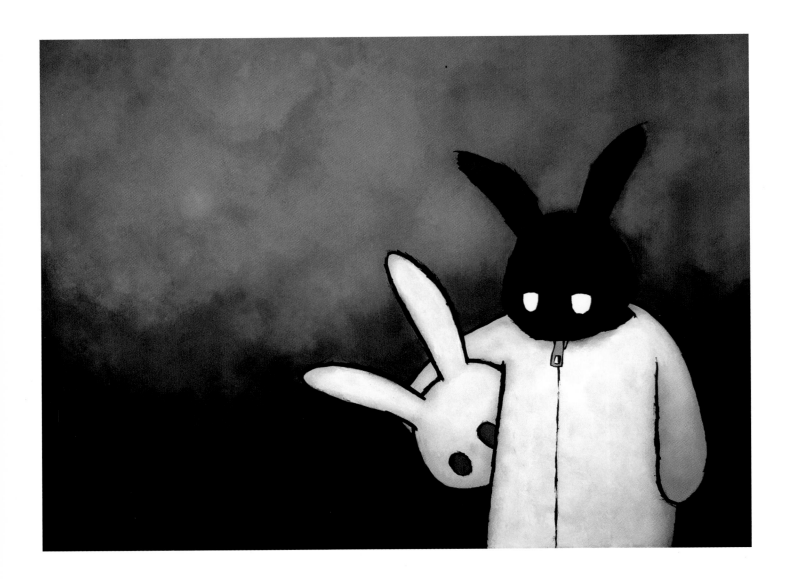

Black In White
Acrylic and ink, 36 x 48 inches, 2004

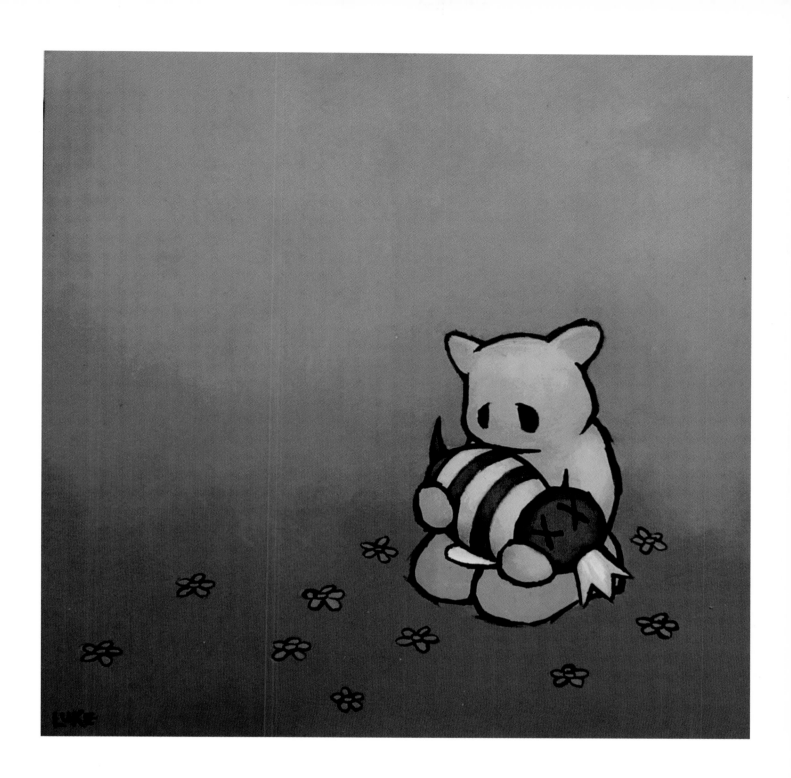

The Queen Is Dead (Version 2)
Acrylic and ink, 12 x 12 inches, 2004

Paintings For Children (Alcohol/Tobacco)
Acrylic and ink, 11 x 14 inches, 2004

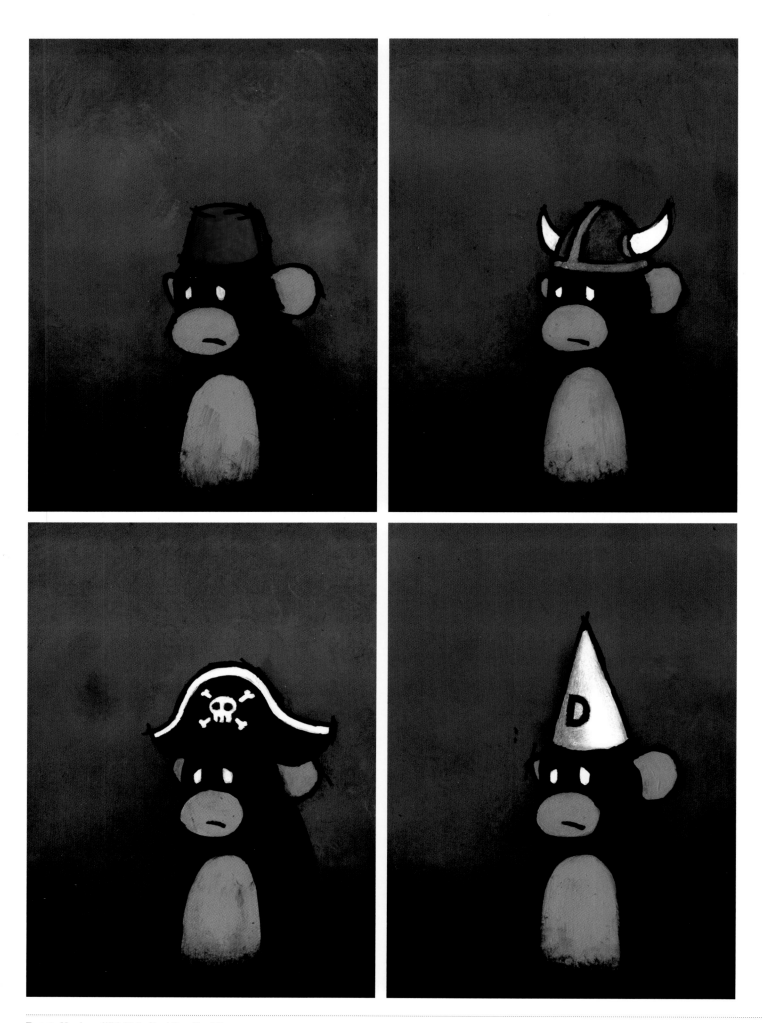

Twenty Monkeys With Hats (And One Squid)
Acrylic and ink, 5 x 7 inches, 2004

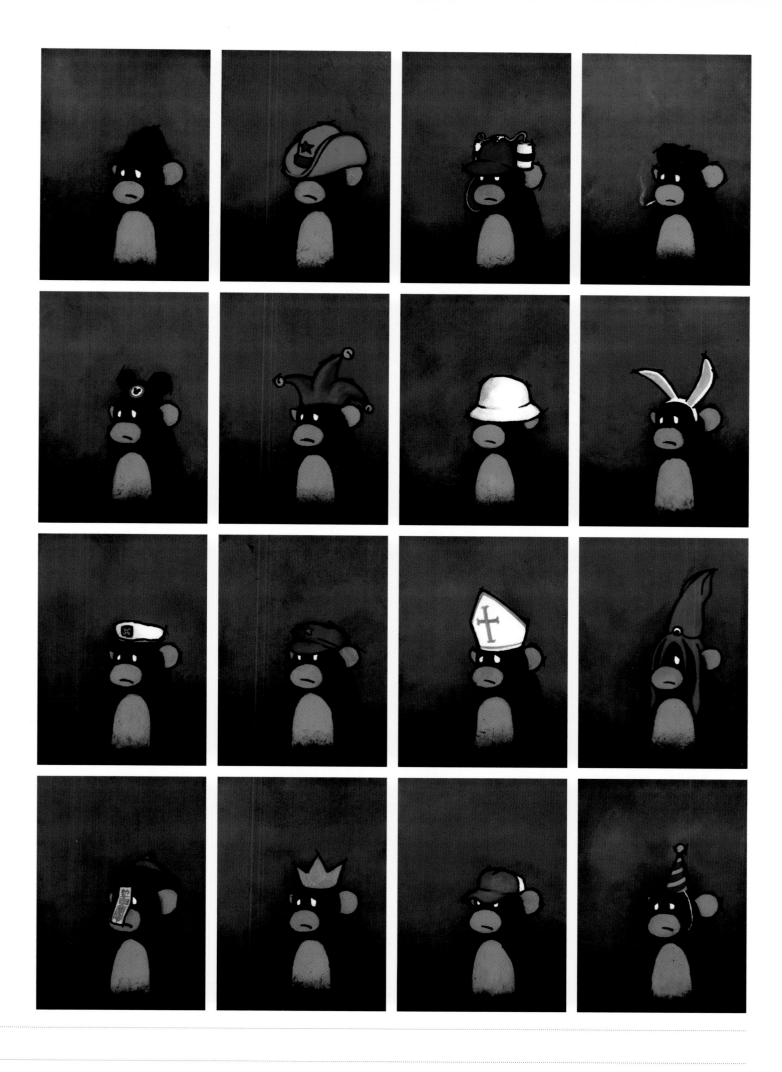

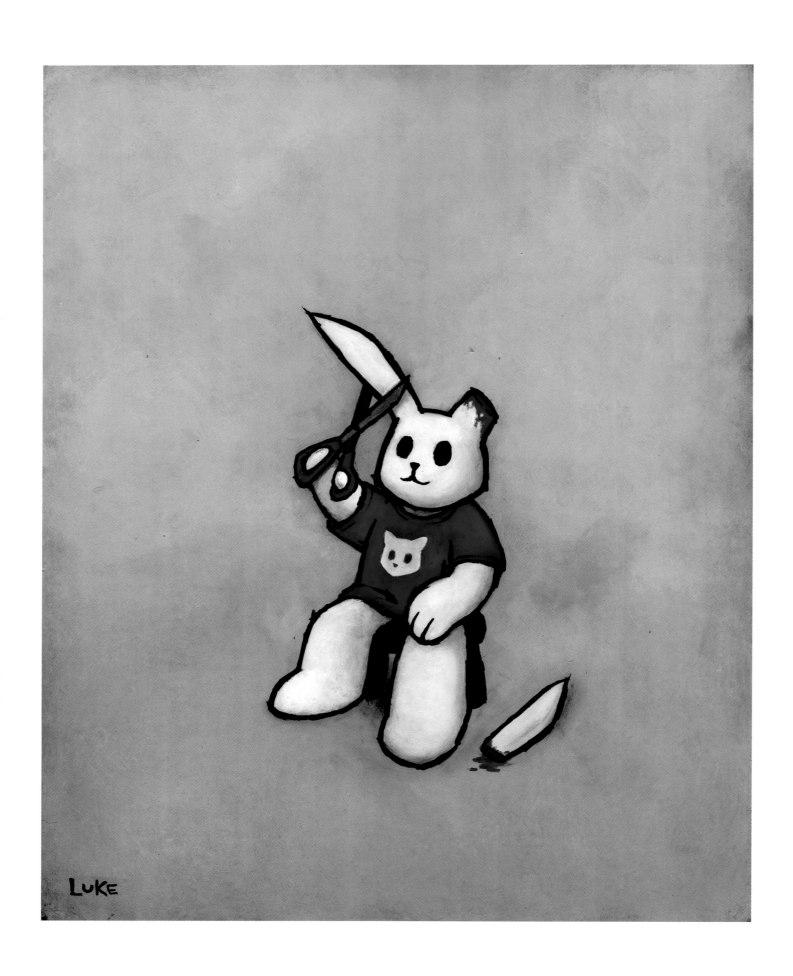

Hare-Cut
Acrylic and ink, 16 x 20 inches, 2004

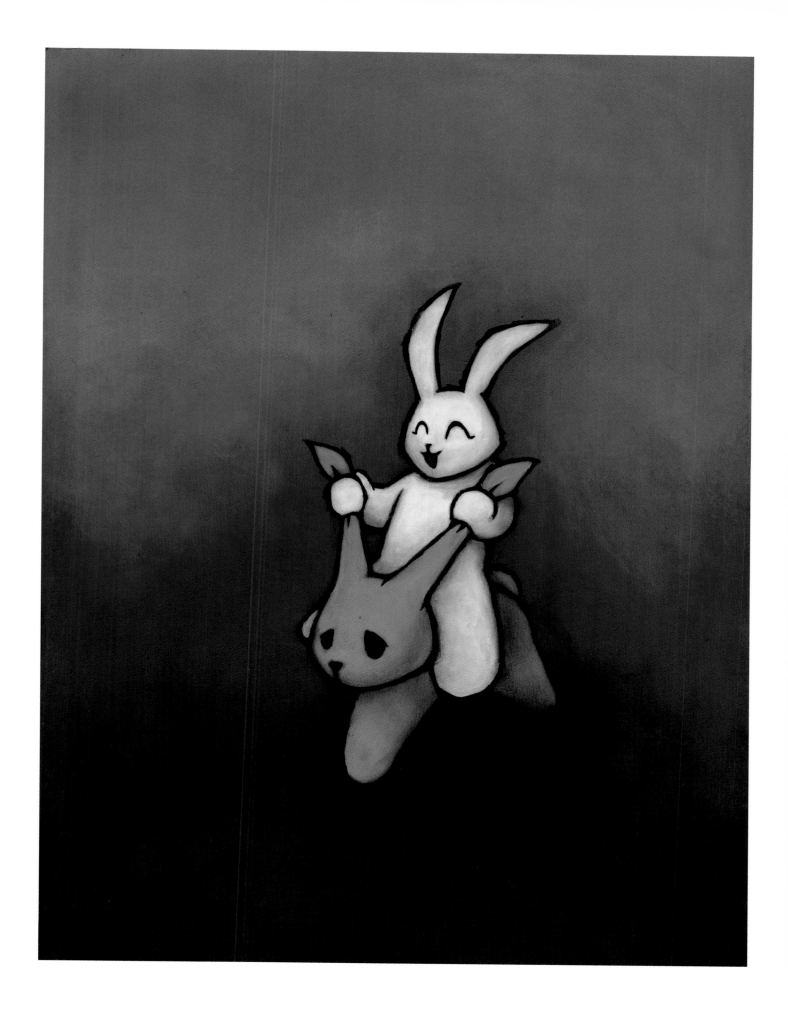

My Happiness Is Riding On Your Misery
Acrylic and ink, 18 x 24 inches, 2004

 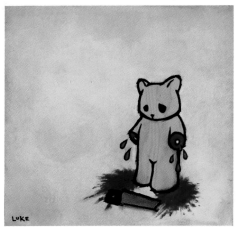 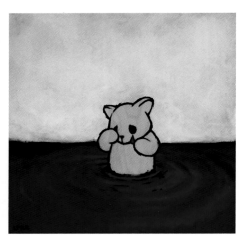

Mourning Wood Series (Burn/Cut/Tears)
Acrylic and ink on wood, 10 x 10 inches, 2004

Southpaw
Acrylic and ink, 36 x 48 inches, 2004

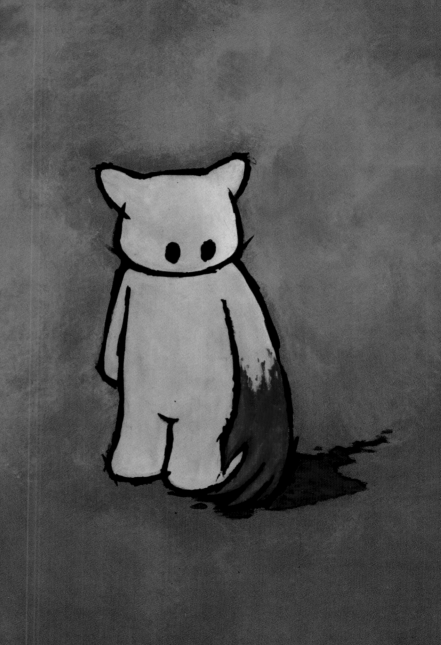

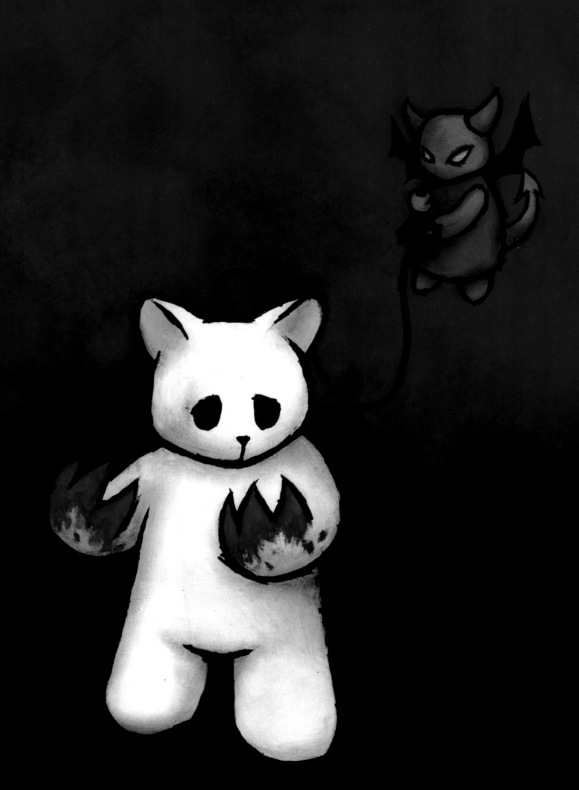

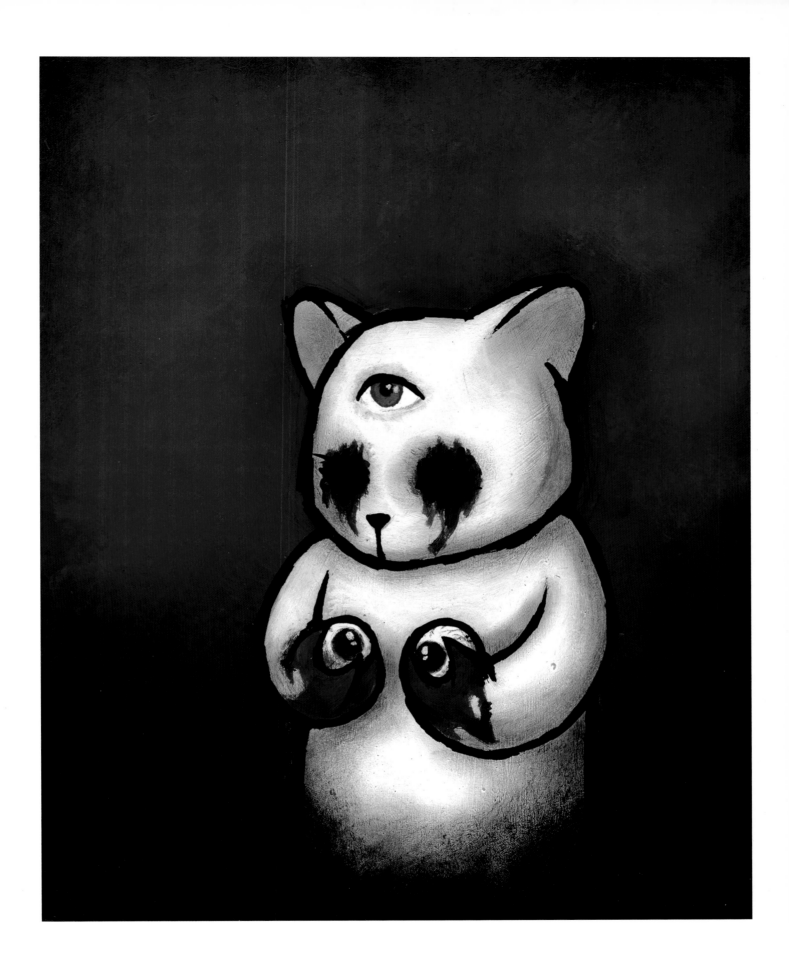

Possessed
Acrylic and ink, 18 x 24 inches, 2004

Two For One (The High Price Of Enlightenment)
Acrylic and ink, 16 x 20 inches, 2004

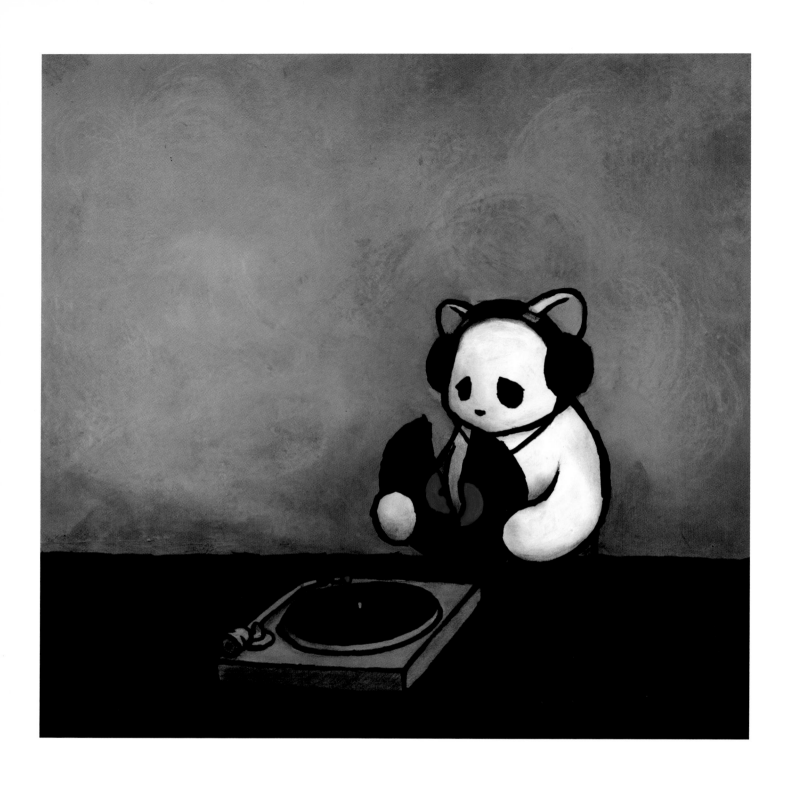

The Soundtrack (To My LIfe)
Acrylic and ink, 12 x 12 inches, 2004

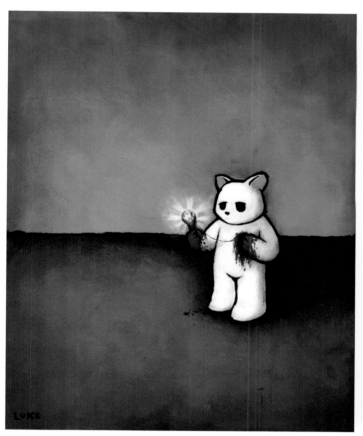

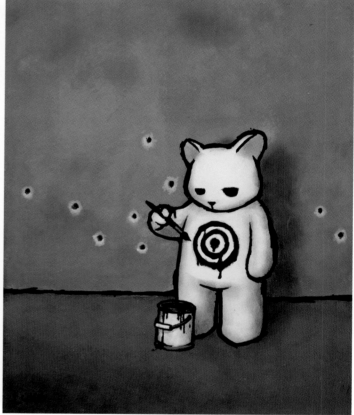

Inspiration (Bright Ideas From The Hole In My Soul)
Acrylic and ink, 16 x 20 inches, 2004

Target
Acrylic and ink, 11 x 14 inches, 2004

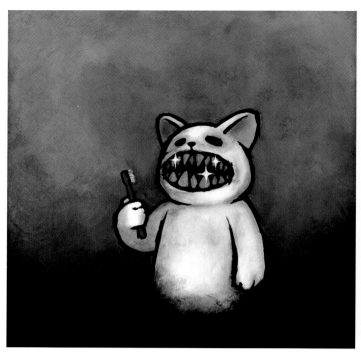

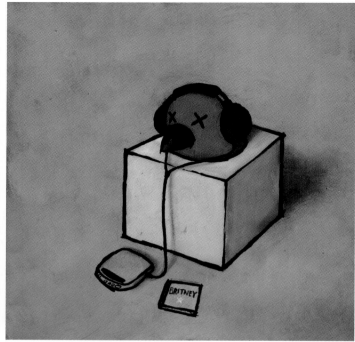

Polishing My Grill
Acrylic and ink, 12 x 12 inches, 2004

Killing Pigeons With The Vampiric/Soul Sucking Power Of Top 40 Music
Acrylic and ink, 12 x 12 inches, 2004

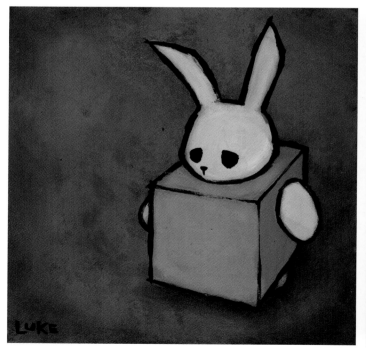

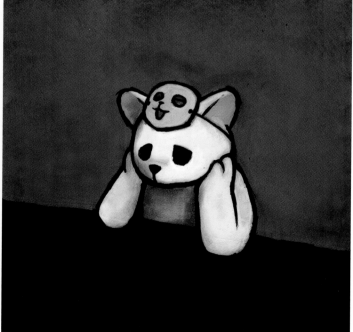

Square Blues
Acrylic and ink, 8 x 8 inches, 2004

The Façade Doesn't Fit
Acrylic and ink, 6 x 6 inches, 2004

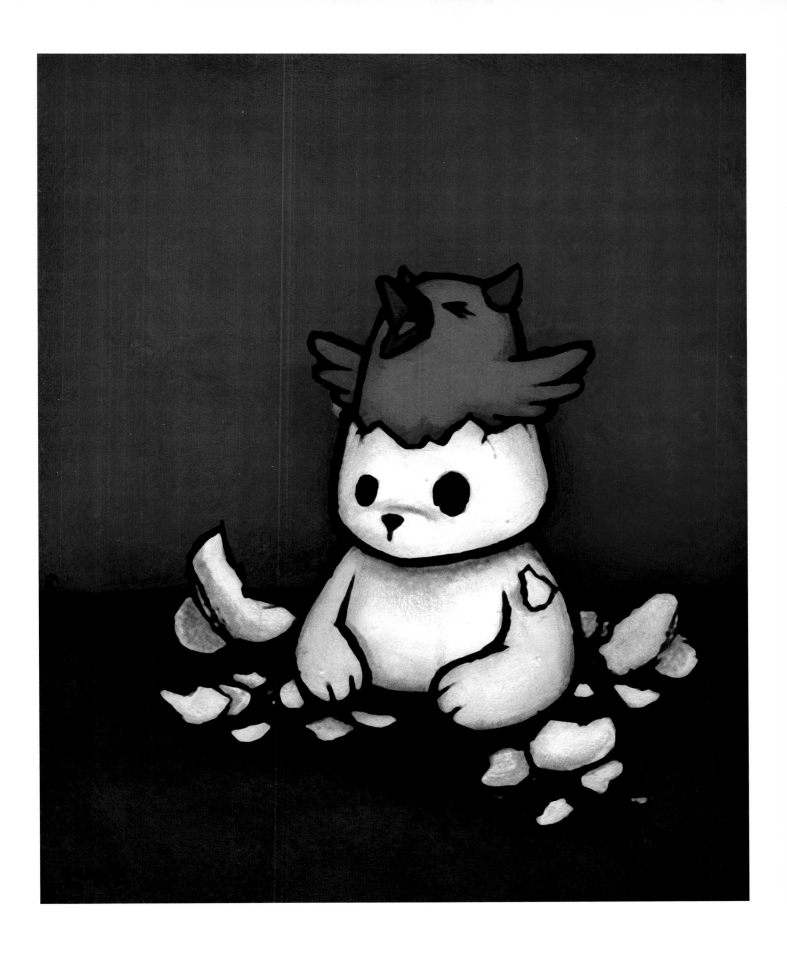

Birdbrained
Acrylic and ink, 8 x 10 inches, 2004

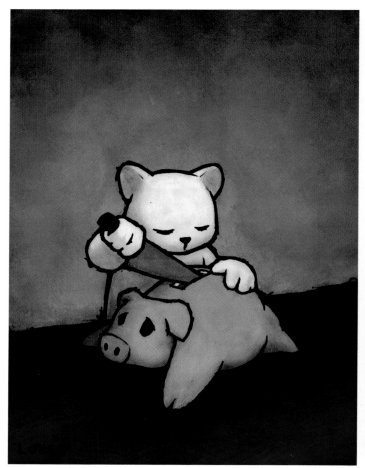

Piggy Bank
Acrylic and ink, 12 x 16 inches, 2004

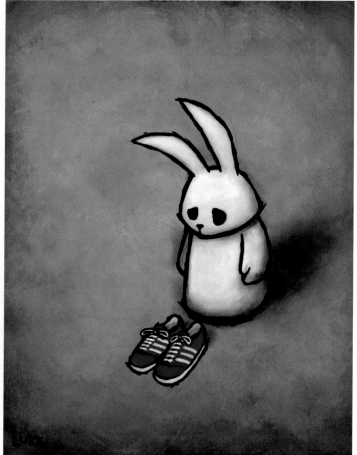

Another Useless Gift (Revisited)
Acrylic and ink, 11 x 14 inches, 2004

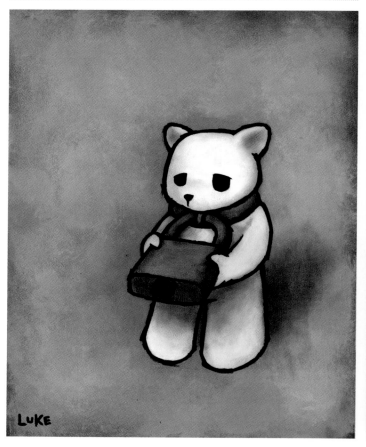

Locked
Acrylic and ink, 11 x 14 inches, 2004

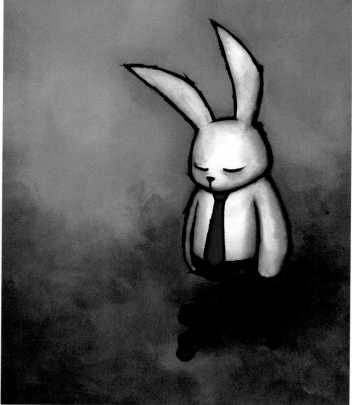

The Chairman
Acrylic and ink, 20 x 24 inches, 2004

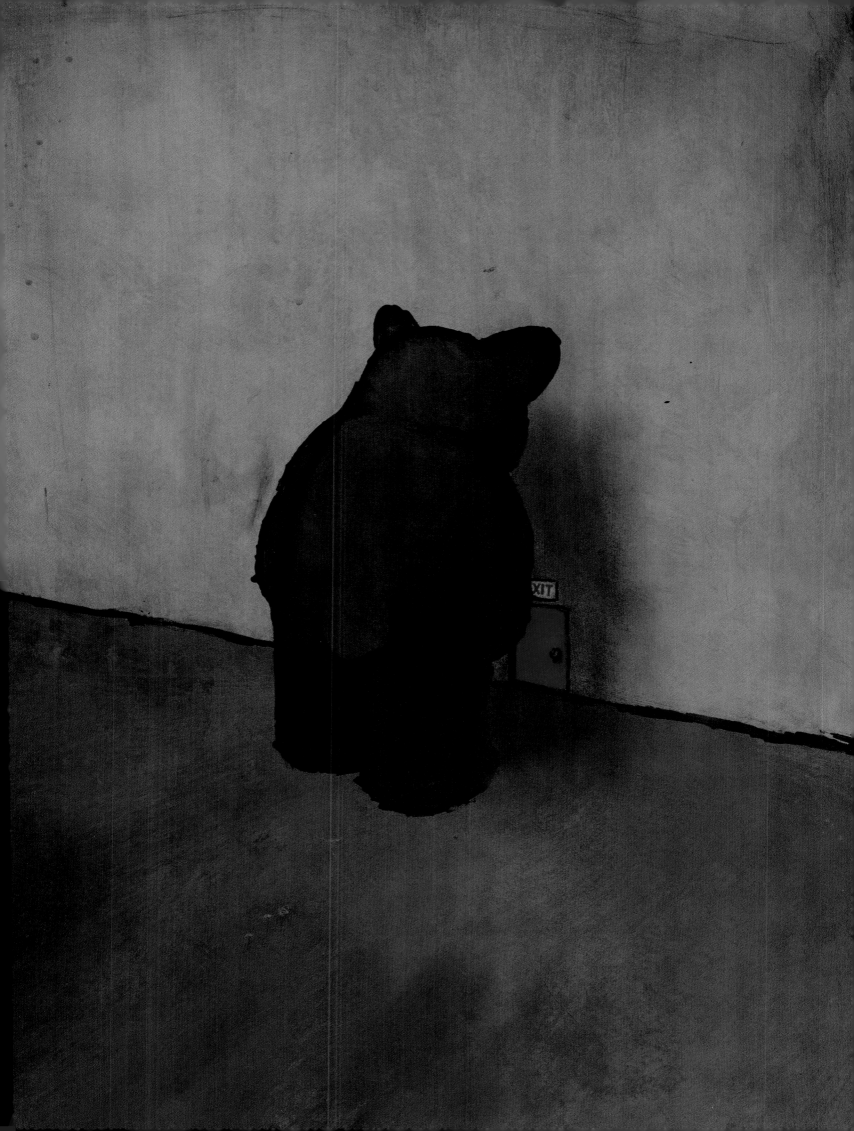

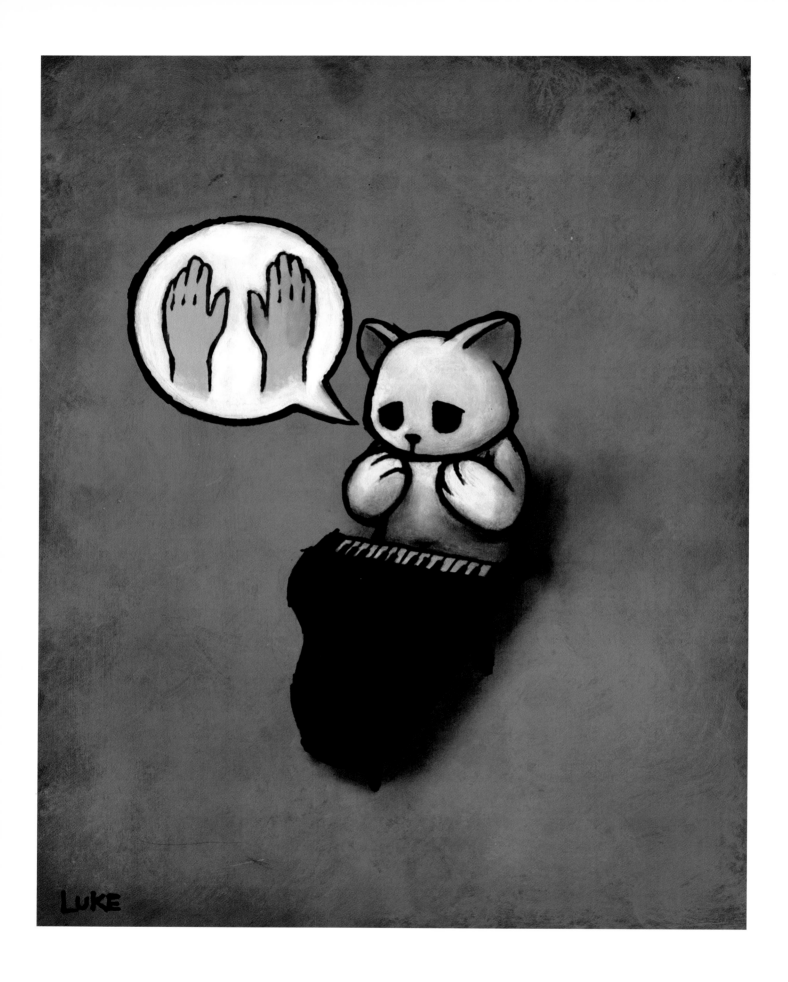

The Exit
Acrylic and ink, 16 x 20 inches, 2004

The Pianist
Acrylic and ink, 11 x 14 inches, 2004

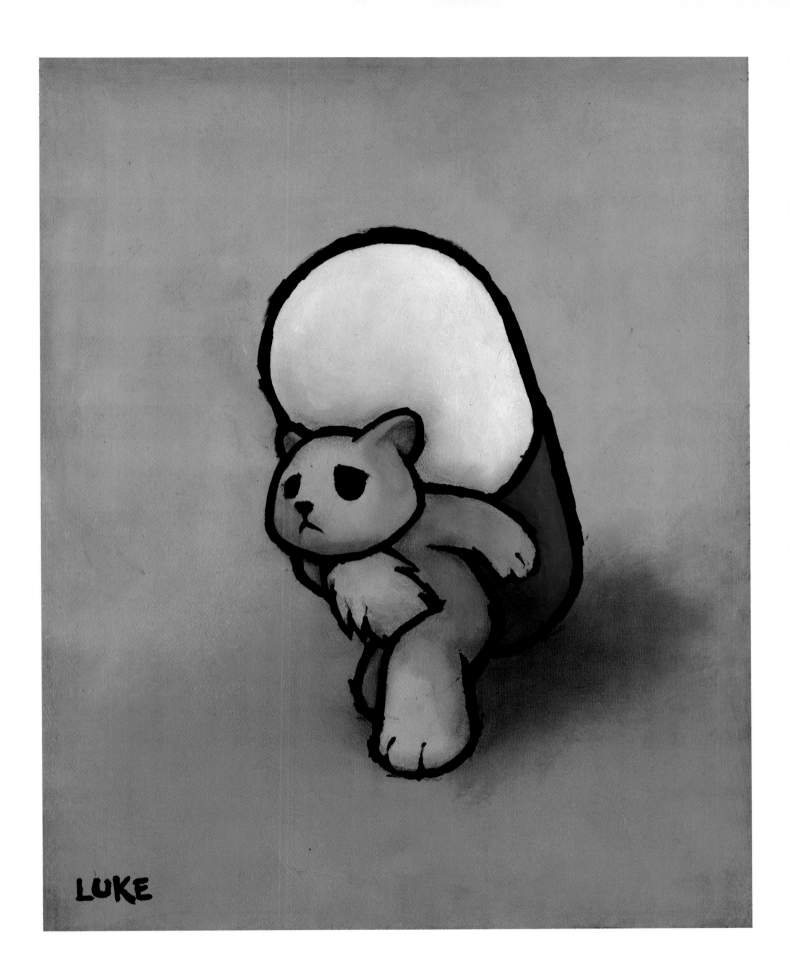

Pharm-Life
Acrylic and ink, 11 x 14 inches, 2004

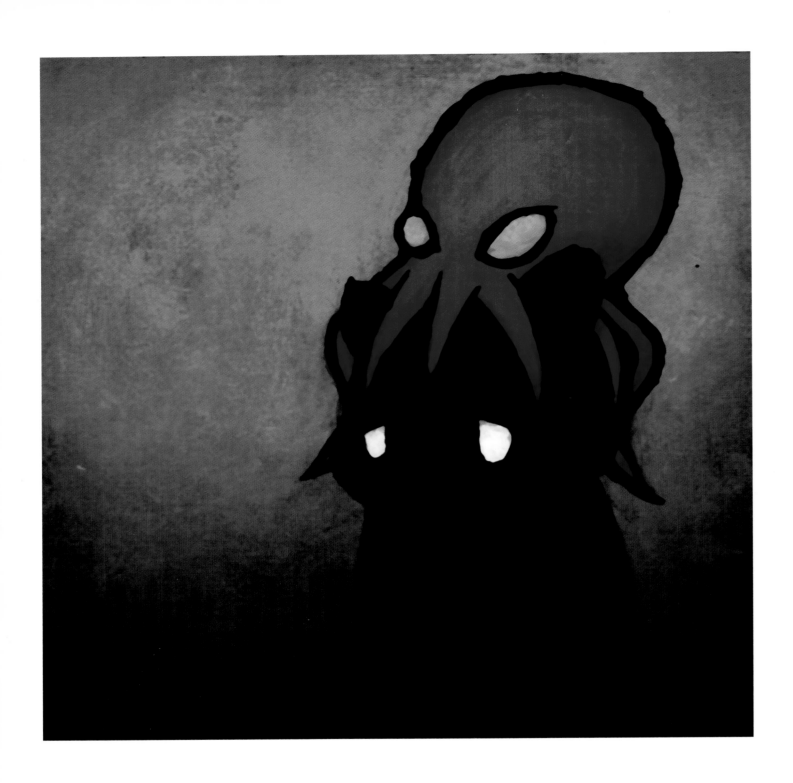

Six By Six Series (Devil Fish/Fire/Eyes/Horns/Teeth)
Acrylic and ink, 6 x 6 inches, 2004

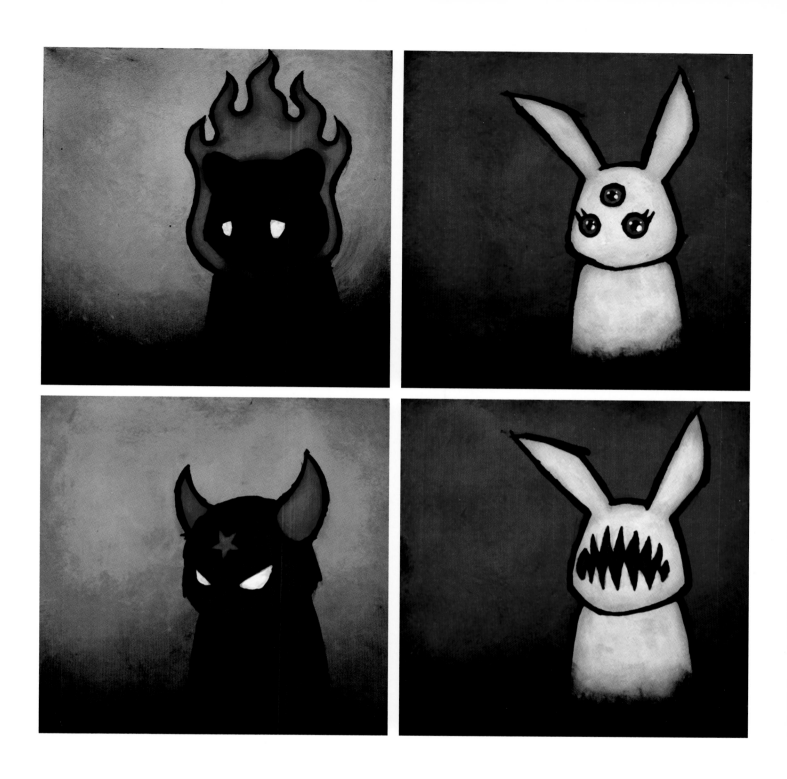

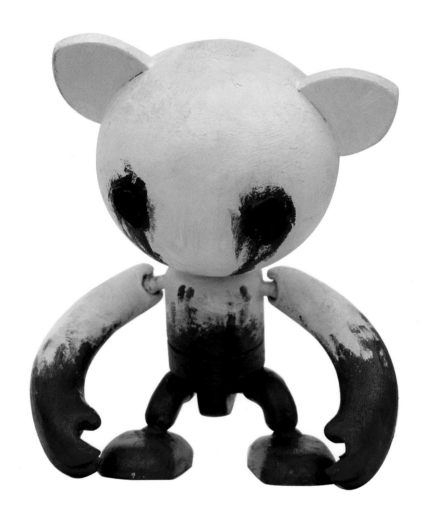

B.B. Birdy
Acrylic on B.B. Birdy figure, approx 4 inches, 2004

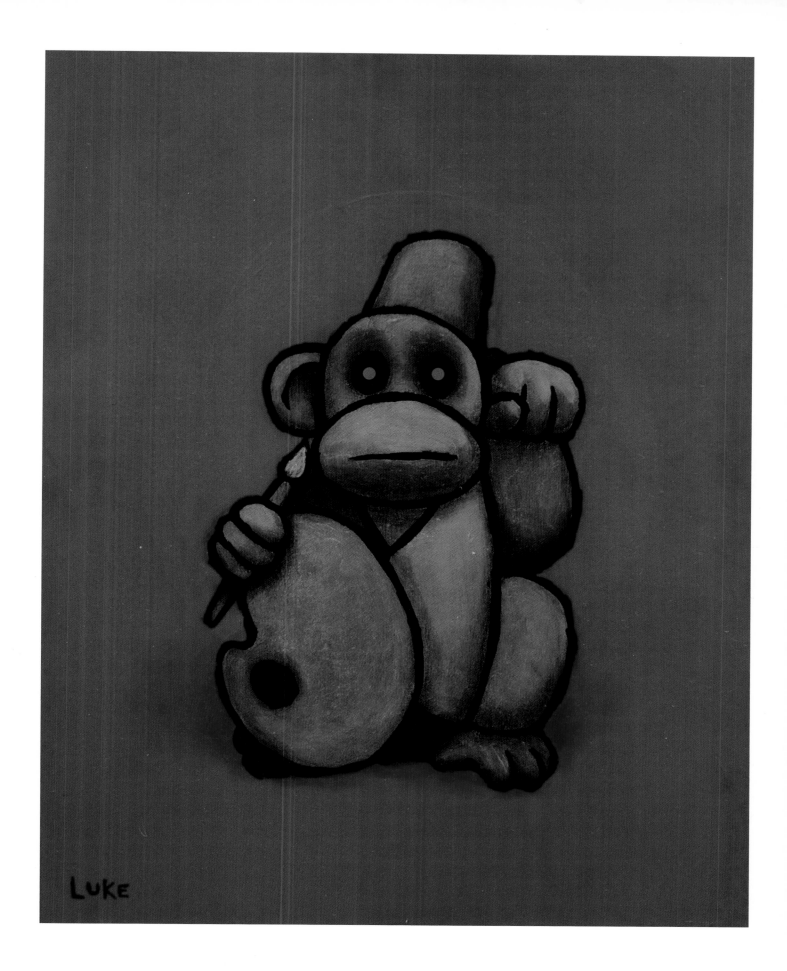

You Can't Spell Monkey Without M.O.N.E.Y
Acrylic, ink and red dots, 8 x 10 inches, 2004

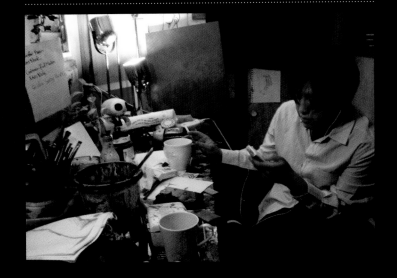

Just another evening in the Shedio
Photo by Kim Chueh

2005

On a lazy Sunday afternoon in Chinatown, I caught Luke Chueh stealing from my store. Well at least that's what I thought he was doing. Instead, he was sneakily poking his fingers into every blind box mini-figure on the shelf, trying to peek inside to get the one he wanted. And just as I was about to demand that he leave and never come back, he introduced himself as Luke Chueh, whose paintings I had stopped to admire recently in a local clothing store. That was the beginning of a friendship and collaboration that has grown with the success of his career and of Munky King. Working with Luke on his toy projects has been one of the most fulfilling parts of my experience in the designer toy business. Immensely protective of the integrity of his work, his passion has inspired me to push the envelope to do justice to his art. And as his work evolves, so does the man himself. Seeing him fight through his darkest hours and emerge victorious reignited my faith in the human spirit and the endurance of the human body. It gives me great pleasure to be writing this for his first book instead of his eulogy, for I love this guy not only for his talent, but for the close friendship we have shared through the years.

Patrick Lam, Munky King

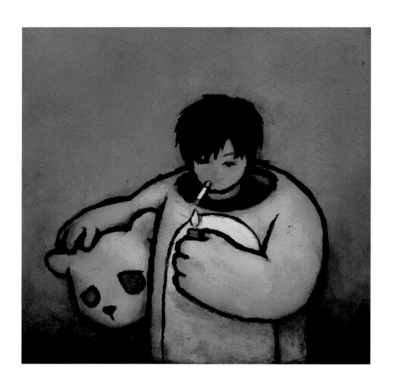

Self Portrait
Acrylic and ink, 6 x 6 inches, 2005

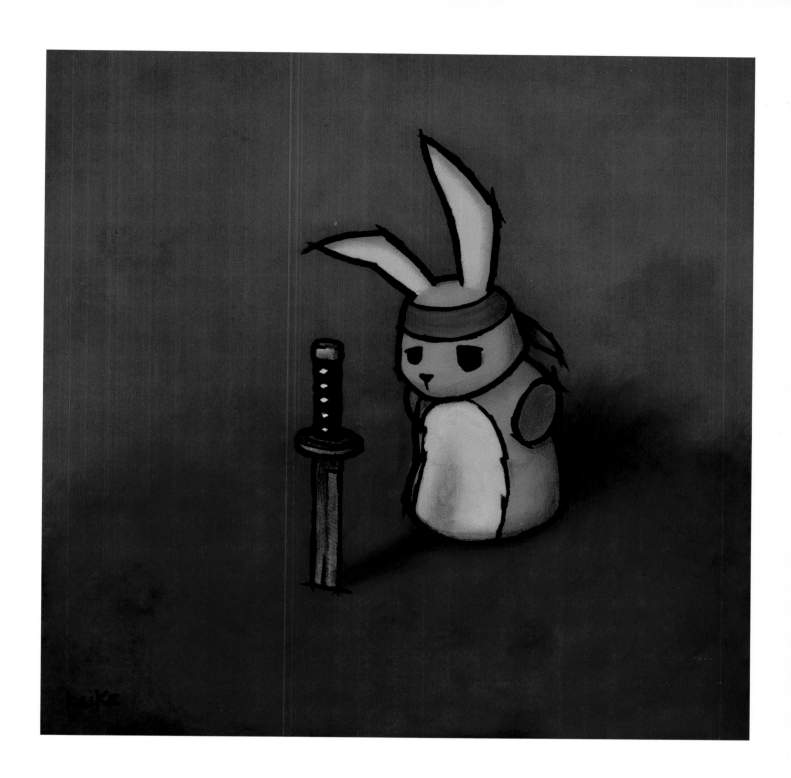

Life By The Knife
Acrylic and ink, 12 x 12 inches, 2005

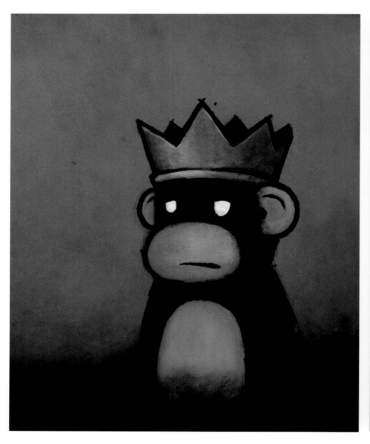

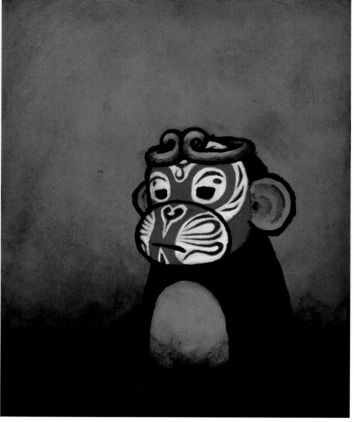

A Monkey King
Acrylic and ink, 9 x 12 inches, 2005

The Monkey King
Acrylic and ink, 8 x 10 inches, 2005

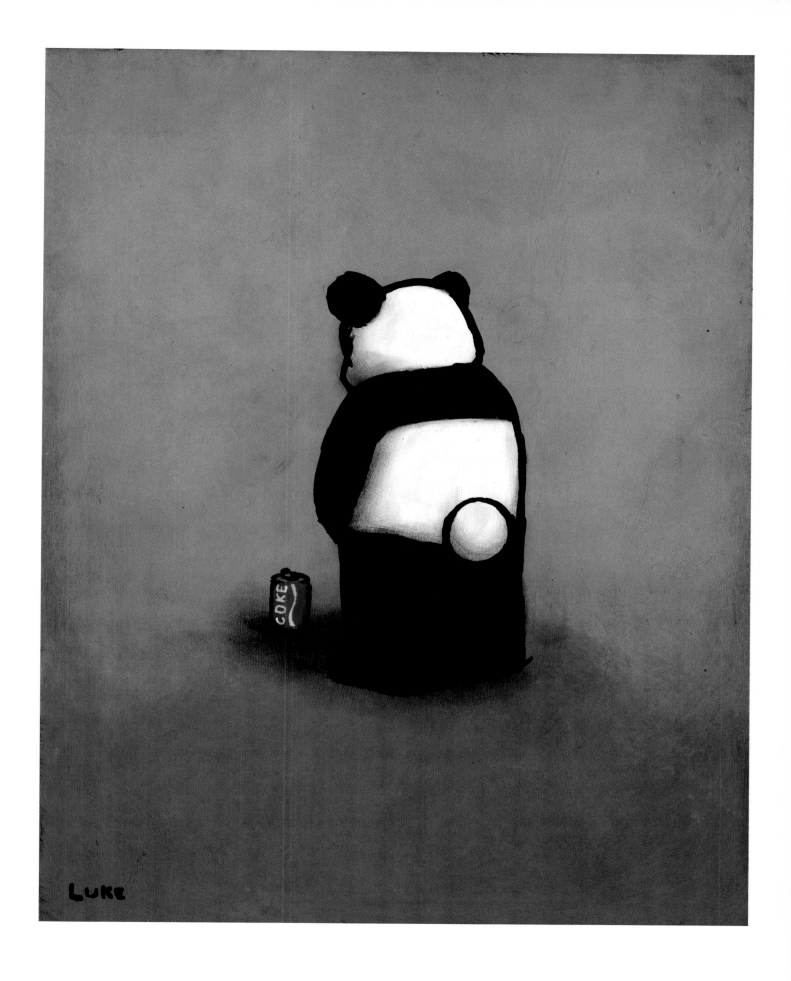

Me Play Joke
Acrylic and ink, 11 x 14 inches, 2005

Southpaw (Revisited)
Acrylic and ink, 16 x 20 inches, 2005

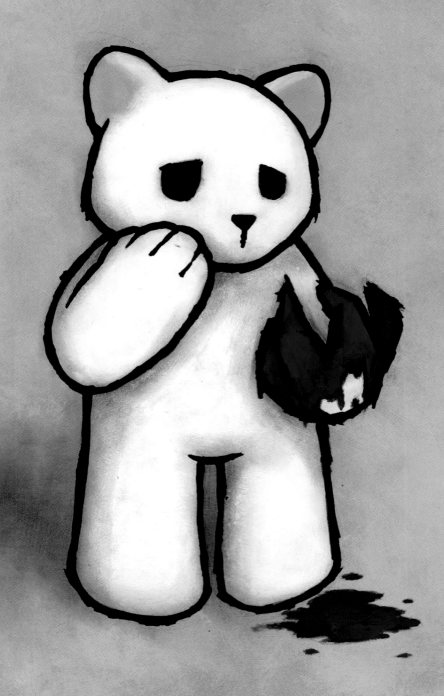

LUKE

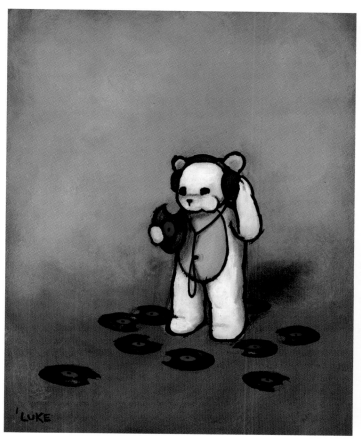

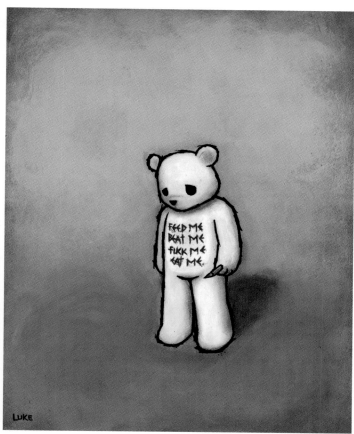

Sound-Bite
Acrylic and ink, 11 x 14 inches, 2005

I Am Your Plaything
Acrylic and ink, 11 x 14 inches, 2005

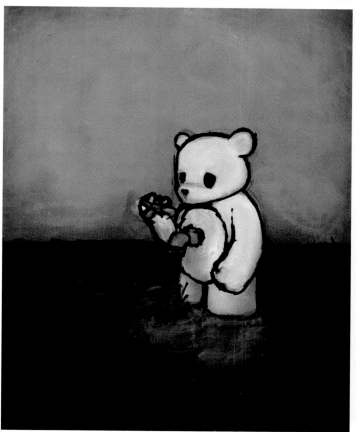

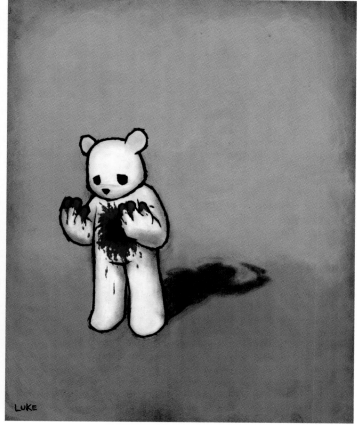

Bad Plumbing
Acrylic and ink, 8 x 10 inches, 2005

Shadowplay
Acrylic and ink, 16 x 20 inches, 2005

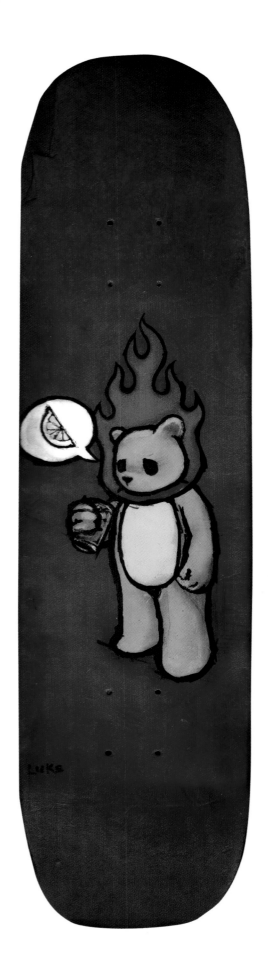

No Lemon (Skateboard)
Acrylic and ink, 7.75 x 30 inches, 2005

Skate & Grate (Skateboard)
Acrylic and ink, 7.75 x 30 inches, 2005

Dig Dug
Acrylic and ink, 11 x 14 inches, 2005

Black In White And Red All Over
Acrylic and ink, 8 x 10 inches, 2005

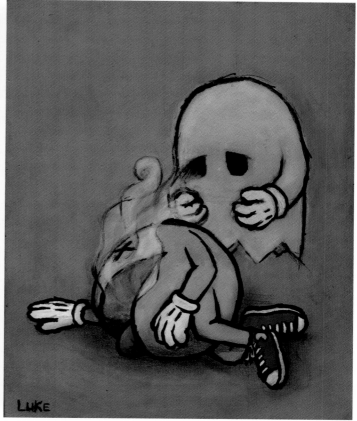

Hustle For Happiness (Remixed)
Acrylic and ink, 8 x 10 inches, 2005

(Pac Man) Becoming My Own Worst Enemy
Acrylic and ink, 8 x 10 inches, 2005

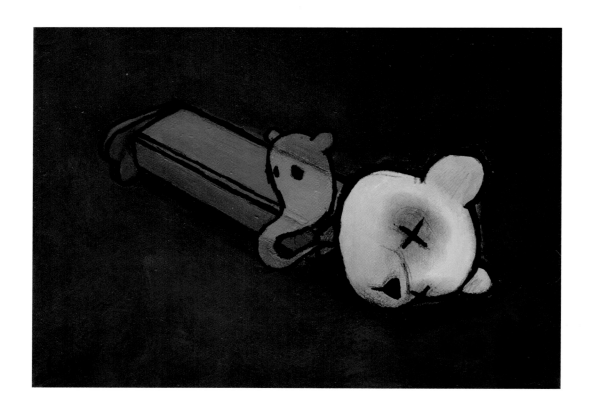

Dead Pez
Acrylic and ink, 6 x 8 inches, 2005

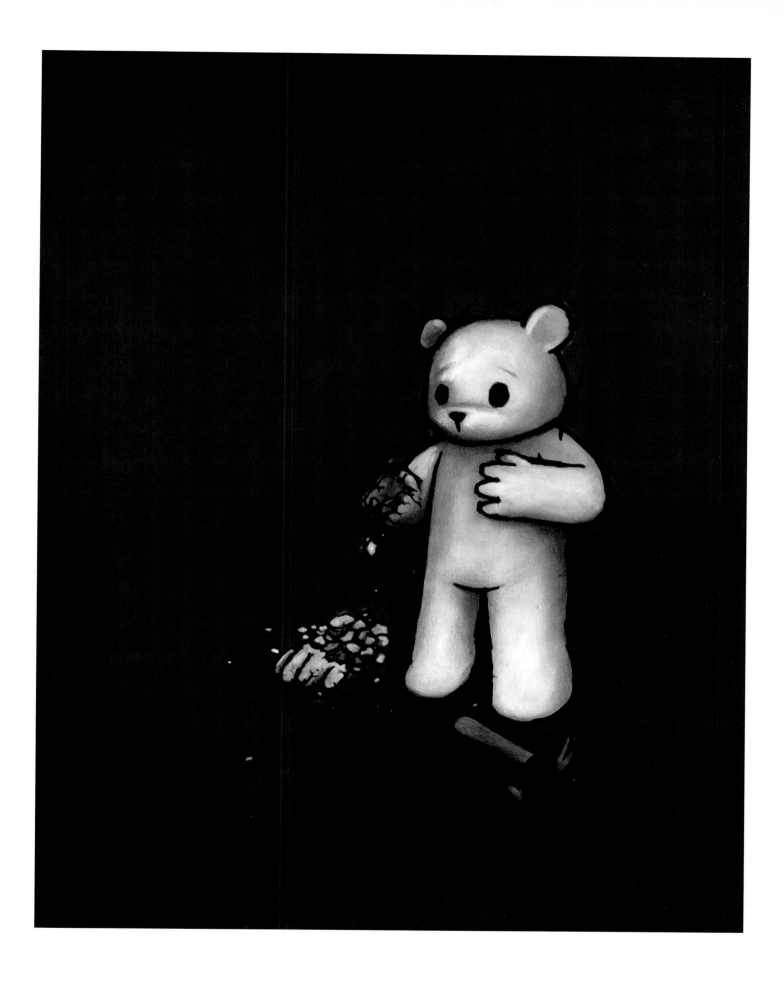

Cracked
Acrylic and ink, 11 x 14 inches, 2005

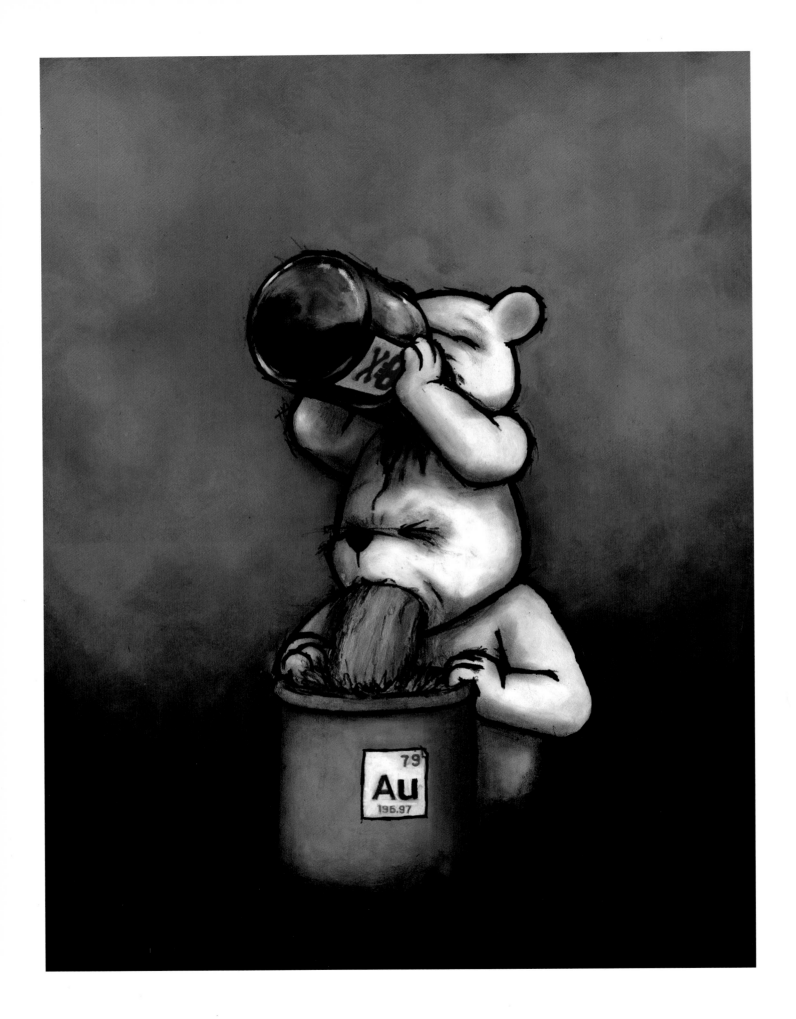

The Alchemist
Acrylic and ink, 18 x 24 inches, 2005

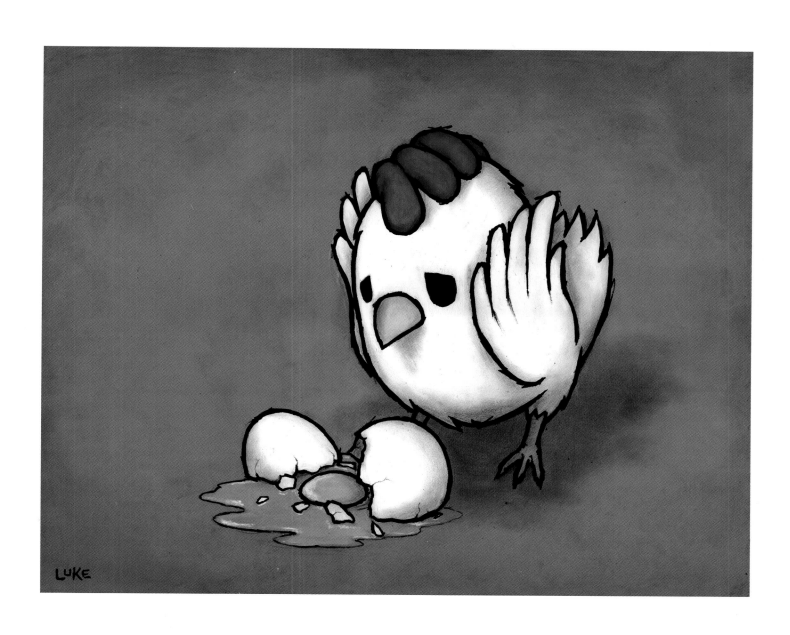

The Miscarriage
Acrylic and ink, 16 x 20 inches, 2005

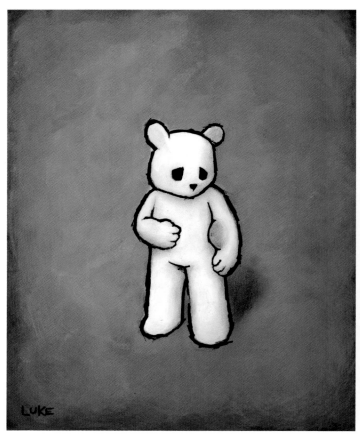

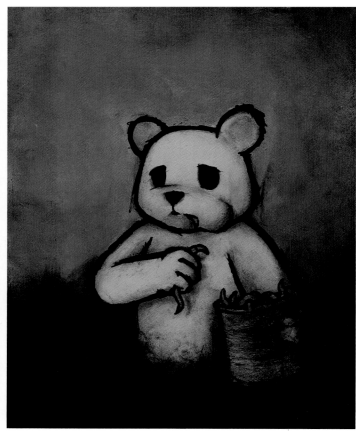

The Abscess
Acrylic and ink, 8 x 10 inches, 2005

Nobody Loves Me Everybody Hates Me
Acrylic and ink, 8 x 10 inches, 2005

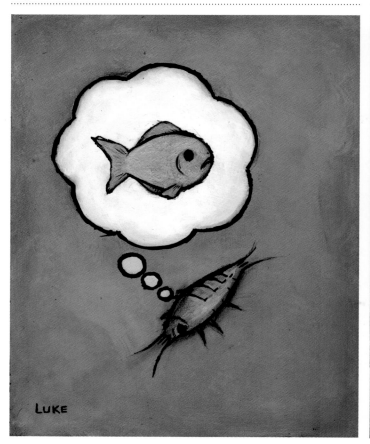

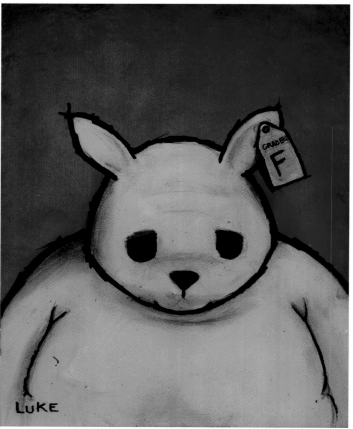

Silverfish/Goldfish
Acrylic and ink, 8 x 10 inches, 2005

F Is For Fatty
Acrylic and ink, 8 x 10 inches, 2005

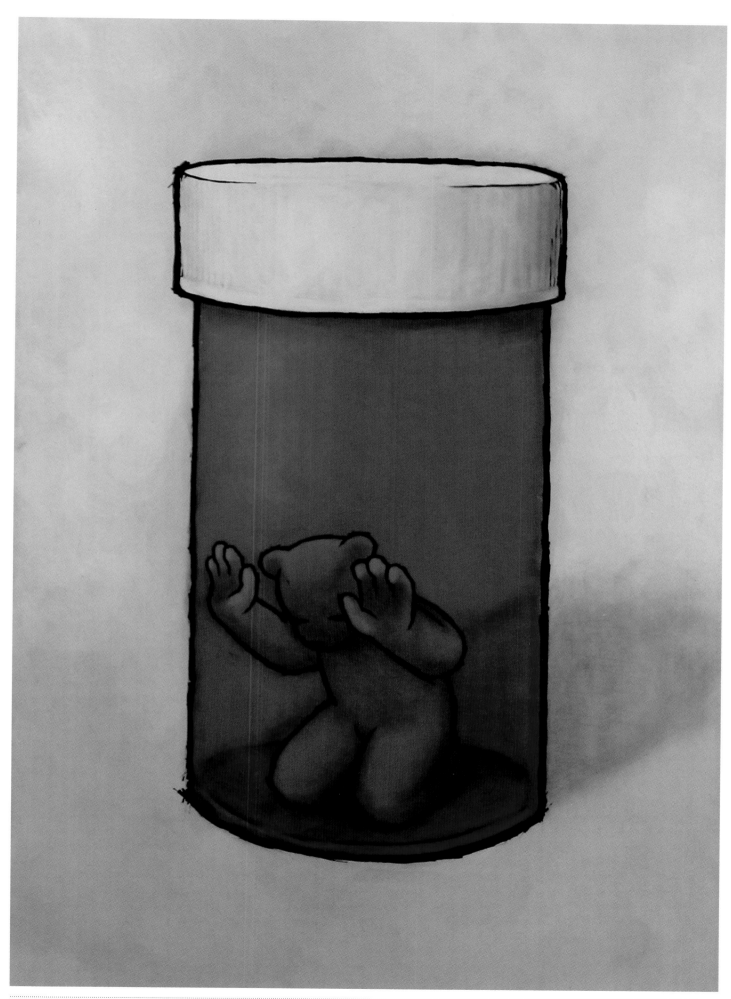

The Prisoner
Acrylic and ink, 24 x 36 inches, 2005

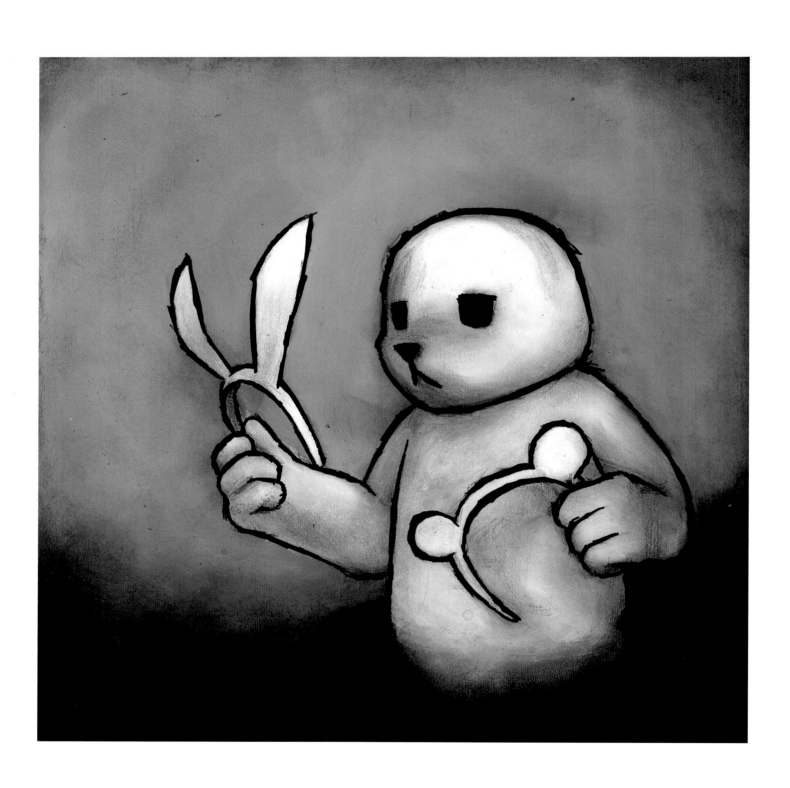

Indecision
Acrylic and ink, 12 x 12 inches, 2005

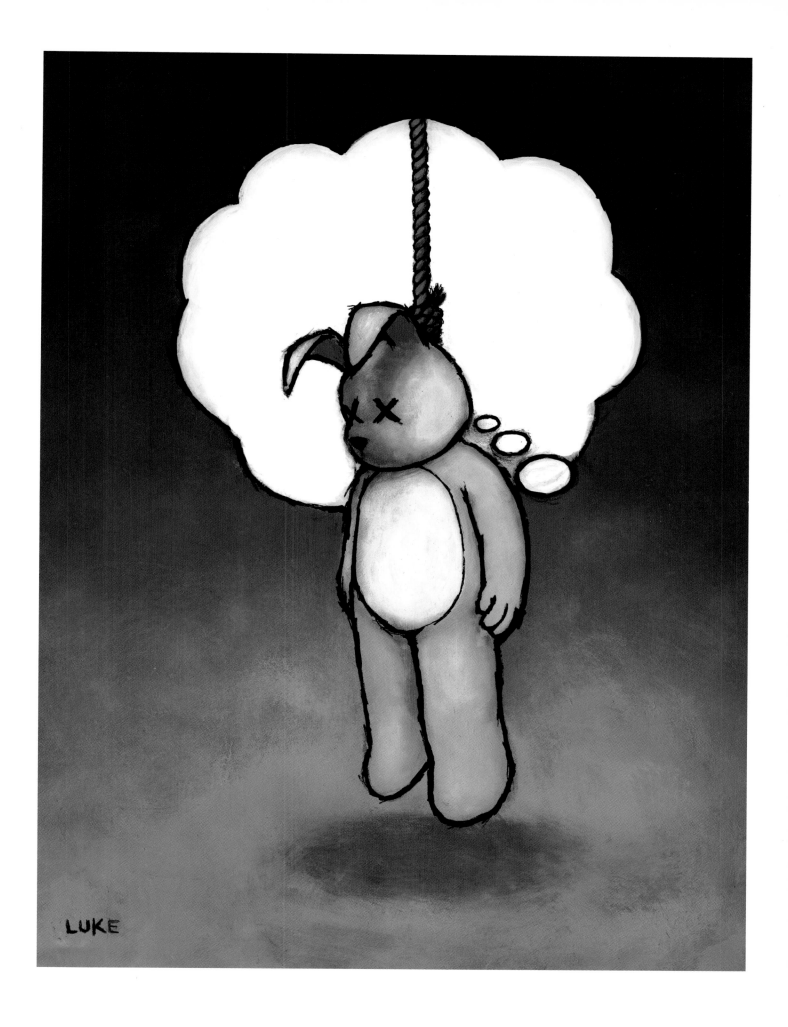

Deathwish
Acrylic and ink, 18 x 24 inches, 2005

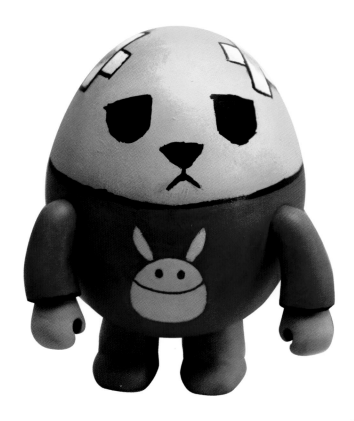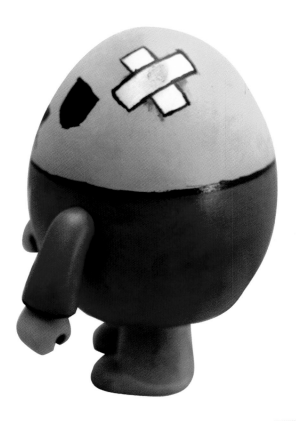

Off Ears And Eggs
Acrylic and ink on Egg Qee, approx 7 inches, 2005

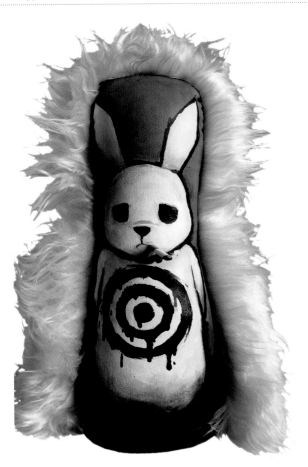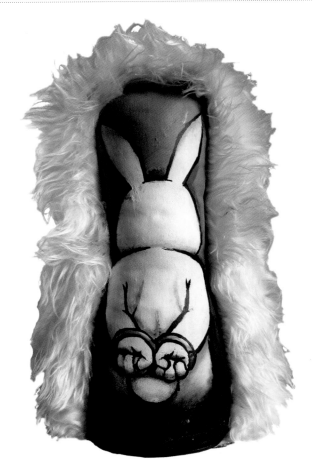

Circus Punks Custom: Target
Acrylic and ink on Circus Punk, approx 12 inches, 2005

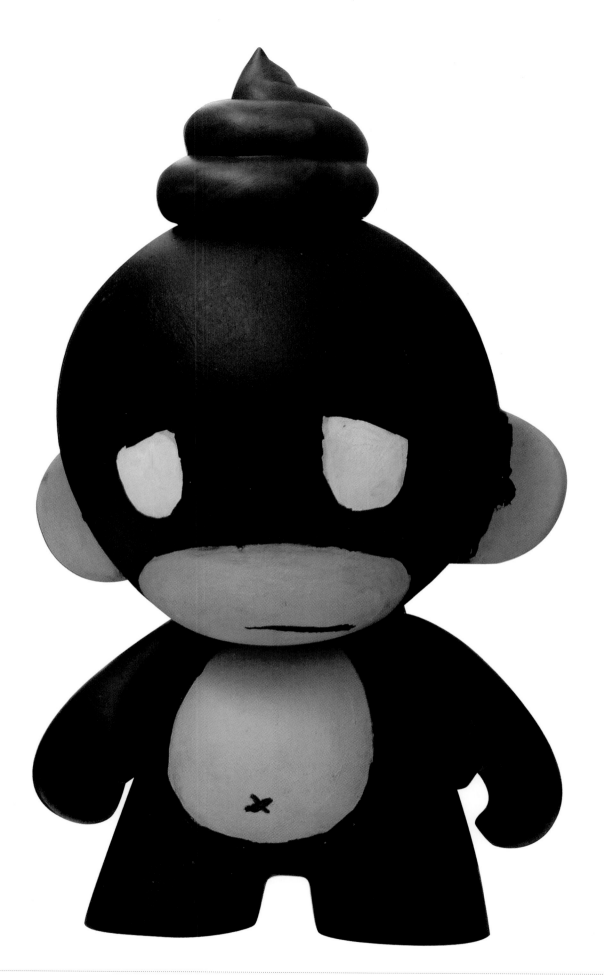

Shithead (Munny)
Acrylic, ink and Munny, approximately 6 inches, 2005

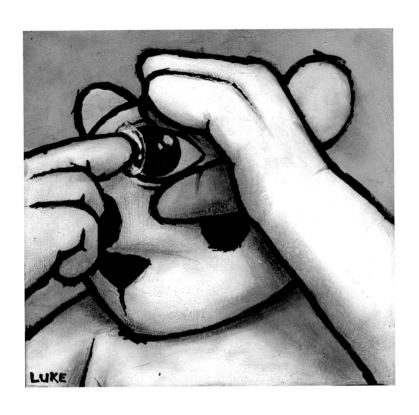

Contact Lens
Acrylic and ink, 6 x 6 inches, 2005

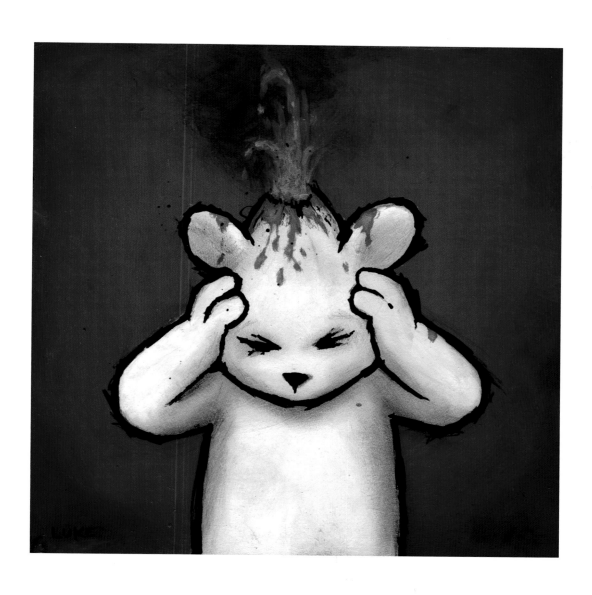

The Eruption
Acrylic and ink, 8 x 8 inches, 2005

A warm summer's day in the Shedio
Photo by Jessica DiCicco

2006

On June 6, 2004, I sat in a room at the Mondrian Hotel in Hollywood, California awaiting the arrival of my brother, Joel, who was late (as usual) to pick me up and take me to the airport. I'd spent four nights at the hotel in L.A., working, but until that moment I had paid no attention to the collection of magazines sitting on the coffee table.

The Book LA, a magazine I had never heard of, was the first atop a fan of magazines spread equidistant from one another. The next was, smaller, darker, Gary Oldman's shadowy image on the cover – I picked it up as a result of something I can only describe as an act of divine intervention.

I swear on my grandfather's grave that I opened it to page 126 and time stopped for four full minutes. This guy, Luke Chueh, says he's been painting for a year and names Rothko as an influence. I'm sold, game over. I had just fallen in love with Luke.

Here I am, eight years later, and let me tell you that GREAT LOVE only happens a few times in your life and I fell in love with Luke Chueh's art the minute I laid eyes on it. There is no question about the capacity for communication that this individual possesses. I saw seven paintings in a smaller than average magazine (8 x 6) that hit me like Rothko, Kandinsky, Warhol, and Basquiat – but all rolled into one.

I just want to say this: I started college as an art major and I had to change majors for circumstances beyond my control. I've seen my friends and family sign major label record deals. I've seen people I know on the silver screen. The reality that true art dies on the assembly line is an accepted fact in my world, I can say this without a doubt: *The fact that Luke Chueh exists makes me believe that real art still happens in a time when I need it most.* Period, the end. And if you get a chance to meet him you will understand what the artist's soul truly is. Needless to say, I'm a believer.

To Luke,

Thank you so much for sharing. Thank you for being here in my time. Thank you for continuing to create. Thank you for creating a world of creative inspiration – for which I will remain always in your debt.

Art Forever,
Josh Madden

I first saw Luke's work when my brother Josh bought one of his prints. I immediately felt connected to Luke for some reason. Happy-looking paintings, that were also very sad, which is a lot like how I see my music. It sounds like it's supposed to be cute and happy, but there is a sad ironic theme in every song. Maybe it's my outlook on life. Sad and ironic – wearing a smile. Once I saw the print my brother had, I started looking everywhere I could for Luke's paintings. I needed to have one to stare at. Shortly after that, I met Jensen at Gallery1988 in Los Angeles, where Luke was soon to have a show. I spent the next year buying every painting I could. I think I bought a total of nine that year, and good thing I did, I haven't been able to get one since. I love these paintings. I never get tired of looking at them. I basically built a gallery of just Luke's work in my old house.

Luke is truly a special artist and I'm excited to see where his ideas and artistic gift take him next.
Joel Madden, Good Charlotte

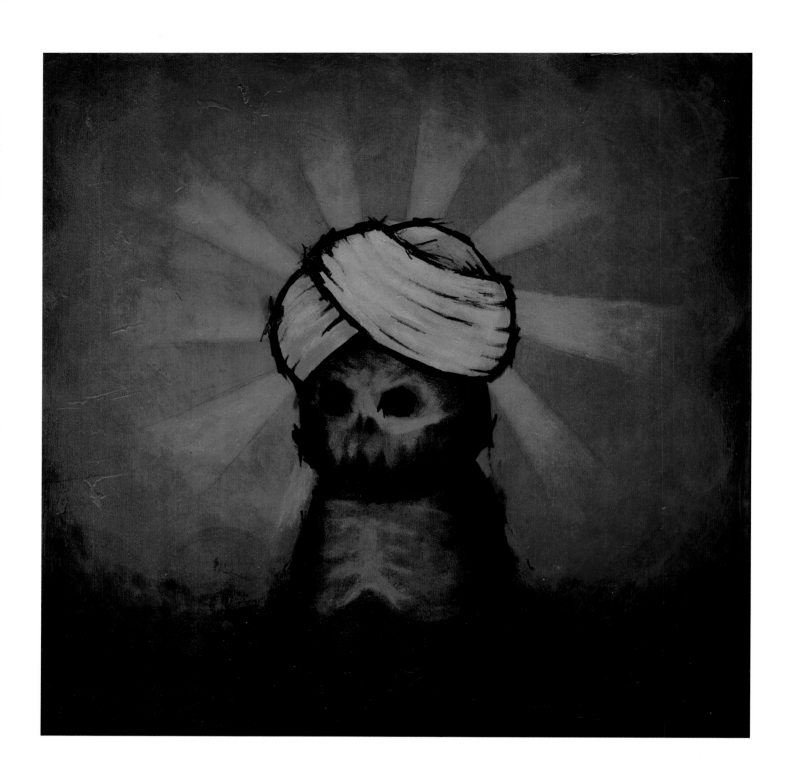

Quatrain 09,073
Acrylic and ink, 12 x 12 inches, 2006

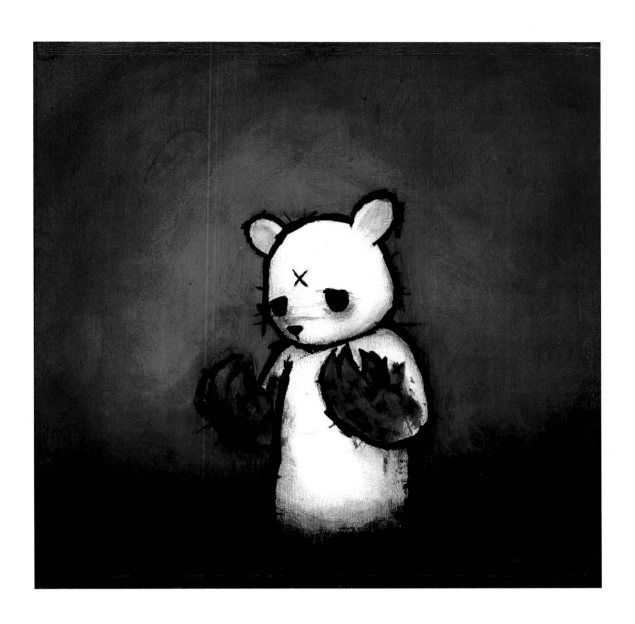

X
Acrylic and ink, 10 x 10 inches, 2006

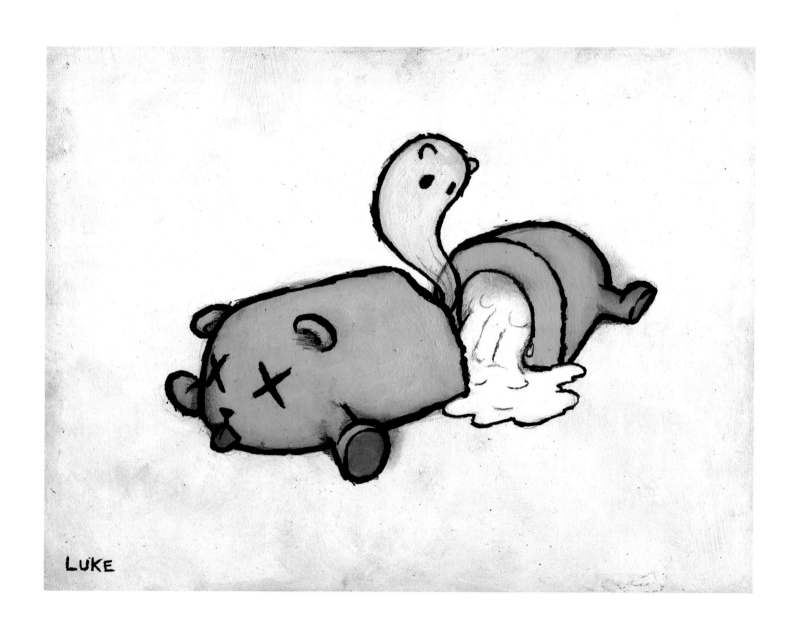

Twinkie
Acrylic and ink, 10 x 8 inches, 2006

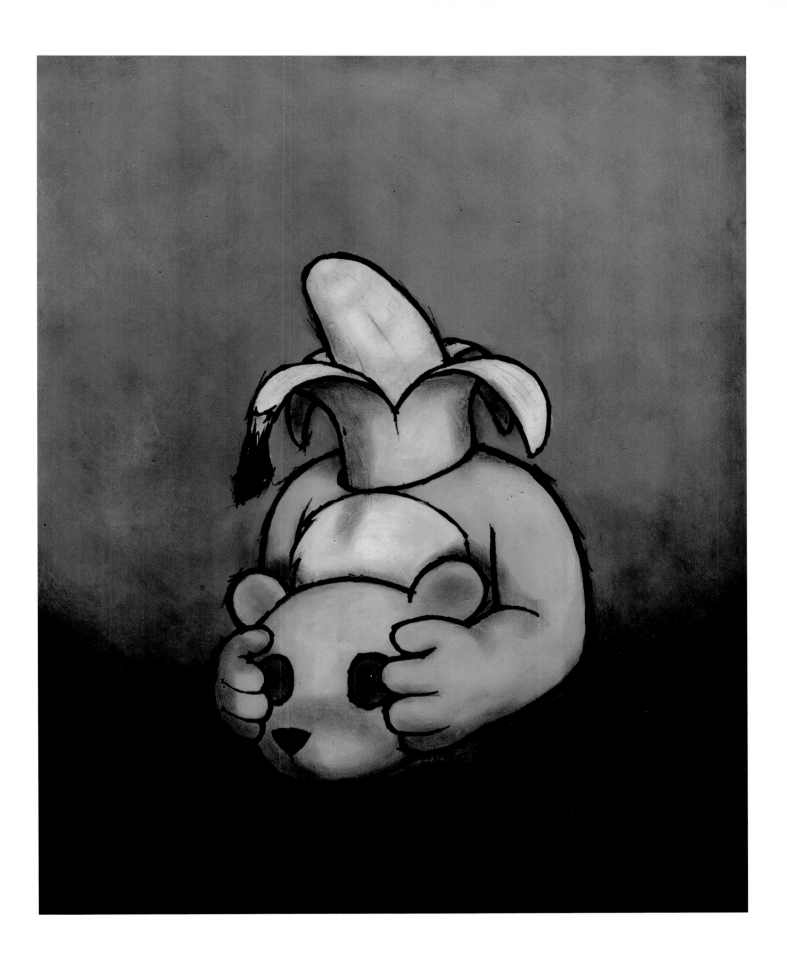

Self Portrait 2
Acrylic and ink, 16 x 20 inches, 2006

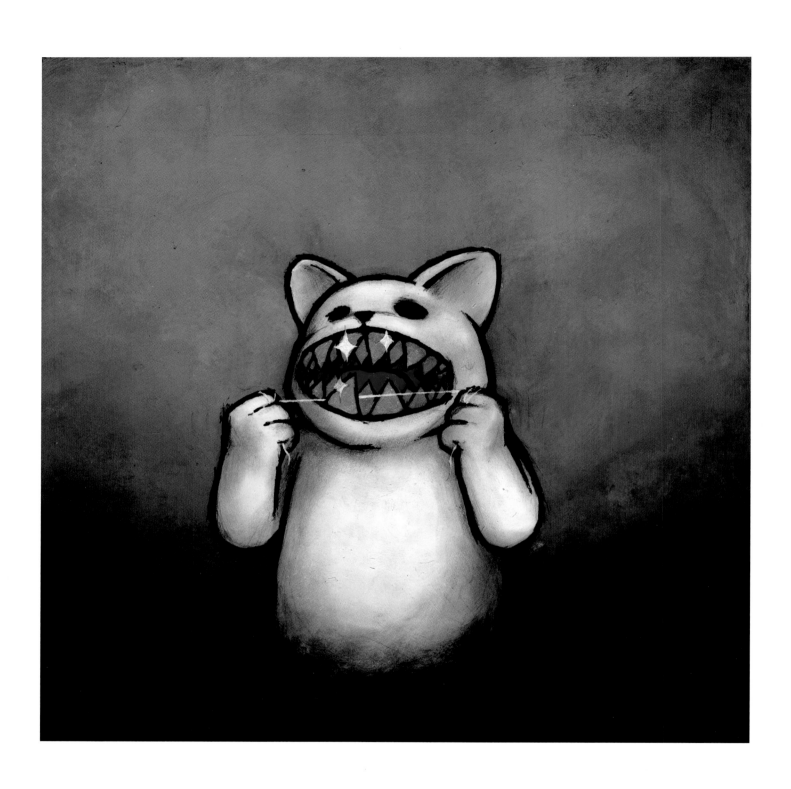

Flossing My Grill
Acrylic and ink, 12 x 12 inches, 2006

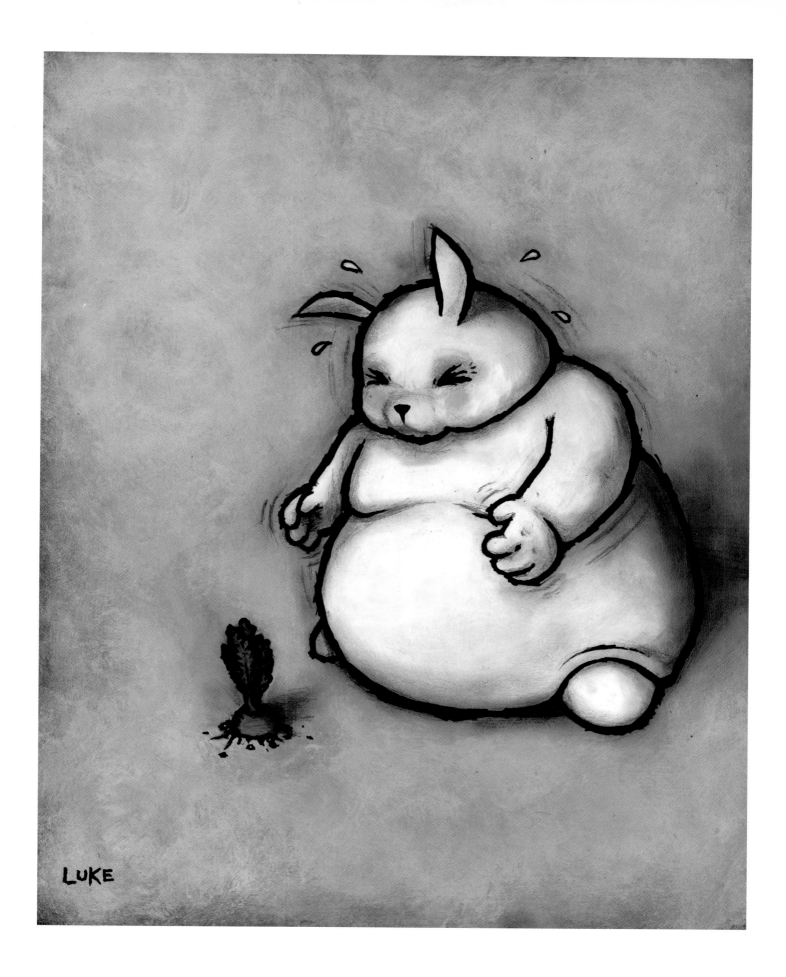

Reach
Acrylic and ink, 11 x 14 inches, 2006

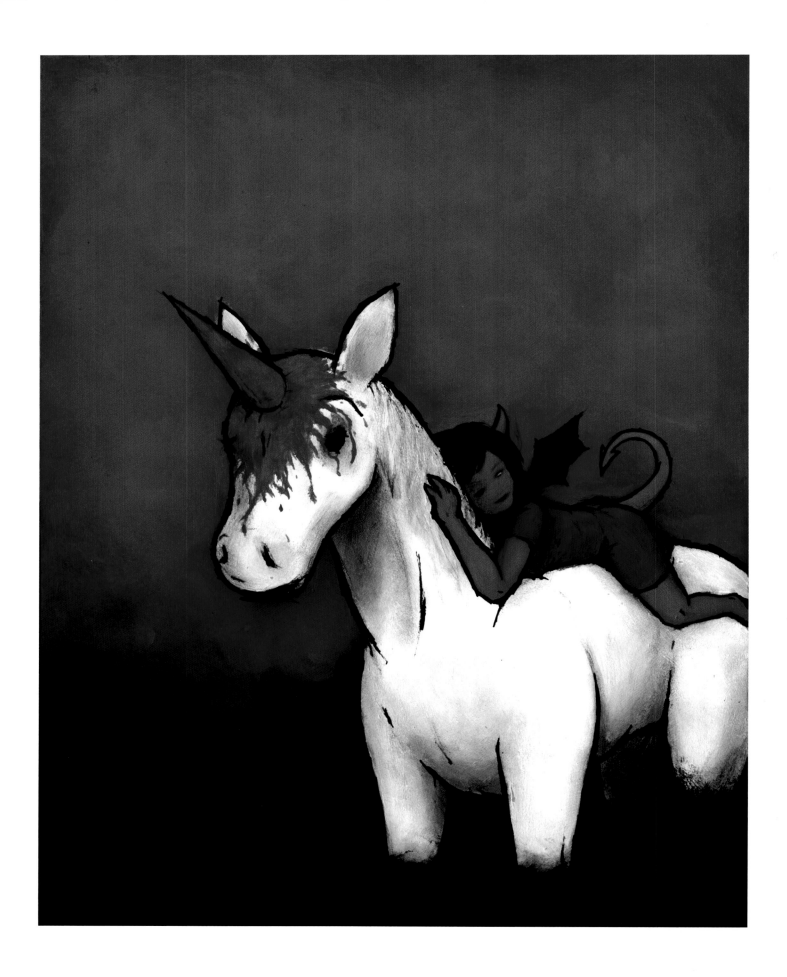

Beauty/Beast
Acrylic and ink, 11 x 14 inches, 2006

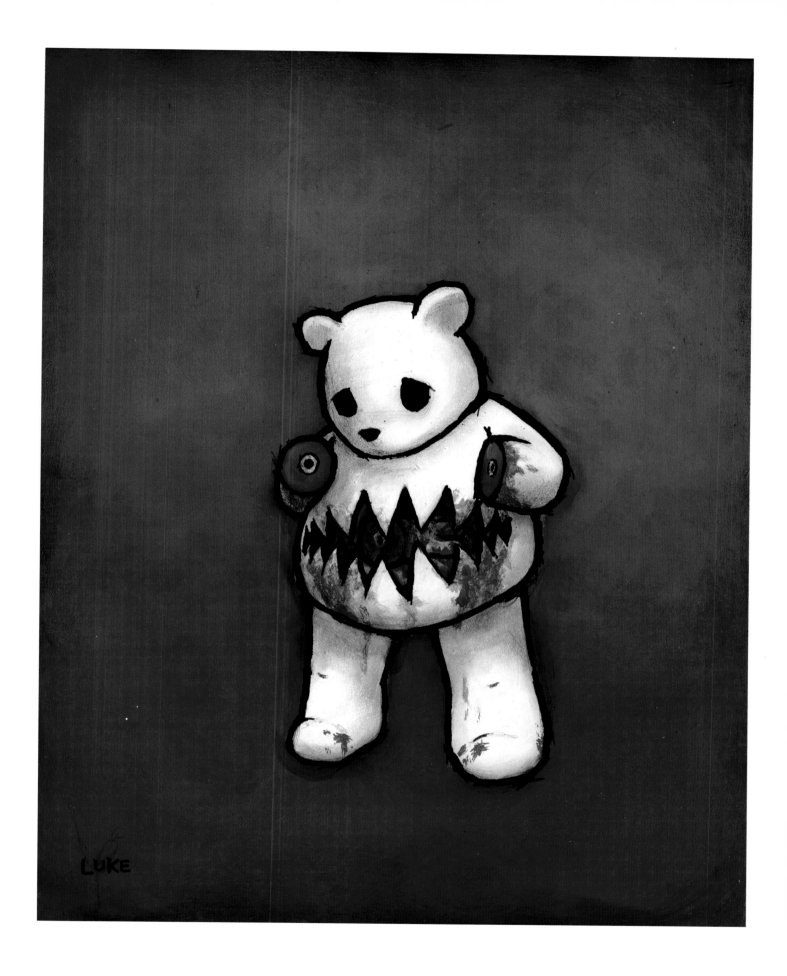

Appetite For Destruction
Acrylic and ink, 11 x 14 inches, 2006

Since I started a career as a full time artist, I became aware of several "schools" of painting technique. The one that I found most interesting is the way some realist painters work. From what I gathered, these artists would gather photographic references and use these to accurately capture shape and shadow. For my solo show "Facing the Façade", I wanted the centerpiece to feature a realistic bear in contrast to my anthropomorphized bear. So, I hit google images, scouring the web for bear images. Ironically, the image I chose to use was actually a wood sculpture of a bear (the kind you'd find in any art gallery in a National Park). The end product was a painting I'm still proud of. It forced me to work outside of my comfort zone, and since then, I've looked for inspiration and ideas that might push me in directions my audience wouldn't expect.

Luke Chueh

Bear In MInd
Acrylic and ink, 24 x 36 inches, 2006

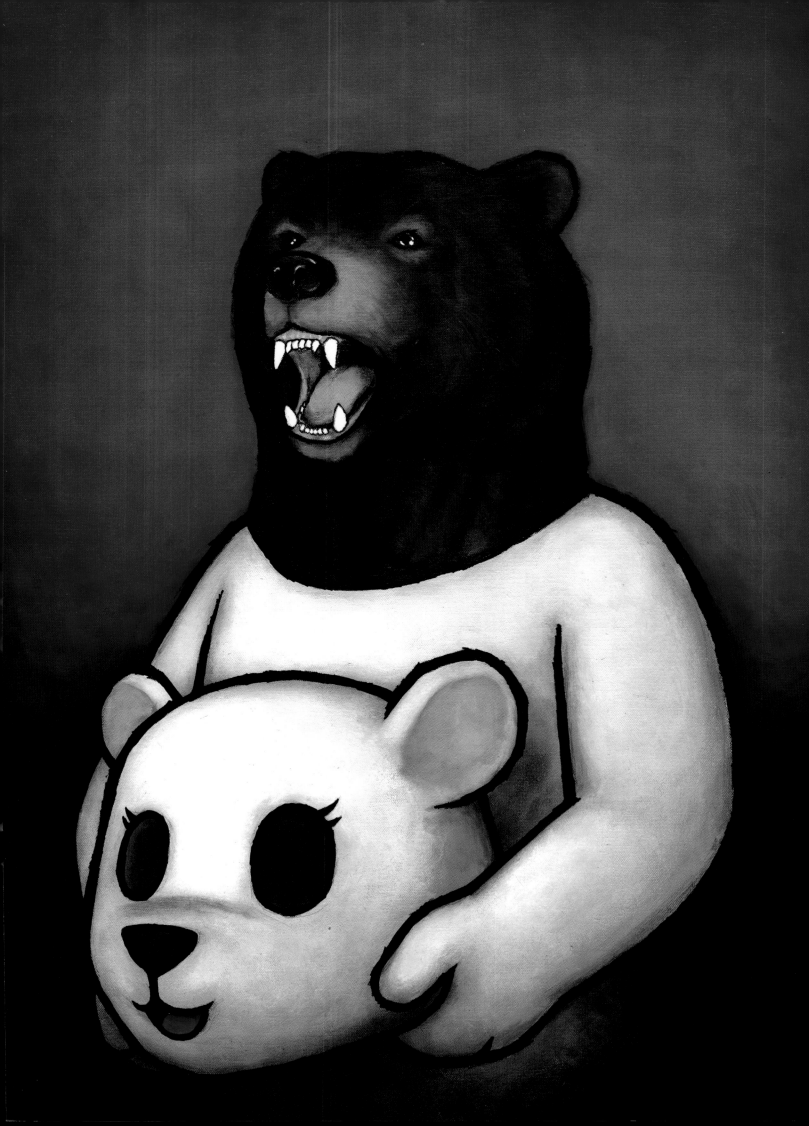

Bubble Trouble (Hoist By My Own Petard)
Acrylic (triptych), 16 x 20 inches, 2006

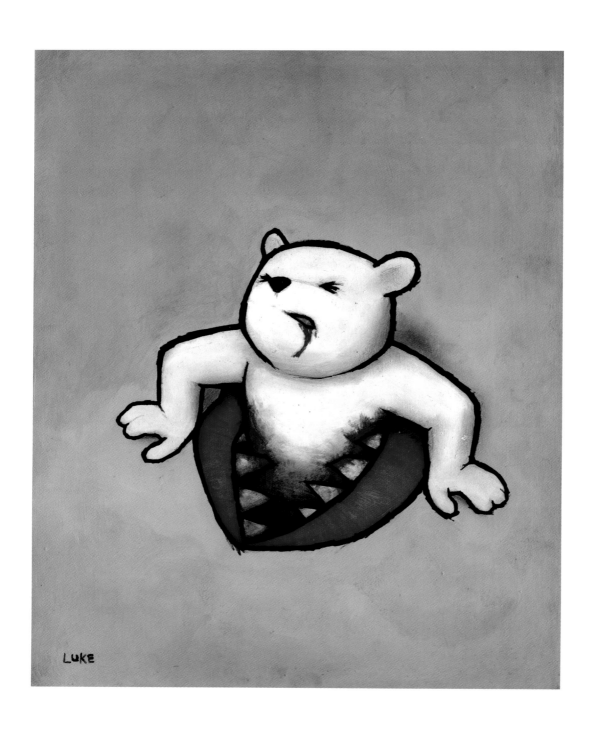

Trapped
Acrylic and ink, 11 x 14 inches, 2006

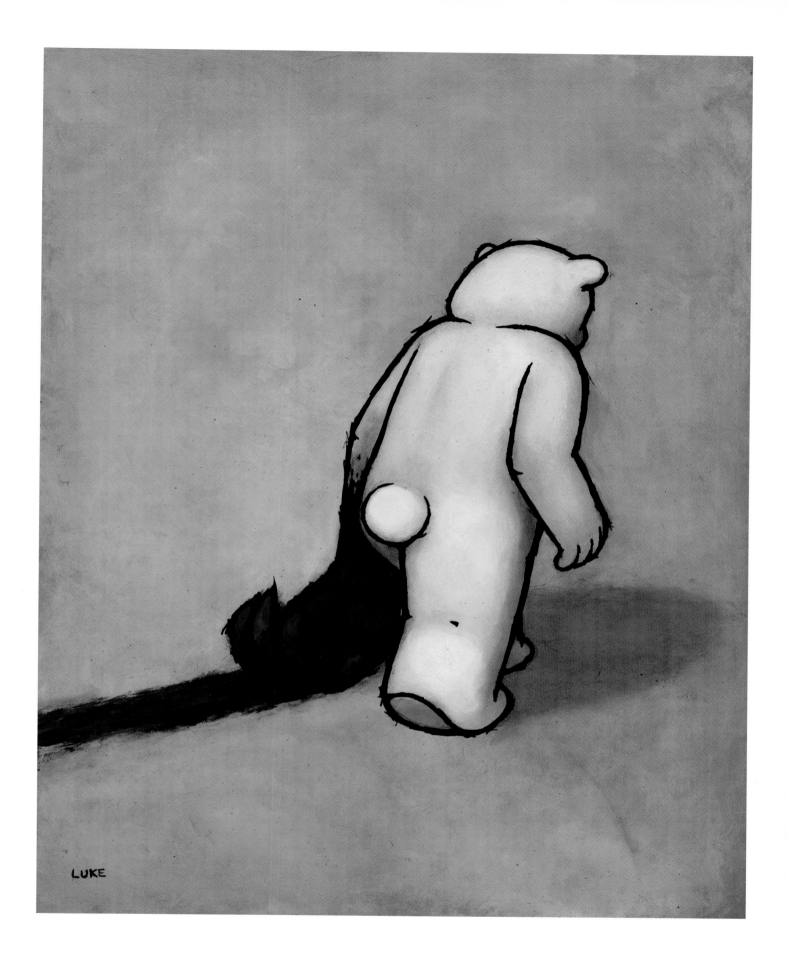

Southpaw (2006)
Acrylic and ink, 16 x 20 inches, 2006

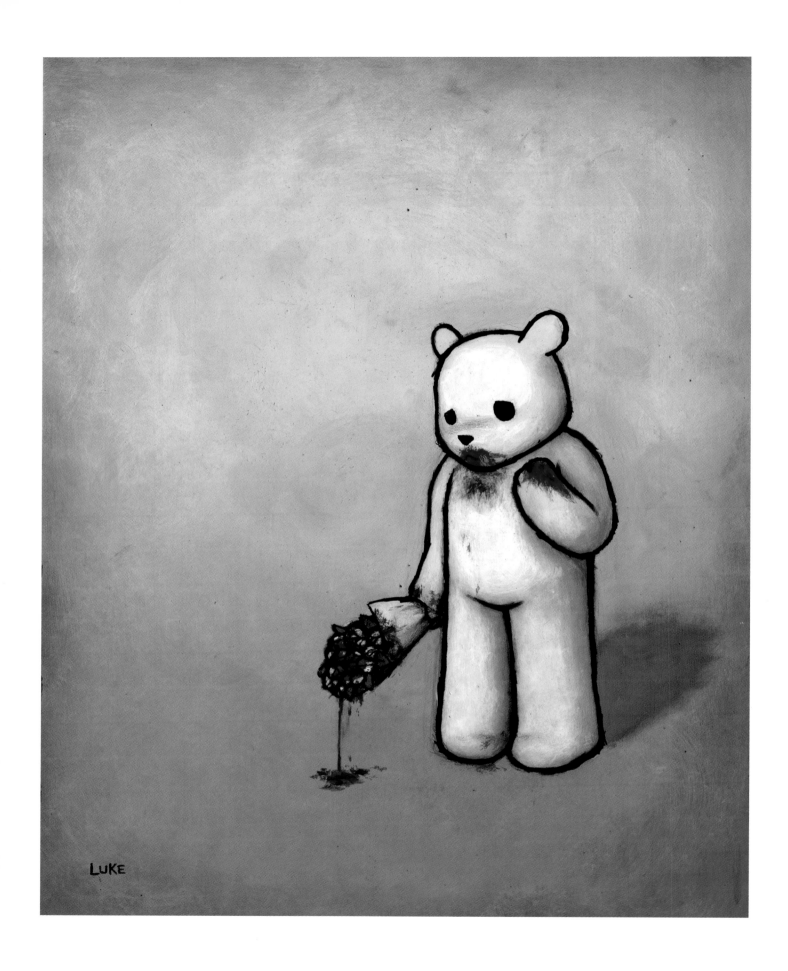

Roses Are Bled
Acrylic and ink, 11 x 14 inches, 2006

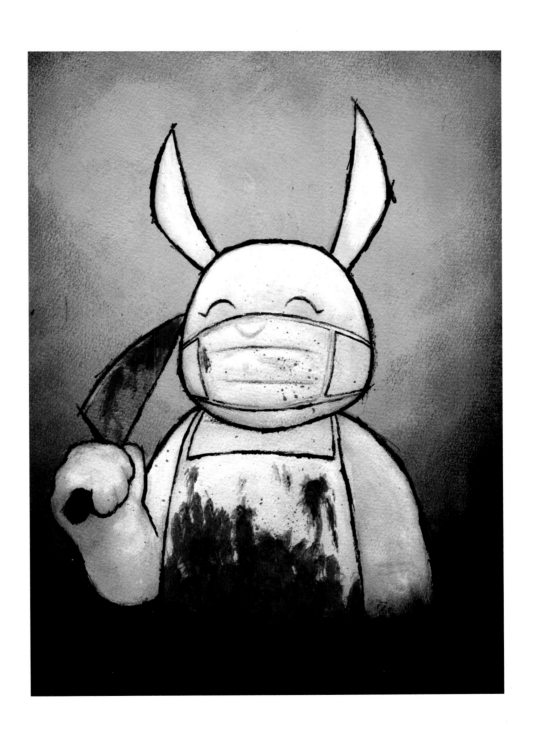

The Surgeon
Acrylic and ink, 11 x 14 inches, 2006

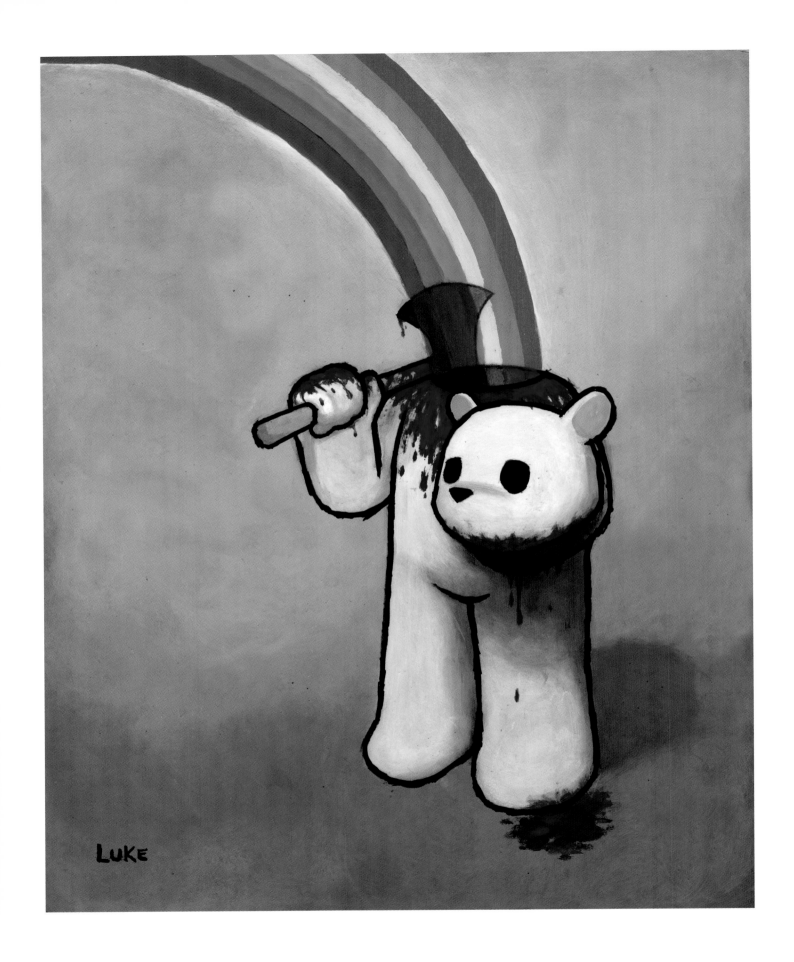

Rainbow Series 1
Acrylic and ink, 16 x 20 inches, 2006

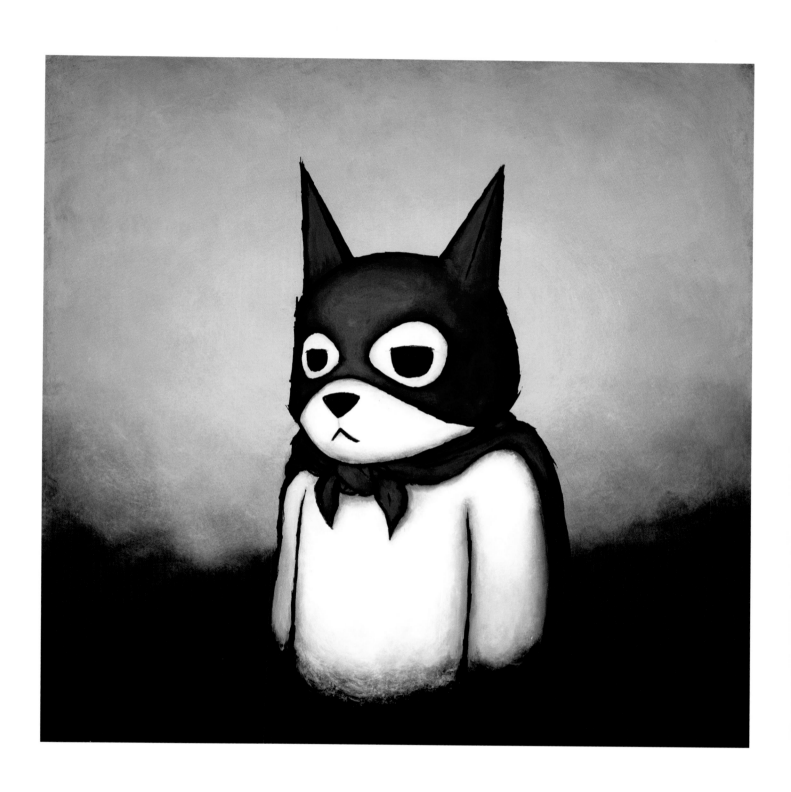

Gero-Hero/Bat-Bear
Acrylic and ink, 24 x 24 inches, 2006

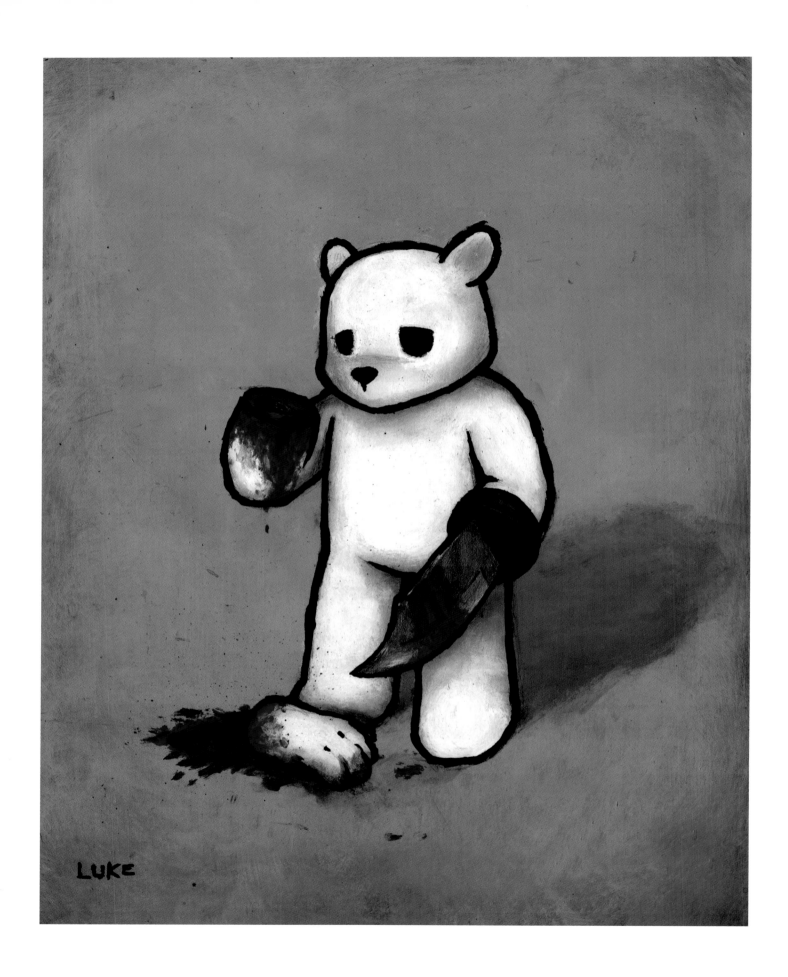

Bear With Knife Hand... Bad Idea
Acrylic and ink, 11 x 14 inches, 2006

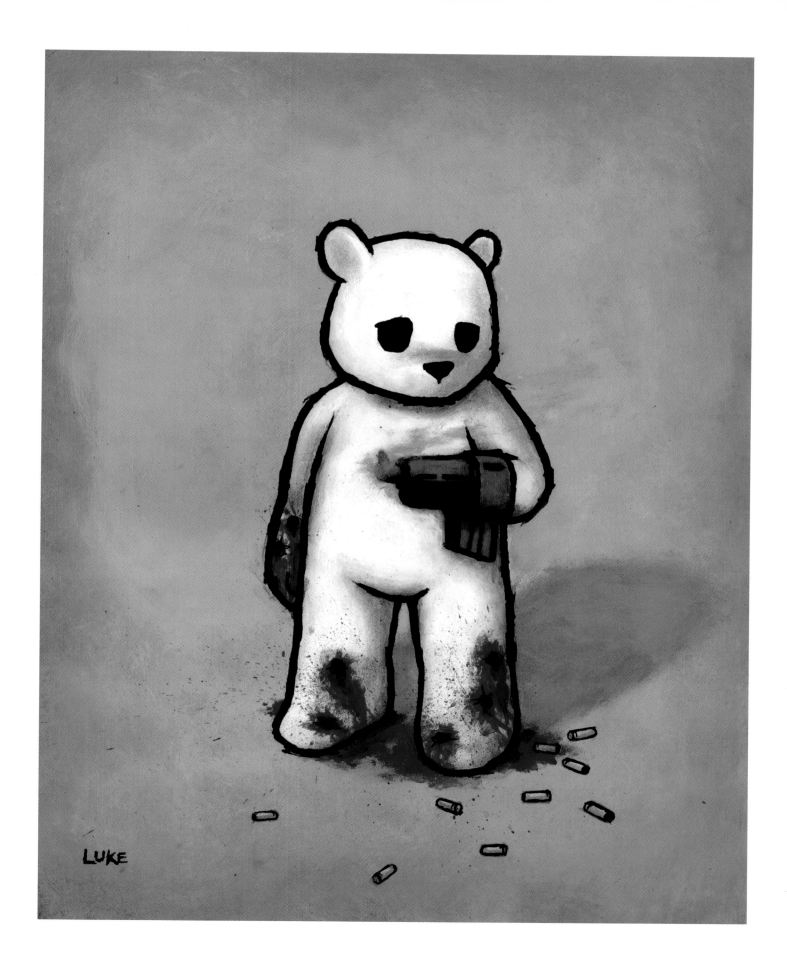

Bear With Gun Hand... Bad Idea
Acrylic and ink, 11 x 14 inches, 2006

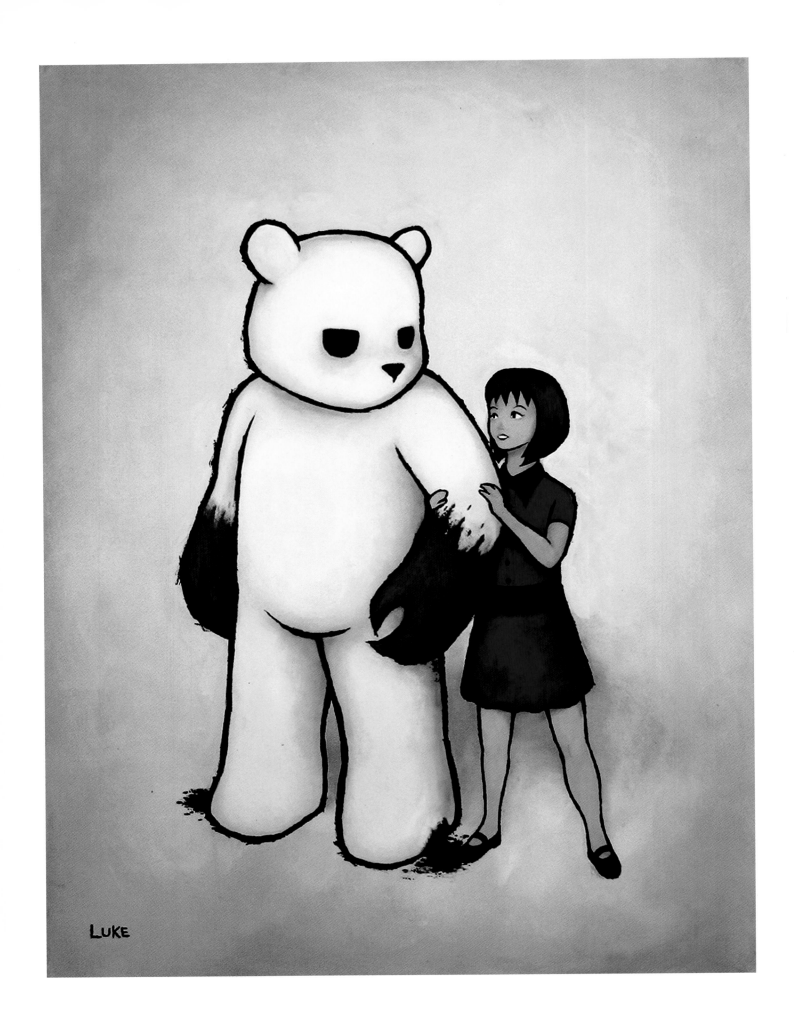

The Crush
Acrylic and ink, 30 x 40 inches, 2006

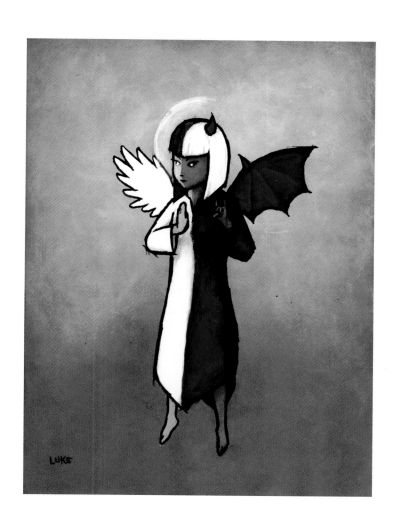

Angels & Devils – One In The Same
Acrylic and ink, 8 x 10 inches, 2006

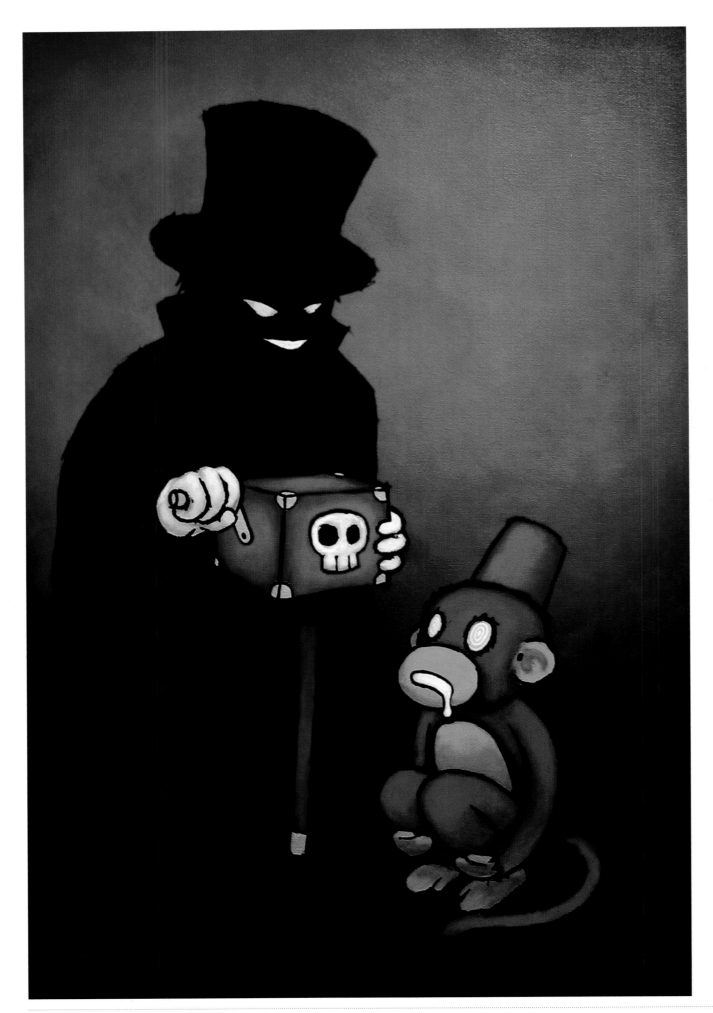

Monkey Grinder
Acrylic and ink, 24 x 36 inches, 2006

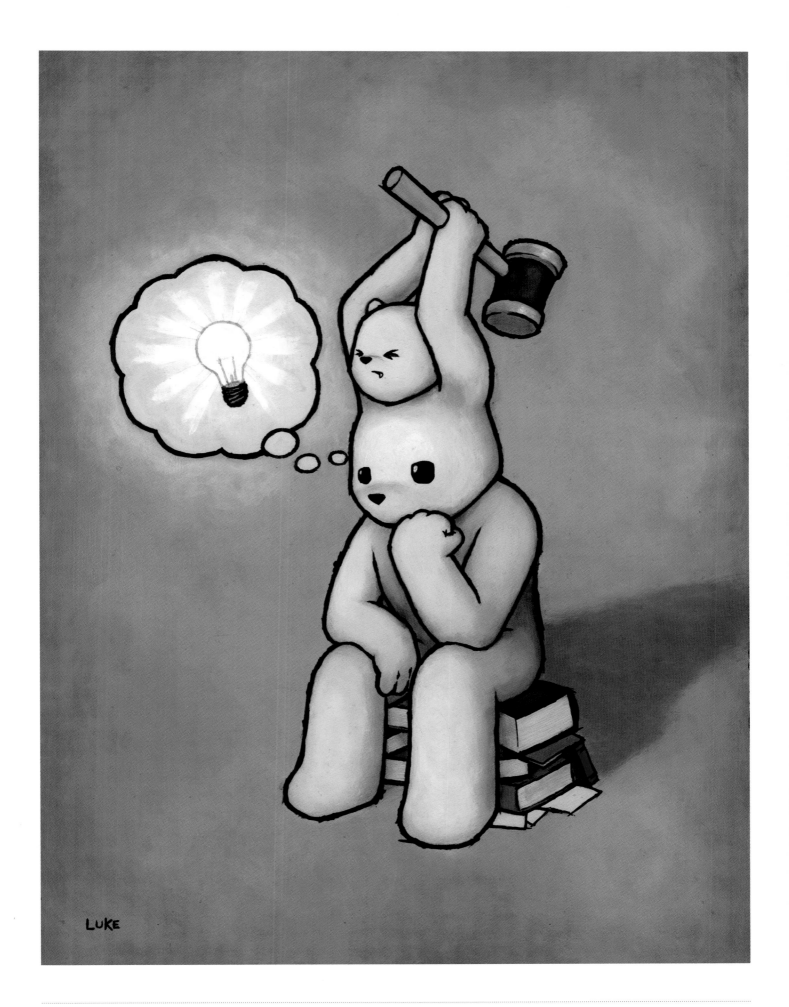

Inhibition
Acrylic and ink, 18 x 24 inches, 2006

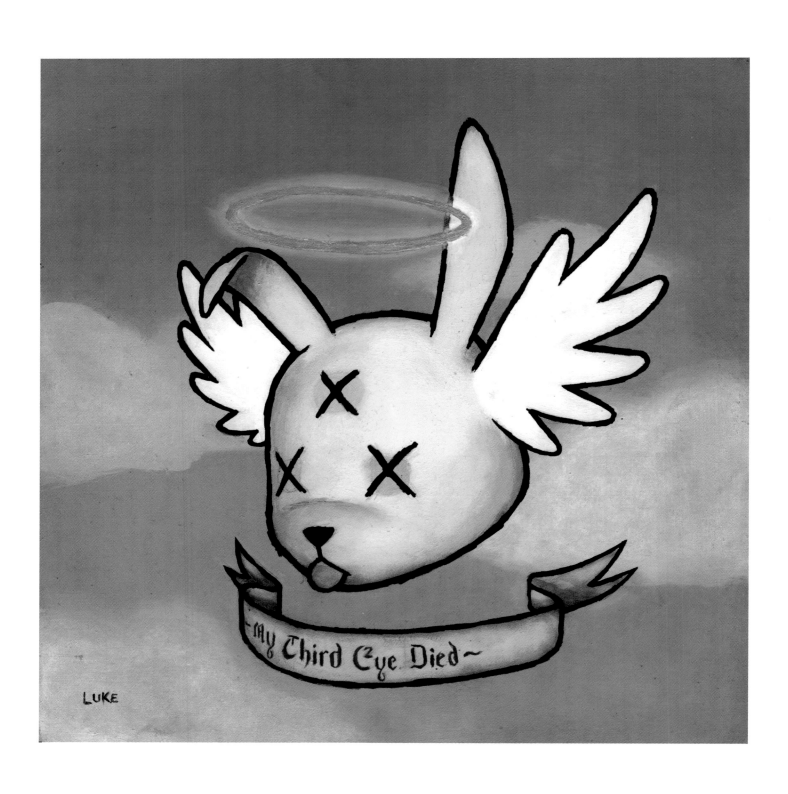

My Third Eye Died
Acrylic and ink, 12 x 12 inches, 2006

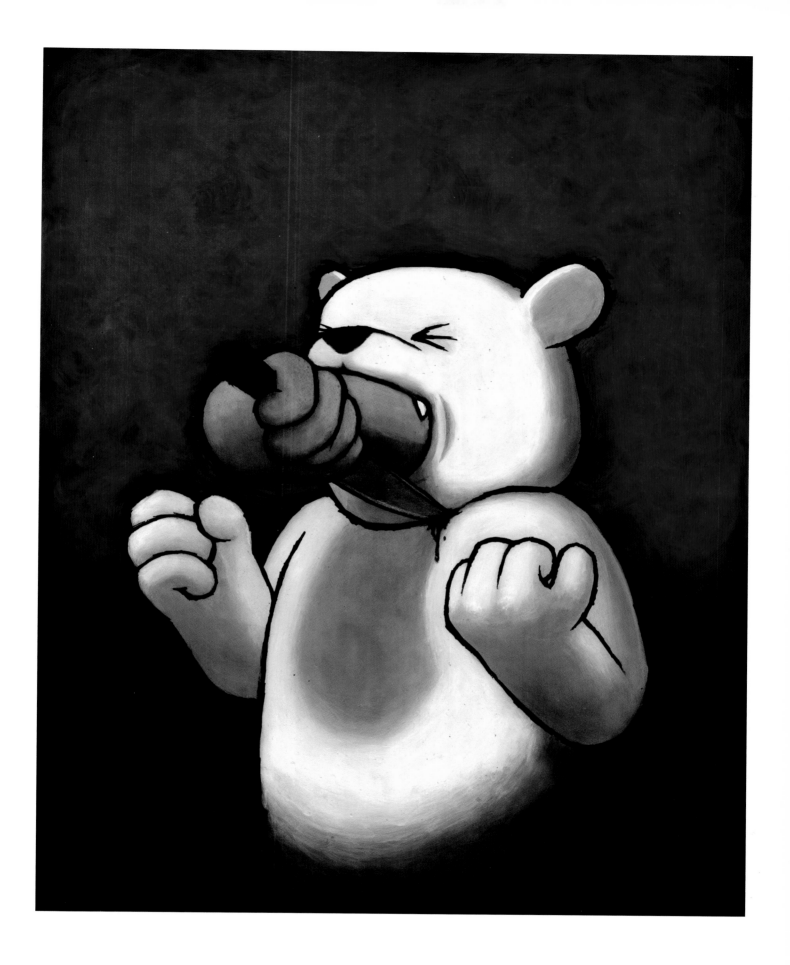

Sharp Tongue
Acrylic and ink, 16 x 20 inches, 2006

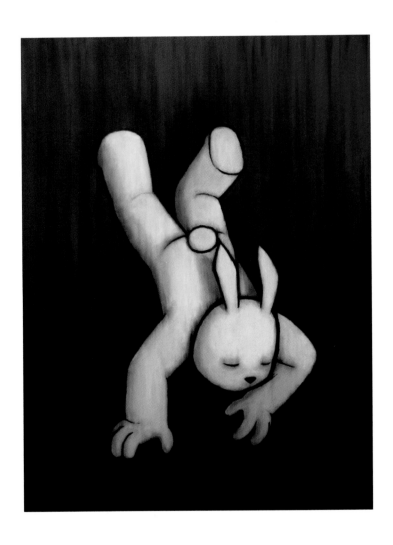

The Fall/Coming To Terms With My Lot In Life
Acrylic and ink, 24 x 36 inches, 2006

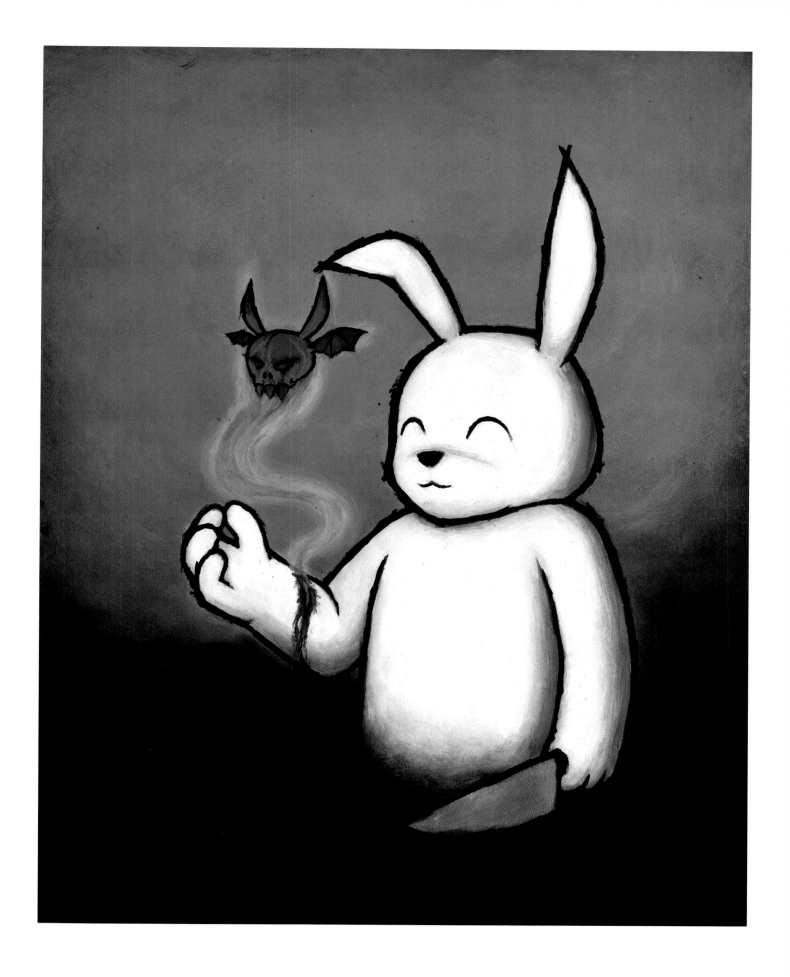

The Cut
Acrylic and ink, 11 x 14 inches, 2006

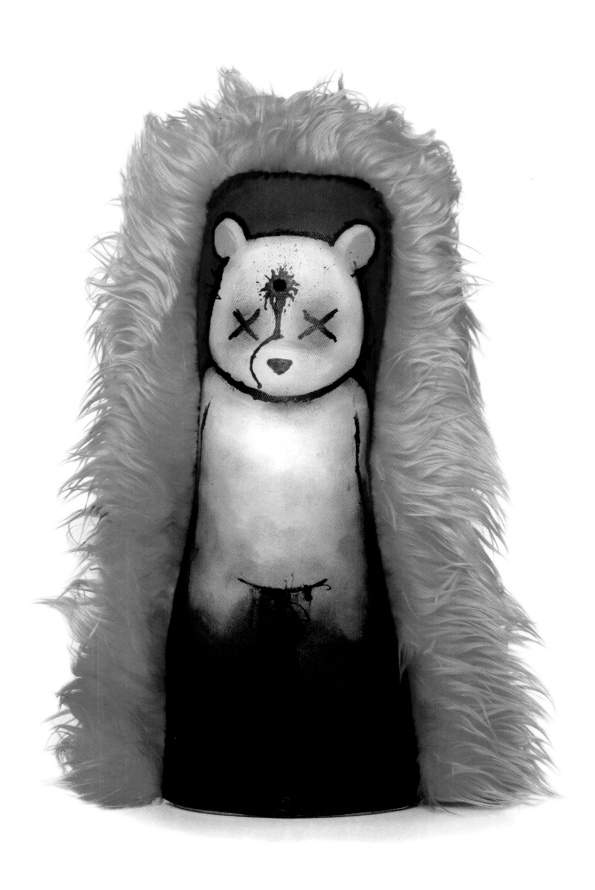

Circus Punk Custom: Shot In The Head
Acrylic and ink on Circus Punk, approx 12 inches, 2006

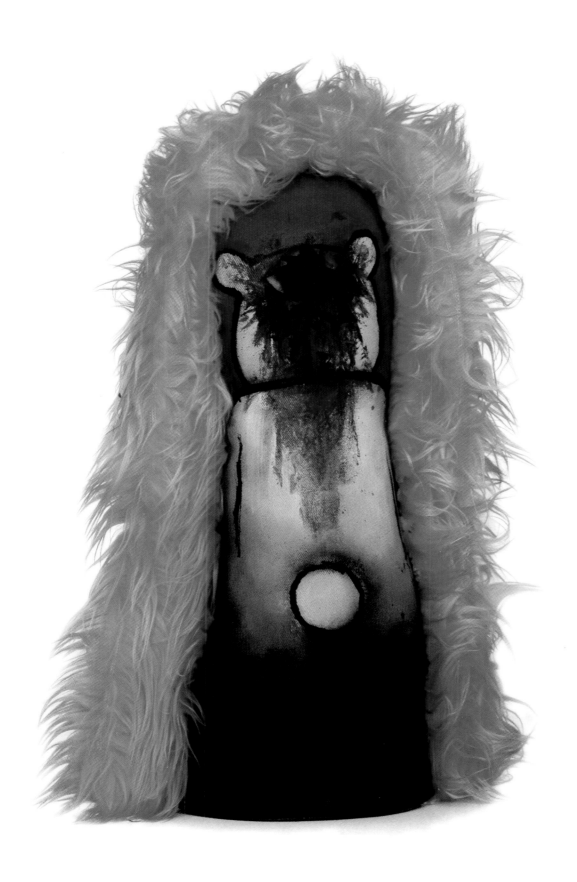

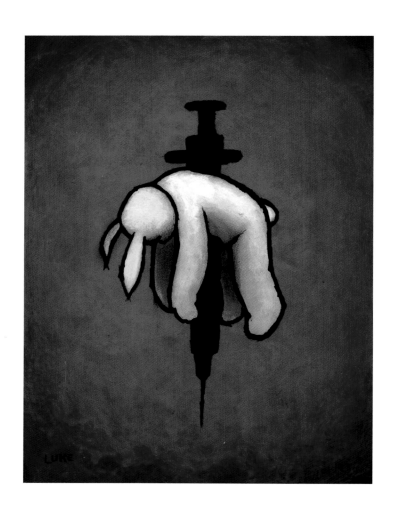

Impaled
Acrylic and ink, 6 x 8 inches, 2006

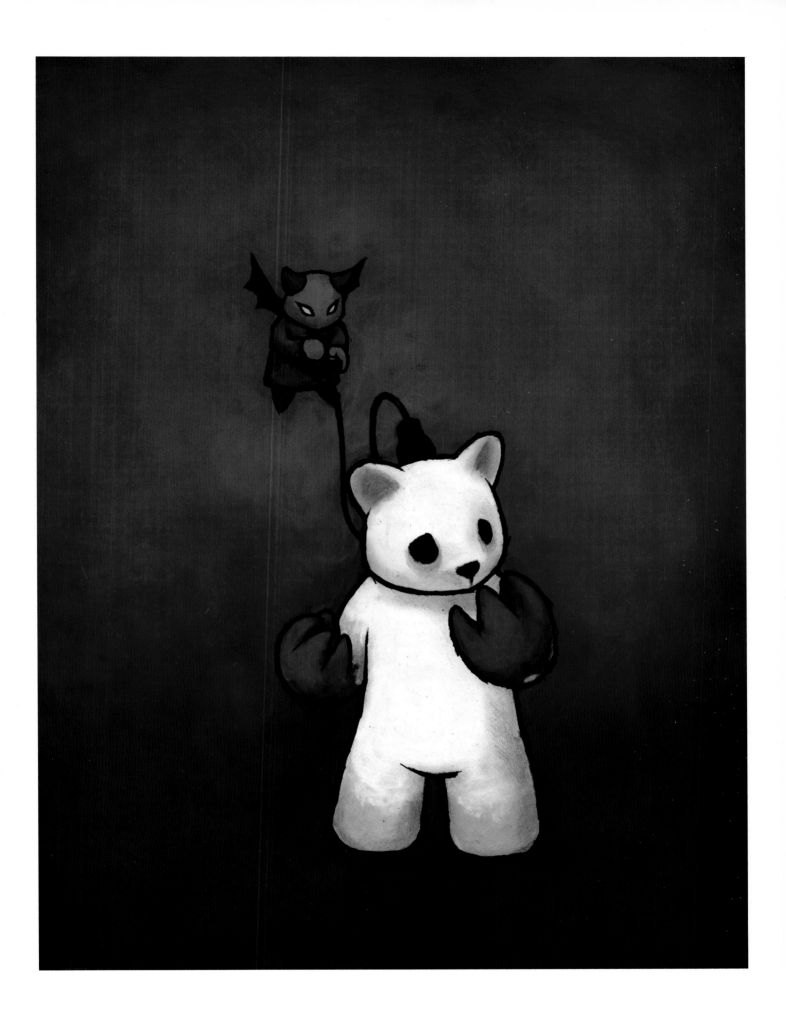

Possessed (Box Painting)
Acrylic and ink, 18 x 24 inches, 2006

Signing Disintegration canvas giclée prints at Gallery 1988
Photo by Jensen Karp

2007

I first saw Luke's art at the Cannibal Flower show in 2002 and loved the message in his work, but thought it was very raw. There were a lot of up-and-coming artists showing there at the time and many showed potential, but I wasn't sure where everyone was headed. I was a little skeptical, but kept an open mind. I met Luke around 2003 and thought he was a really sincere person and funny as hell, so we immediately hit it off and I wanted him to show at Copro. It took a while, but we finally worked it out and set up a small show in 2005 called "Life By the Knife". Luke showed up at the last minute with a handful of cool little paintings, all raw and rough around the edges. "Black In White And Red All Over" was one of the pieces and it looked good to me, but Luke wanted to touch up the blood on it. It had already sold, but he took it outside anyway and did his thing! Around the first week, after the opening, he stopped by the gallery and painted even more blood and touched it up further.

At the end of "Life By the Knife", before the collector picked up his piece, Luke insisted on taking the painting home ONE MORE TIME for a final going over. I think this really shows Luke's dedication and the care he has for his work and collectors. I was very impressed with that and it led to me and Luke becoming good friends. We found out we had similar viewpoints on art, as well as many other things. The moral of this story is, "If you buy a painting from Luke Chueh, you can rest assured whether it's blood, shit or puke, it will be painted until it's perfect, and you'll end up with a polished piece for your collection!"

Gary Pressman, Copro Gallery

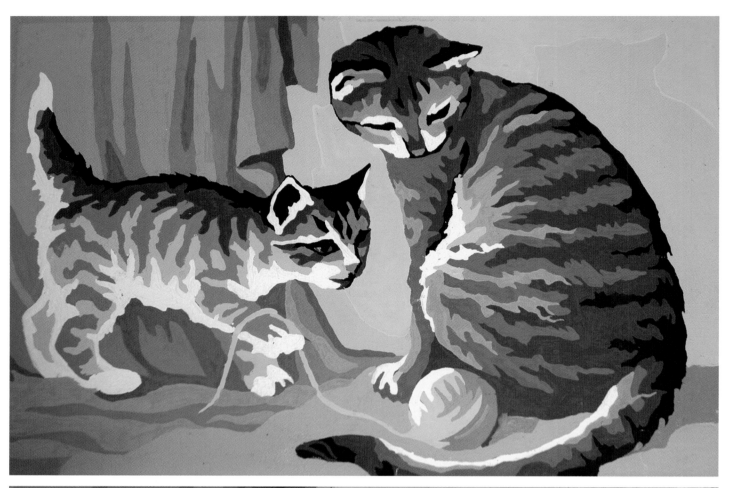

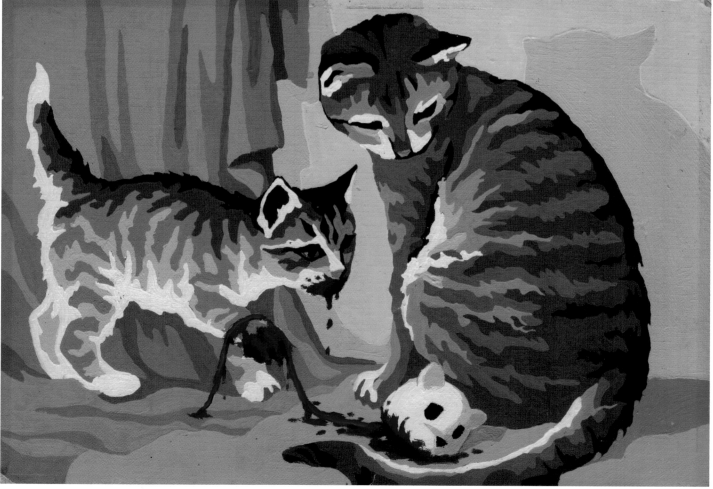

Cats (Before And After)
Acrylic on found painting, 14 x 10 inches, 2007

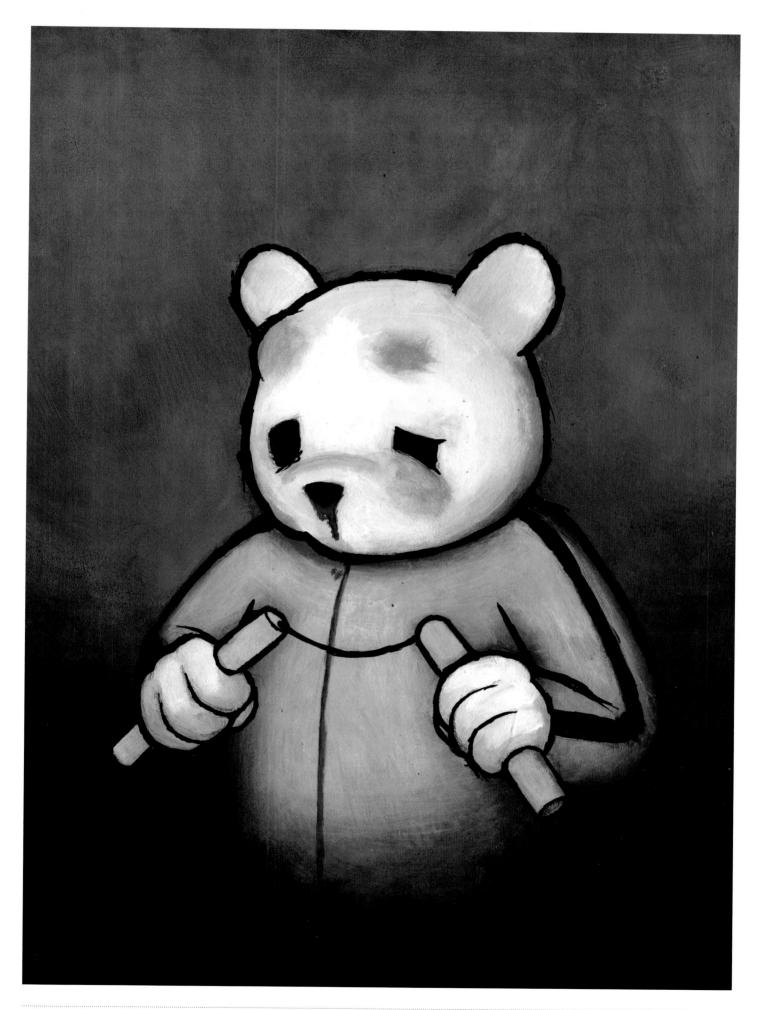

It Takes More Than A Jumpsuit (And Nunchakus)
Acrylic and ink, 11 x 14 inches, 2007

Axes & Rainbows
Acrylic and ink, 8 x 8 inches, 2007

Skeleton Study (Blue)
Acrylic and ink, 8 x 8 inches, 2007

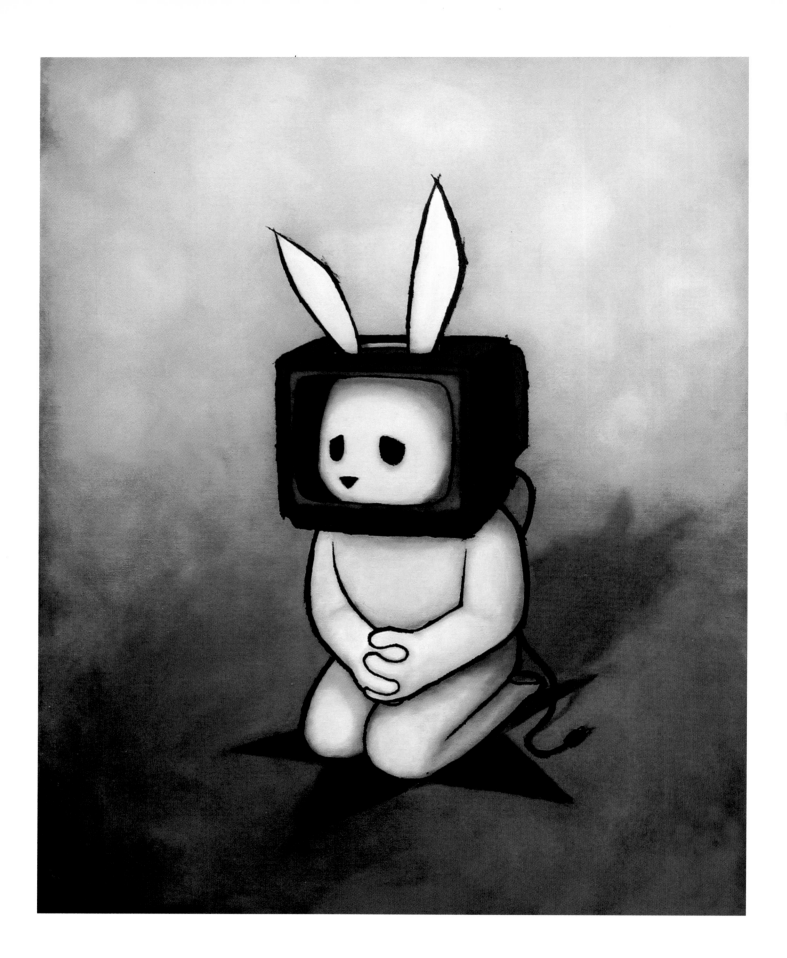

15 Minutes Of Shame
Acrylic and ink, 24 x 30 inches, 2007

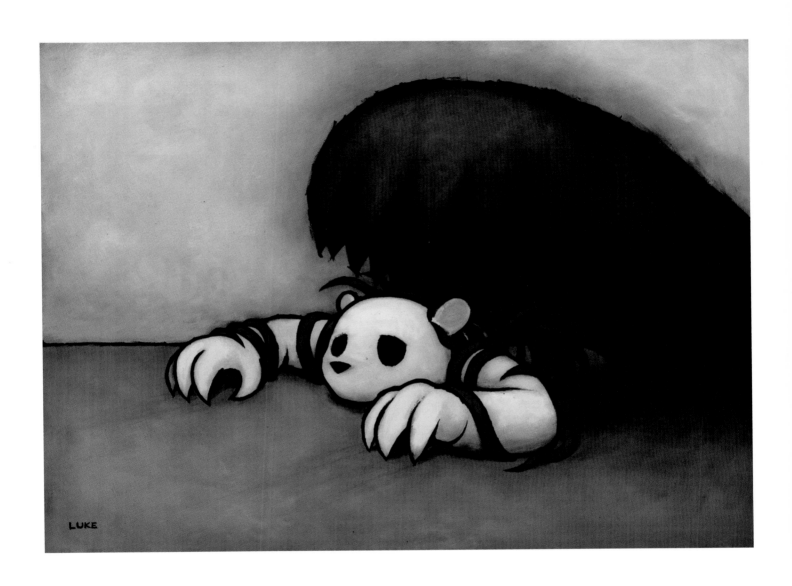

The Darkness
Acrylic and ink, 24 x 18 inches, 2007

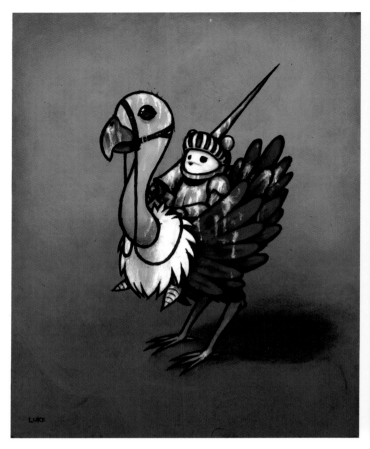

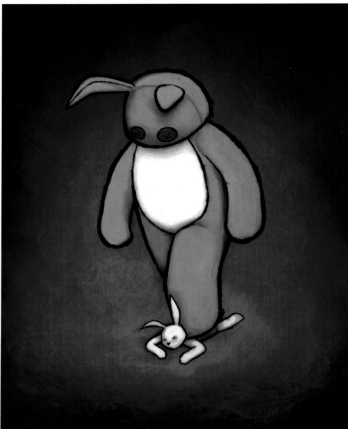

Joust (Bird-Shit)
Acrylic and ink, 11 x 14 inches, 2007

The Things You Love Will Destroy You (Revisited)
Acrylic and ink, 11 x 14 inches, 2007

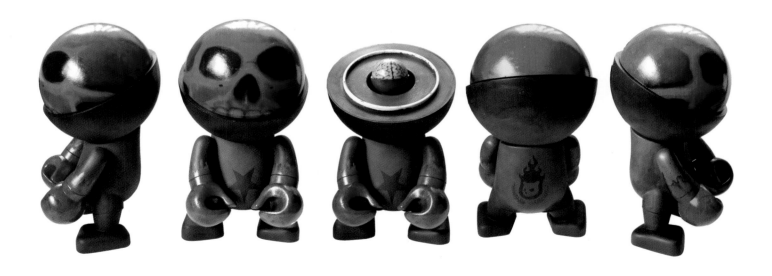

Luke Chueh vs Trexi
Acrylic, ink and Trexy, approximately 10 inches, 2007

Frank (Luke Chueh vs Donnie Darko)
Acrylic and ink, 11 x 14 inches, 2007

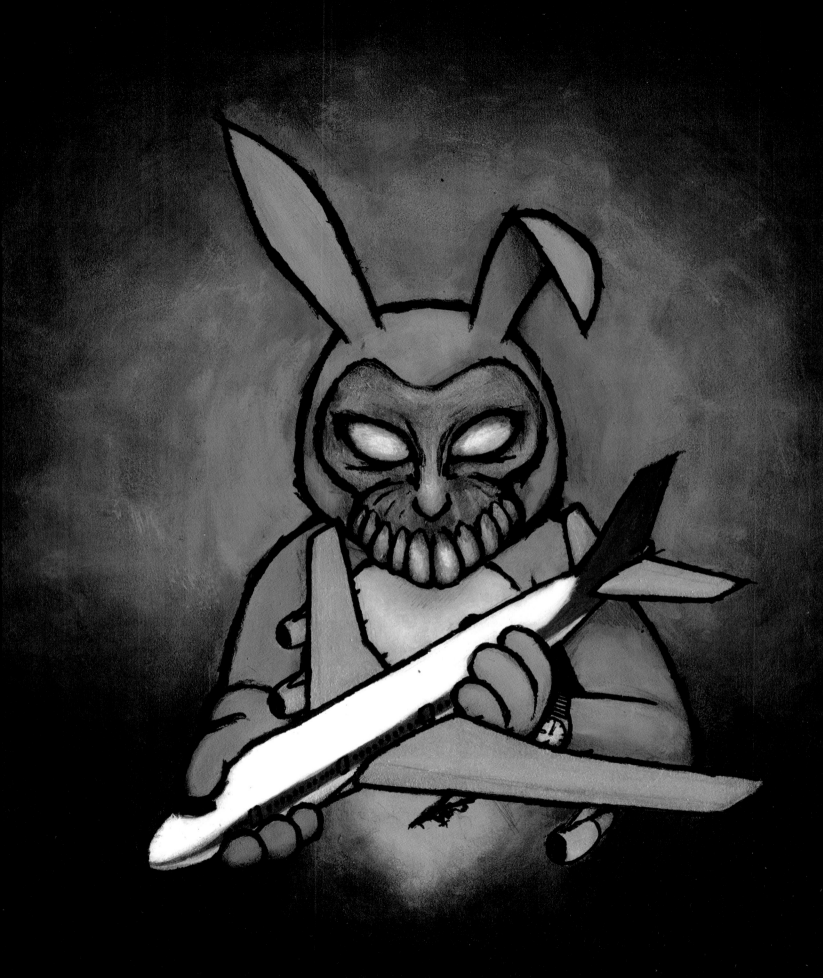

Chuehing Over Kozik
Acrylic and ink, 11 x 14 inches, 2007

Swarm
Acrylic and ink, 36 x 48 inches, 2007

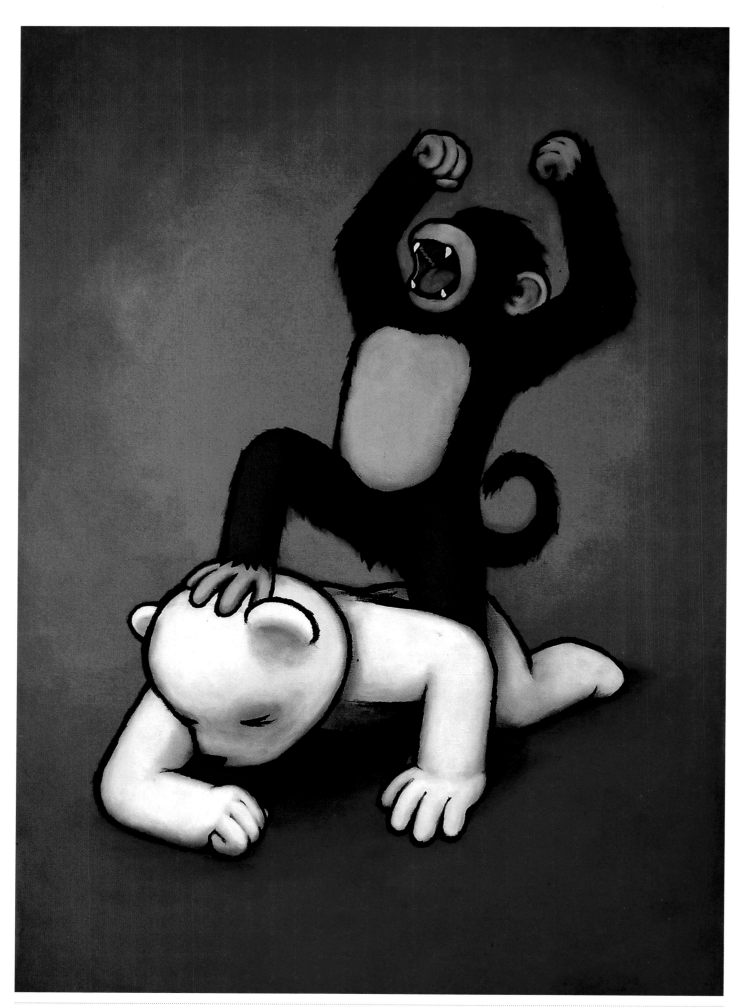

My Monkey
Acrylic and ink, 24 x 36 inches, 2007

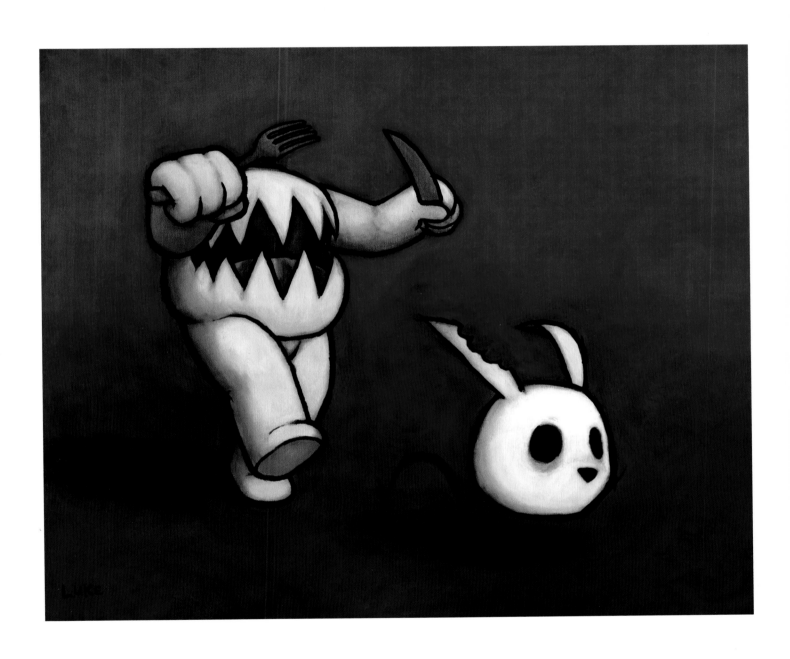

When The Body Hungers, The Mind Suffers
Acrylic and ink, 24 x 20 inches, 2007

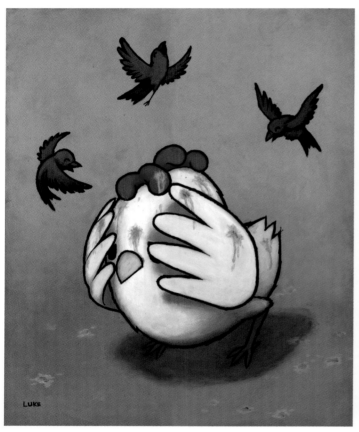

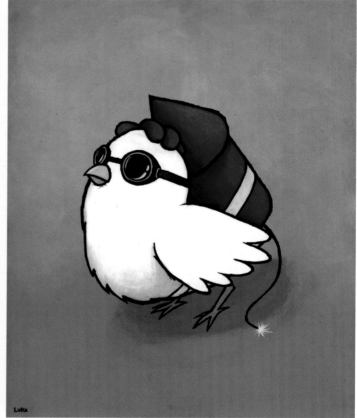

Foul Play/Fowl Play
Acrylic and ink, 16 x 20 inches, 2007

Rocket
Acrylic and ink, 16 x 20 inches, 2007

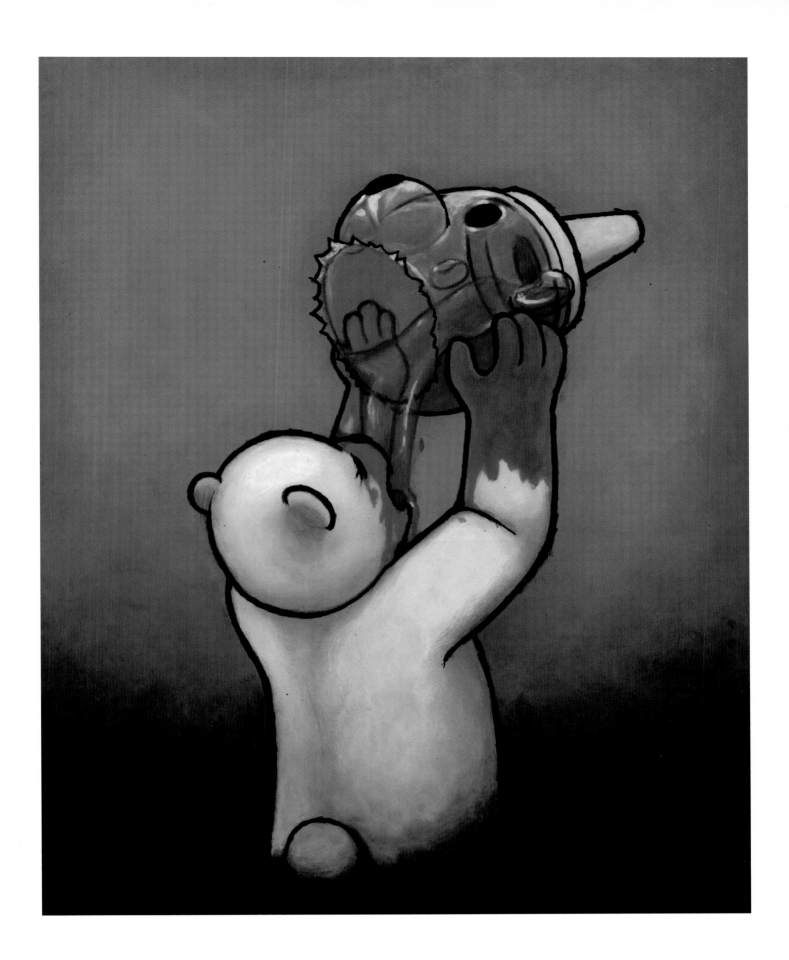

Honey Bear
Acrylic and ink, 16 x 20 inches, 2007

For years now, a theme I've regularly dealt with in my work is façades. Finding ways to illustrate how we are perceived, while really existing as another. Examples of this include "Black In White", "Bear In Mind", and my several self portraits.

One afternoon, it dawned on me: What about those who are stuck with themselves, and, despite their efforts, are unable to be anything but that thing they are? That's how "Inside Out" came to life. Out of all my "façade" paintings, this is one of my favorites simply because I relate to it so much.
Luke Chueh

Inside Out
Acrylic and ink, 18 x 24 inches, 2007

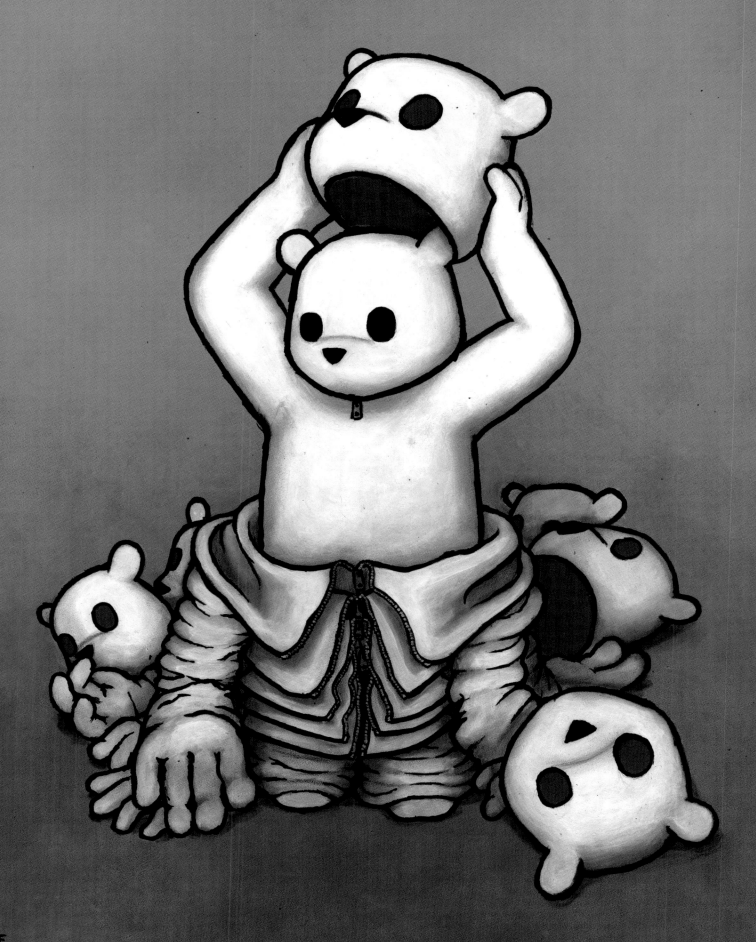

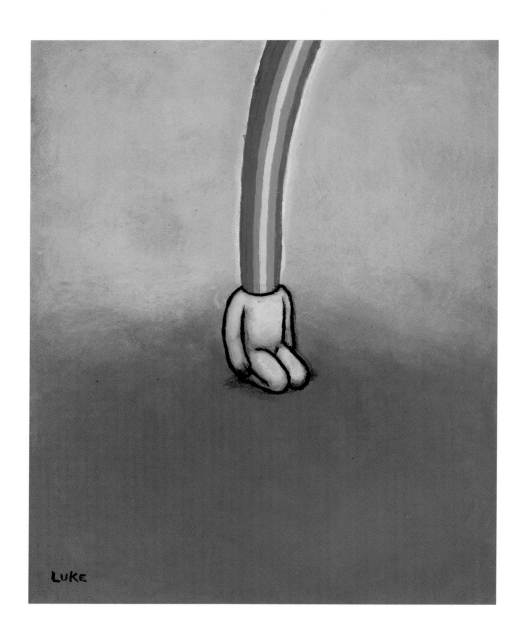

Rainbow Series 2
Acrylic and ink, diptych, 8 x 10 inches, 2007

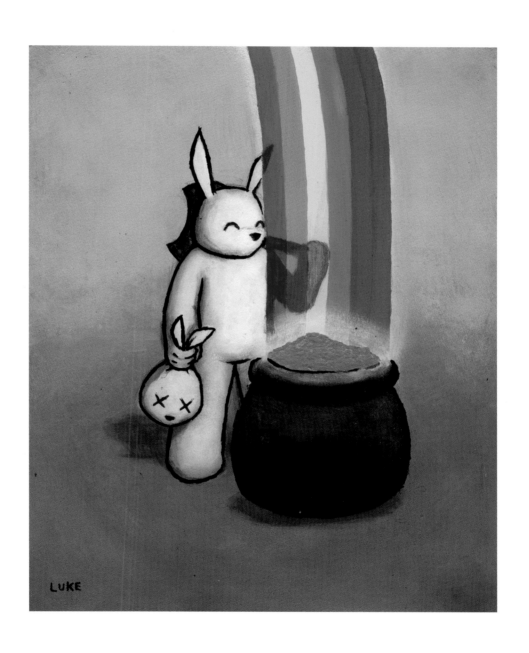

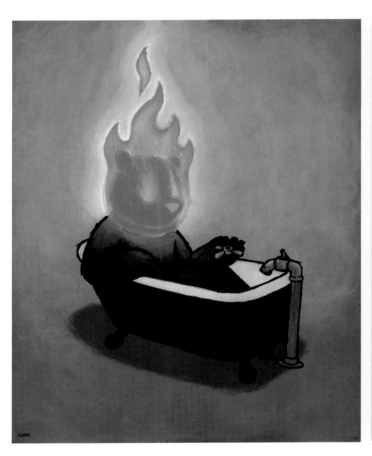

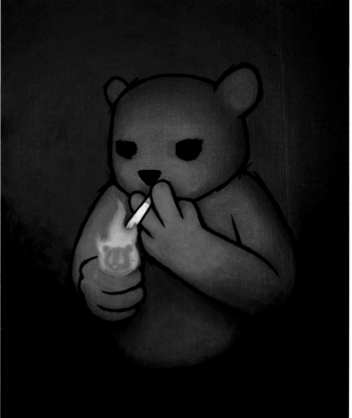

Hope Extinguished (Revisited)
Acrylic and ink, 24 x 30 inches, 2007

C'mon Baby Light My Fire
Acrylic and ink, 16 x 20 inches, 2007

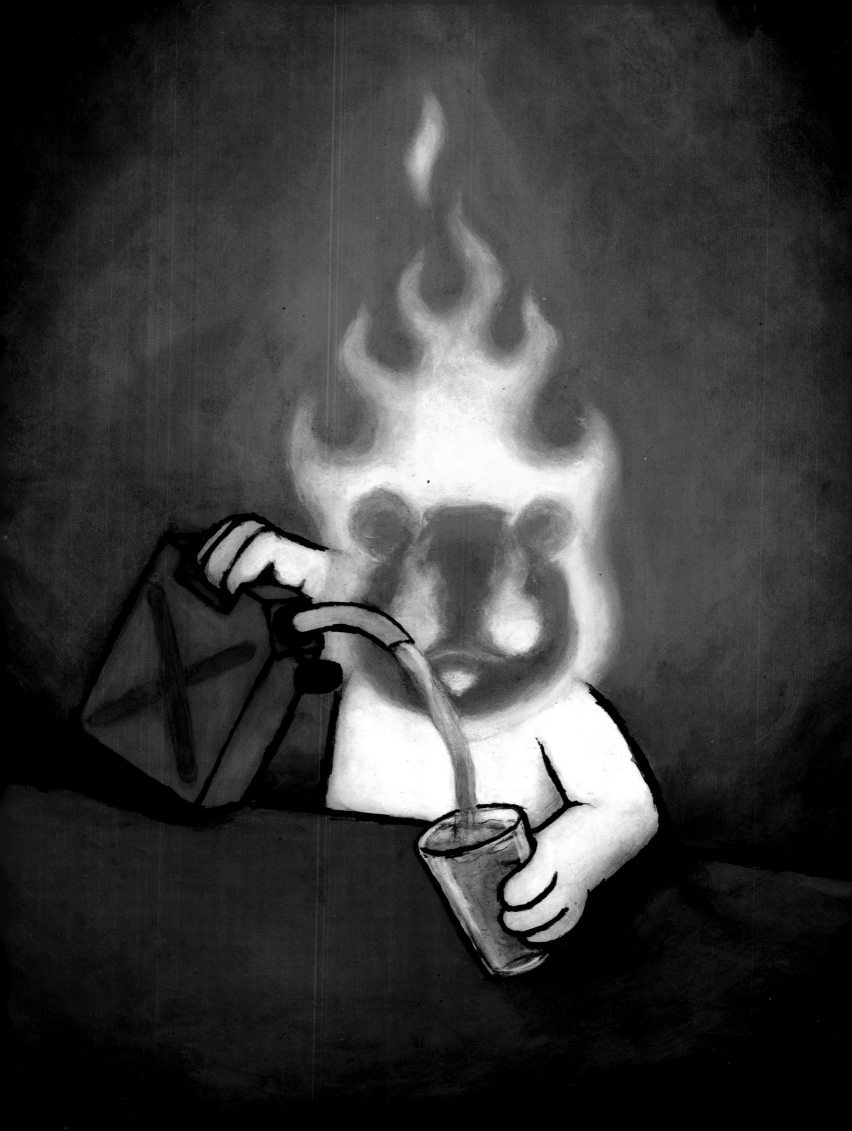

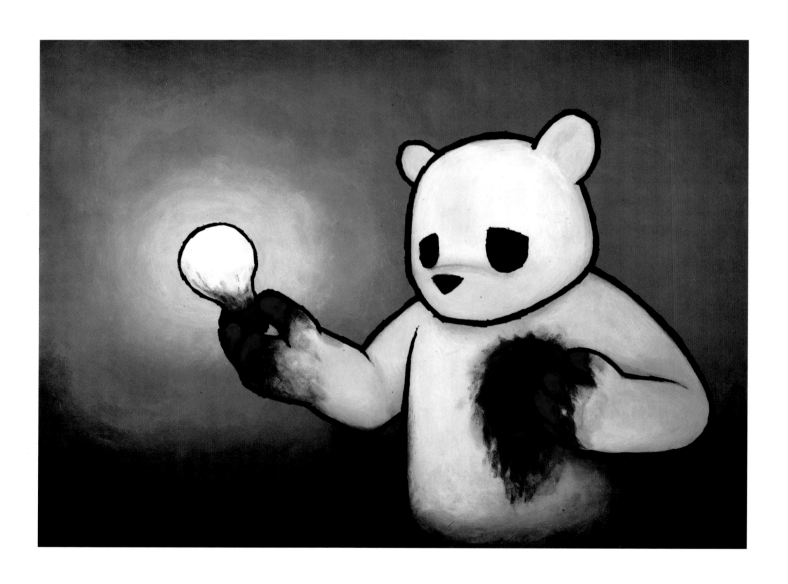

Adding Fuel To The Fire
Acrylic and ink, 16 x 20 inches, 2007

Inspiration (Bright Ideas From The Hole In My Soul) (Revisited)
Acrylic and ink, 24 x 18 inches , 2007

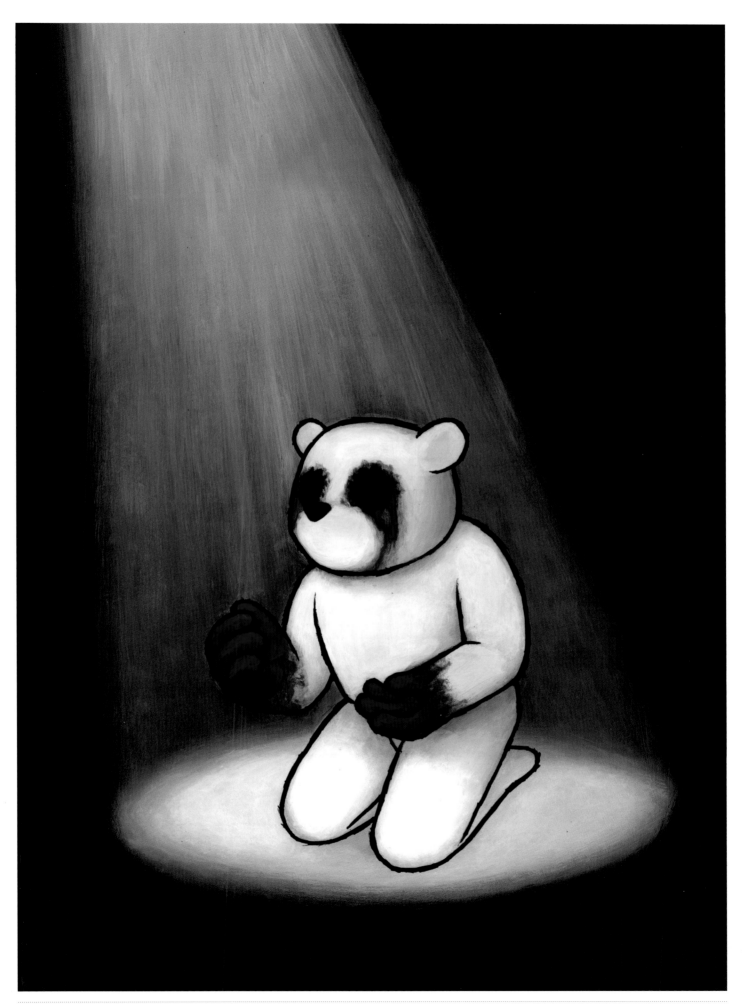

Shining Down On Me
Acrylic and ink, 24 x 36 inches, 2007

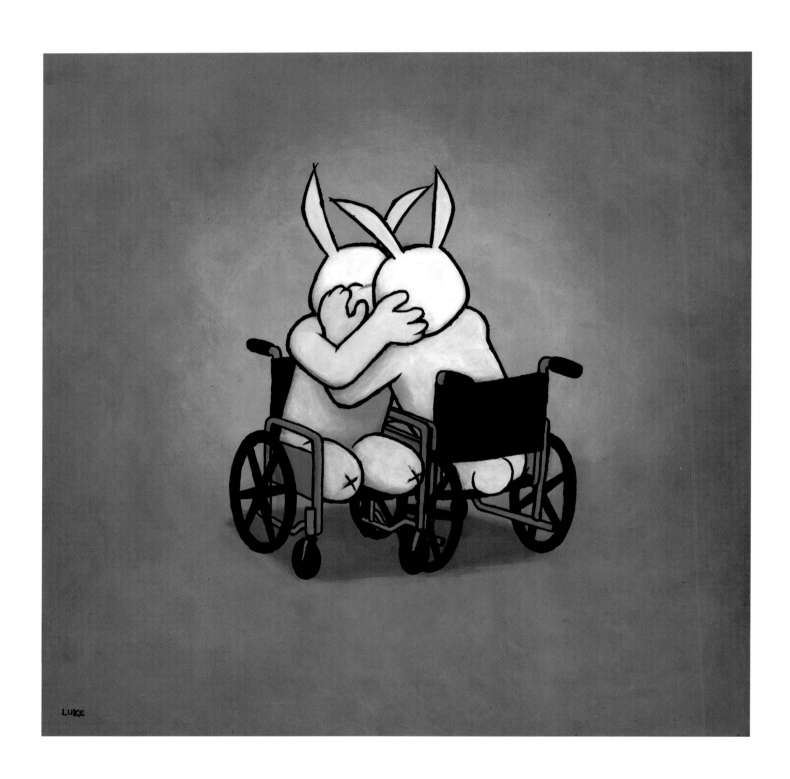

The Kiss
Acrylic and ink, 24 x 24 inches, 2007

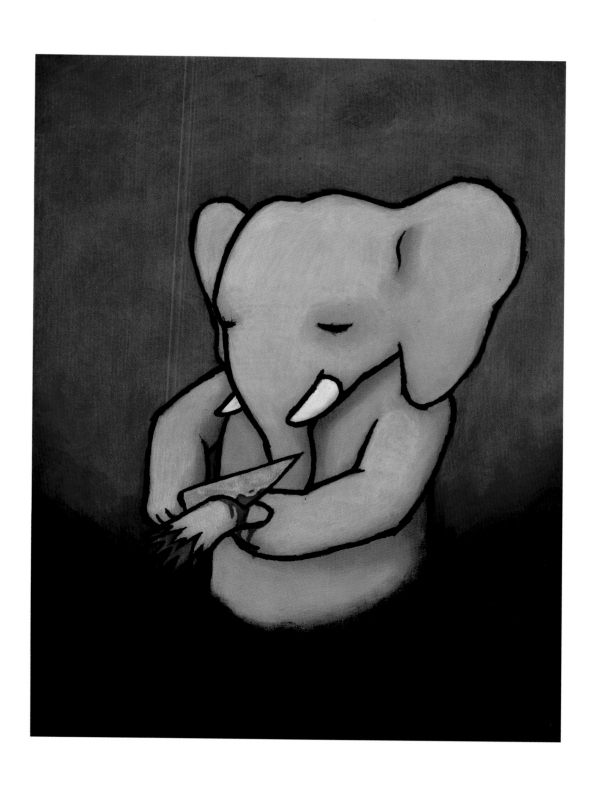

Trimming Off The Frayed Ends
Acrylic and ink, 12 x 16 inches, 2007

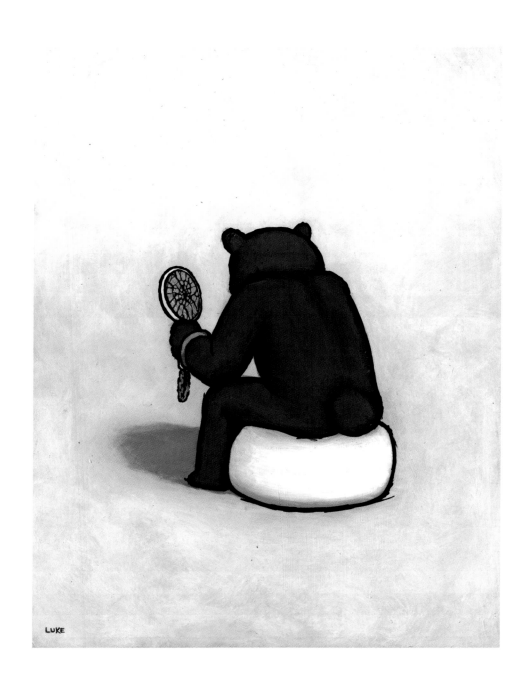

Stuck With Myself
Acrylic and ink, 11 x 14 inches, 2007

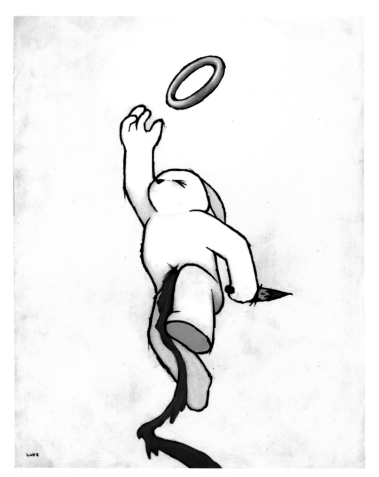

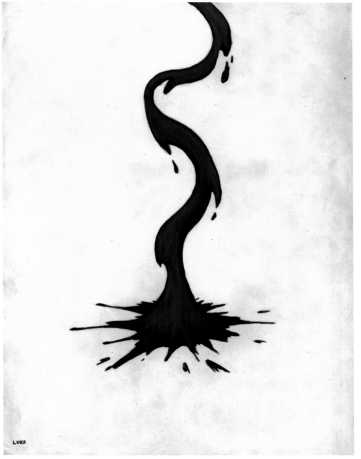

Guts For Glory (Reaching For The Brass Ring)
Acrylic and ink, diptych, 18 x 24 inches, 2007

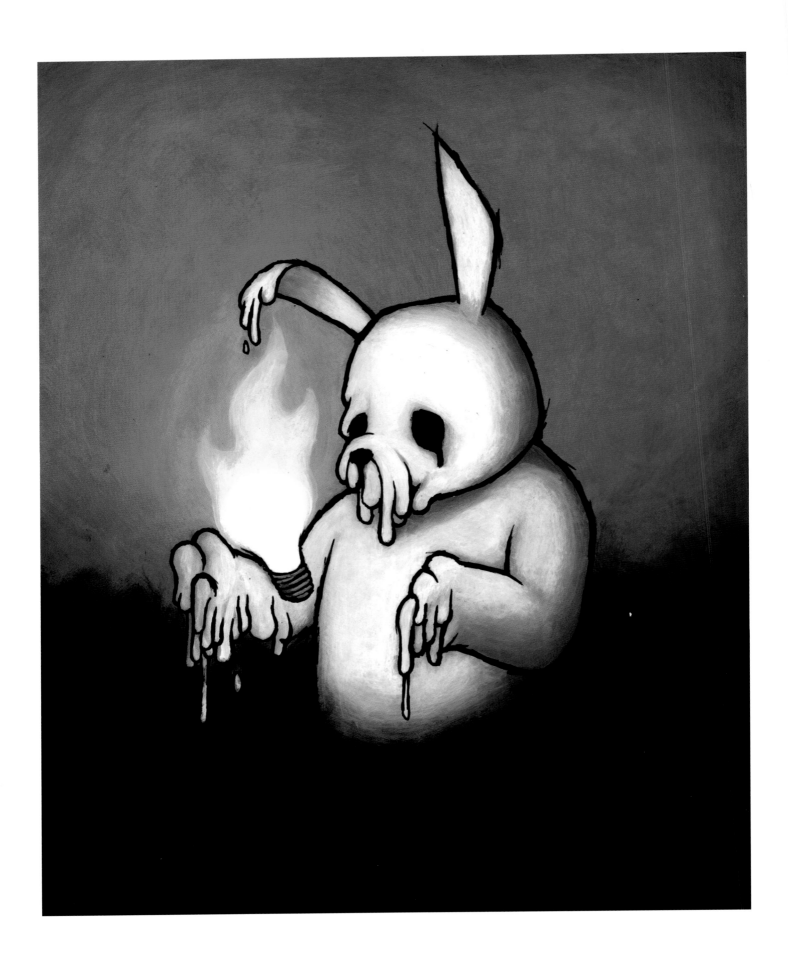

Too Hot To Handle
Acrylic and ink, 16 x 20 inches, 2007

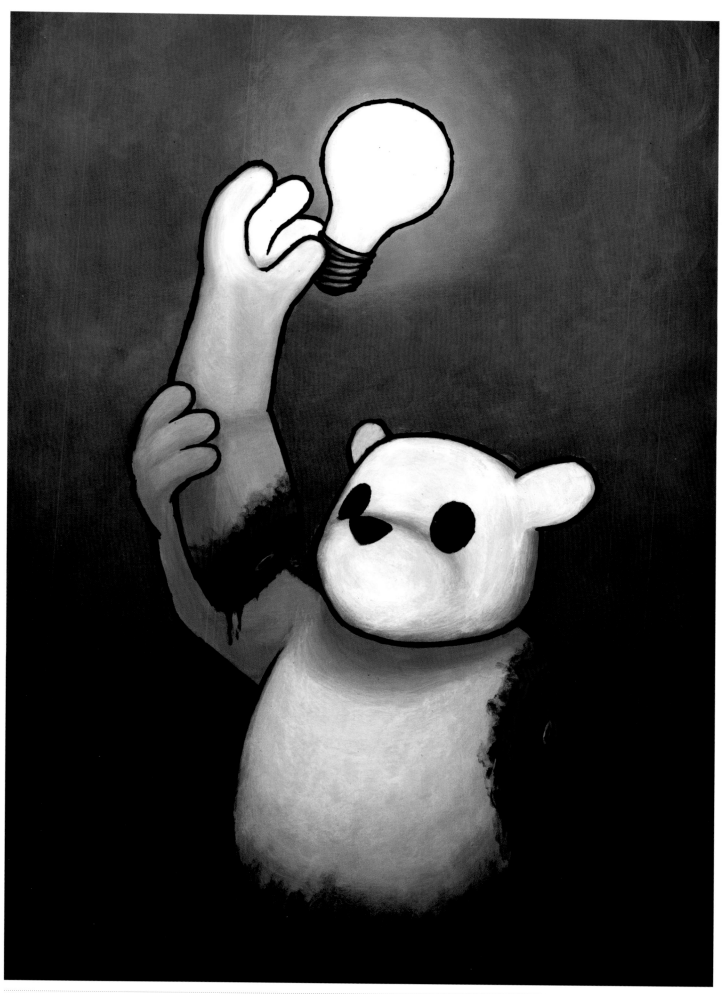

Extension
Acrylic and ink, 24 x 36 inches, 2007

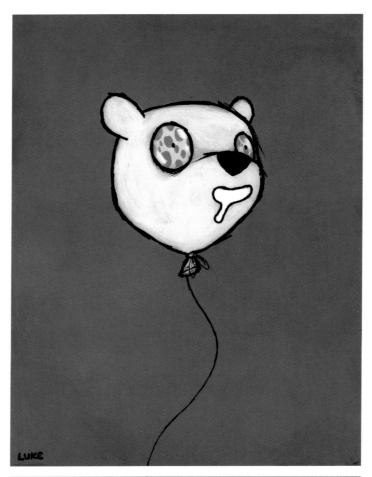

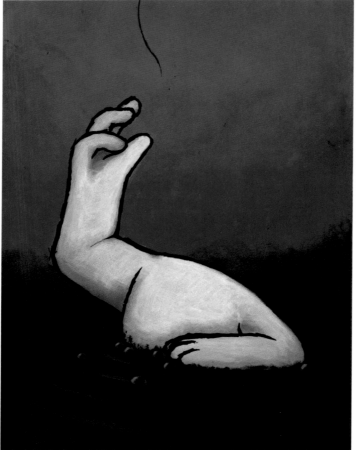

Getting High/Going Low
Acrylic and ink, diptych, 9 x 12 inches, 2007

Root Down
Acrylic and ink, 24 x 36 inches, 2007

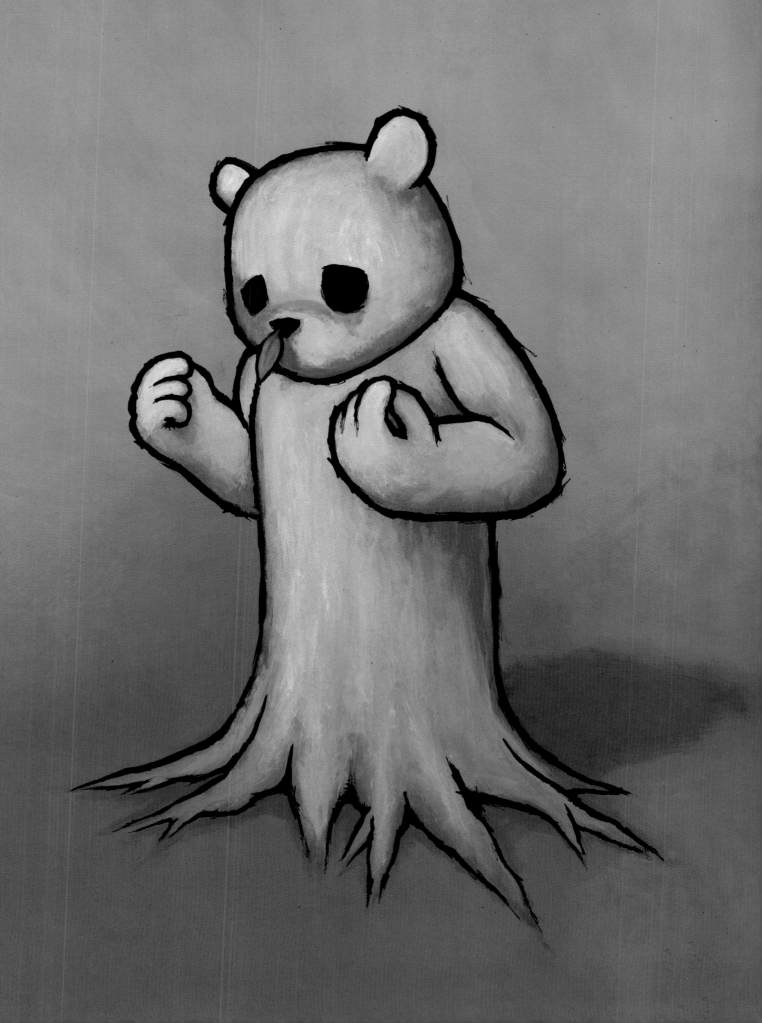

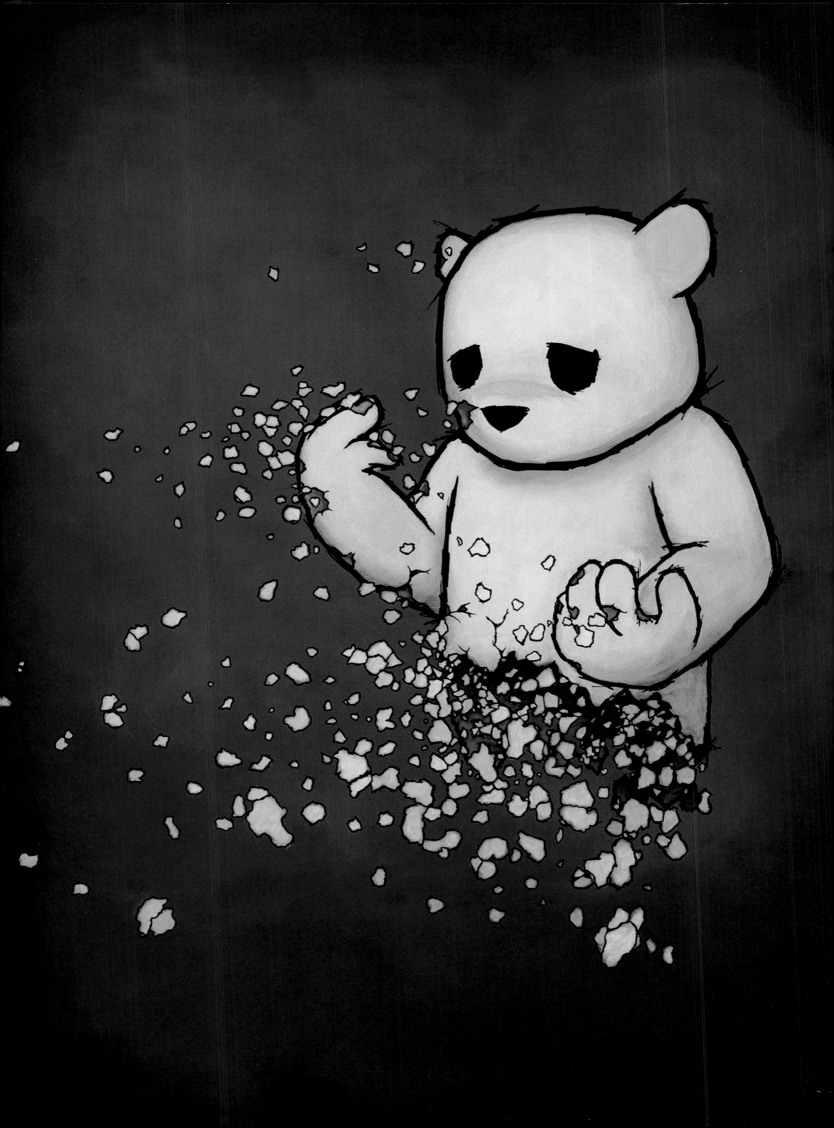

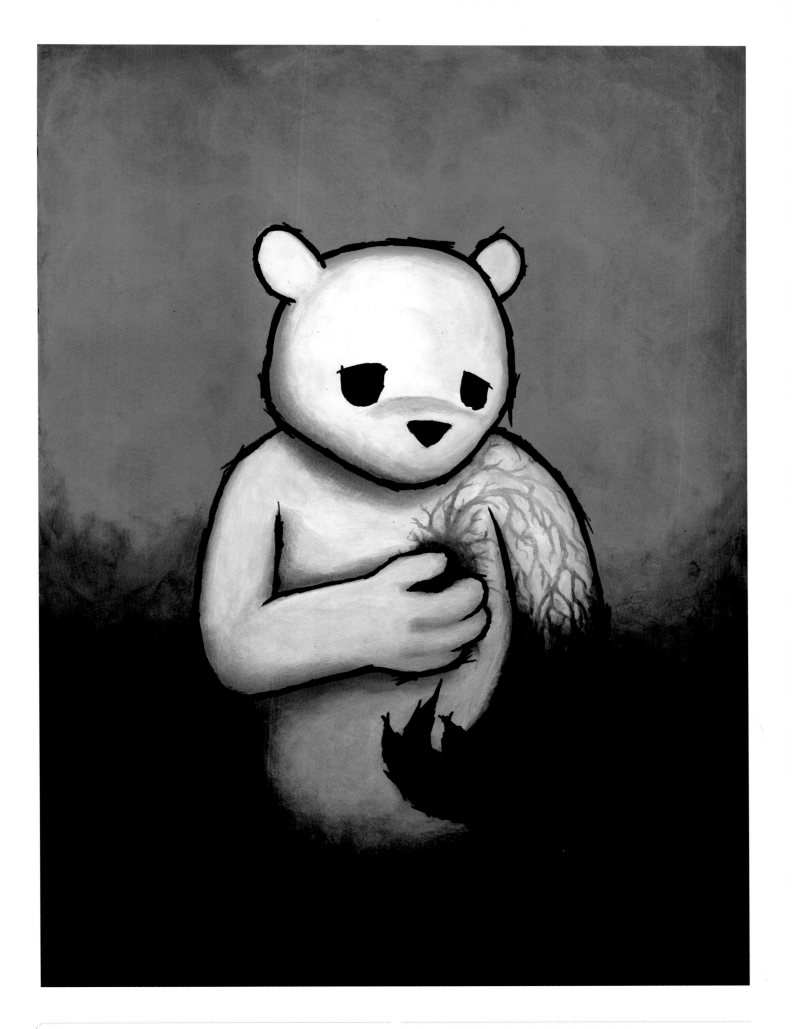

Disintegration
Acrylic and ink, 36 x 48 inches, 2007

Southpaw 2007 (When The Heart Guides The Hand)
Acrylic and ink, 24 x 36 inches, 2007

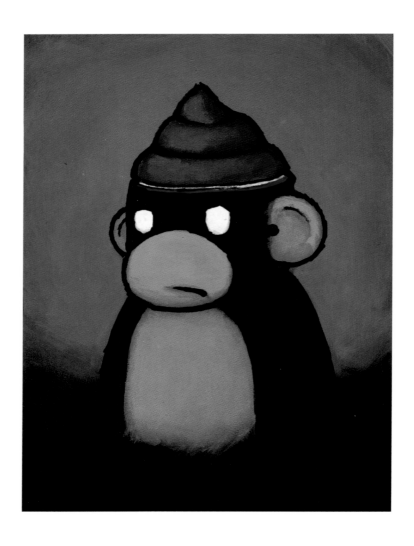

Shit For Brains
Acrylic and ink, 6 x 8 inches, 2007

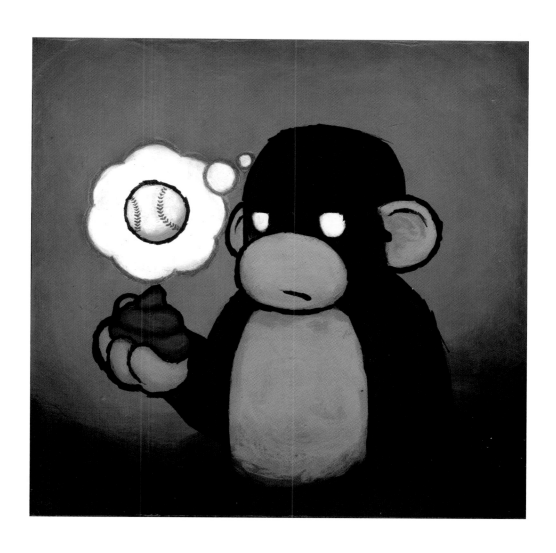

Shit Ball
Acrylic and ink, 8 x 8 inches, 2007

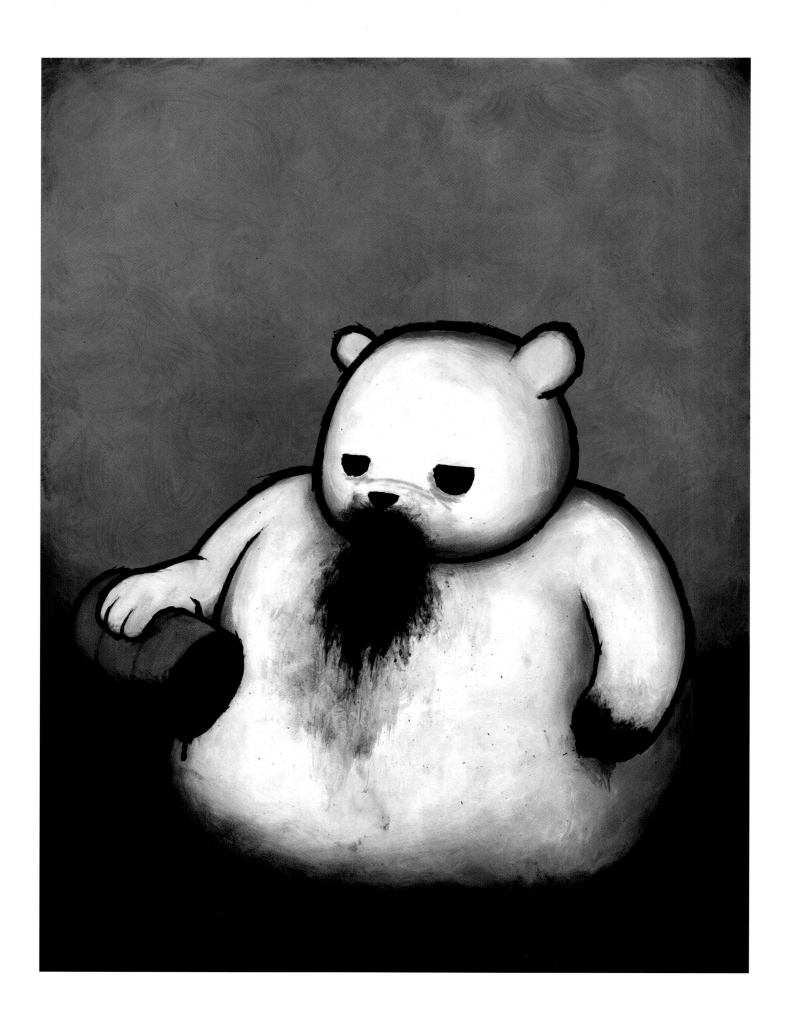

Oil
Acrylic and ink, 18 x 24 inches, 2007

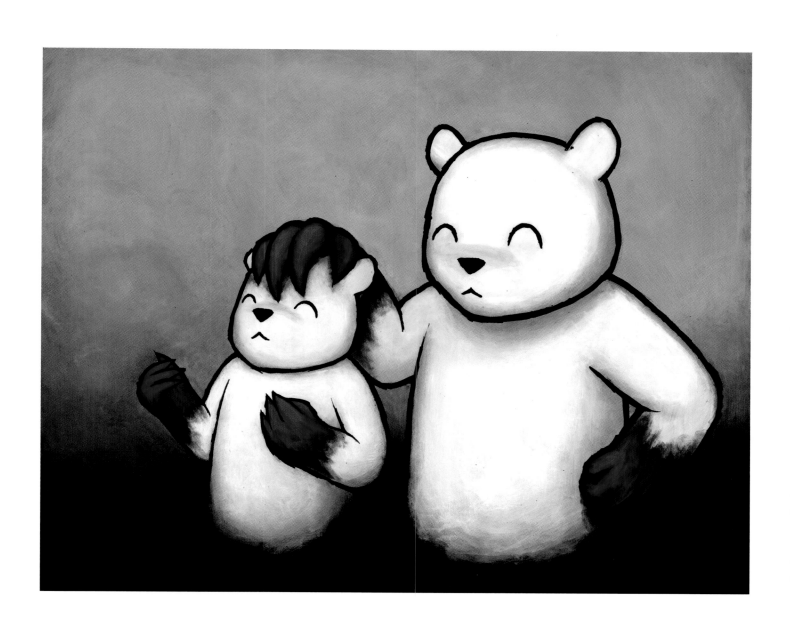

Legacy
Acrylic and ink, 30 x 24 inches, 2007

My Shadow (Hulk)
Acrylic and ink, 12 x 9 inches, 2007

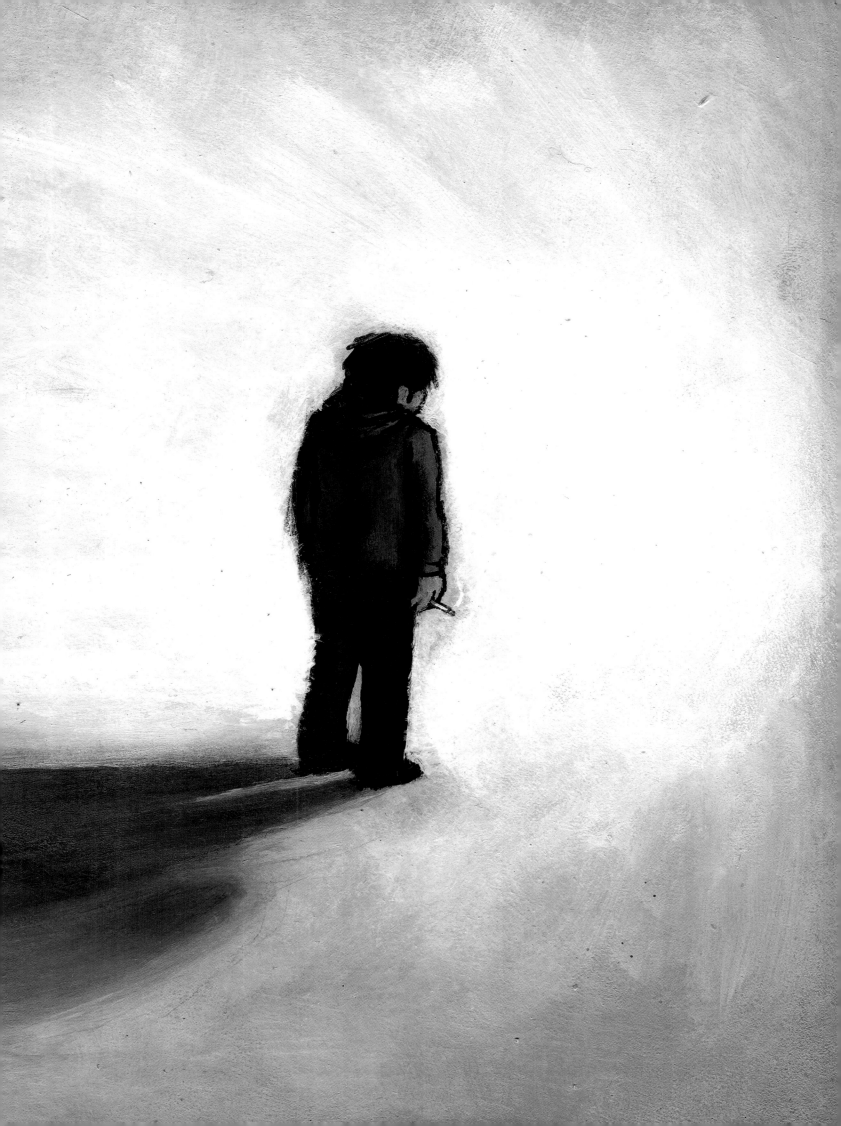

Posing with my 'Decapitated Bear Heads' at the offices of Munky King
Photo by Patrick Lam

2008

when you create art you basically surrender something of yourself. it's as if you are sending a child out into the world, while it's your creation, it's the world that will shape it. that is a scary thought. that is why it is even scarier to allow someone in the world to create in your world. that was never even a thought with luke when we decided to have him create the cover for our album, folie a deux, in 2008. his bears represent the wild and feral in all of us. they represent the other side of civilization. the other part of them represents the teddy bear, the safety that we all cling to; the peacefulness of dreams. when people ask me about luke's cover for the fifth fall out boy record, there isn't much for me to say. I let his genius and wildness speak for itself. we trusted completely in his art and never wanted to micromanage what he did. that bear is the most dear to me forever and ever.

pete wentz

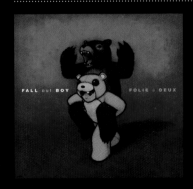

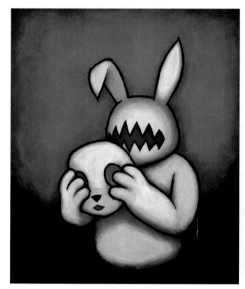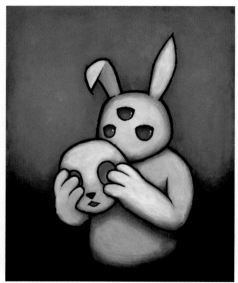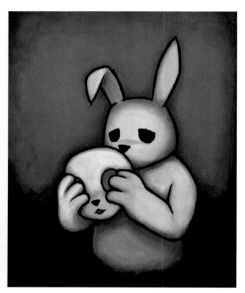

Hiding Behind My Smile (Anger/Knowledge/Sadness)
Acrylic and ink, 16 x 20 inches, 2008

Skeleton Study (Red) (Skateboard)
Acrylic and ink, 7.5 x 30 inches, 2008

Spoonful Of Sugar
Acrylic and ink, 24 x 12 inches, 2008

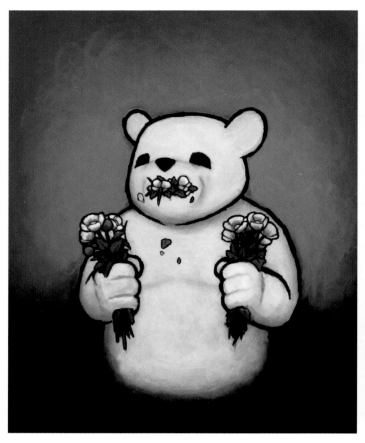

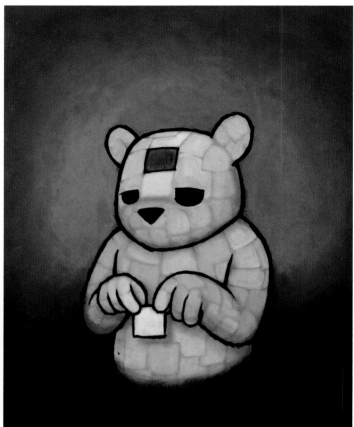

Poppin' Poppies
Acrylic and ink, 12 x 16 inches, 2008

Patch
Acrylic and ink, 16 x 20 inches, 2008

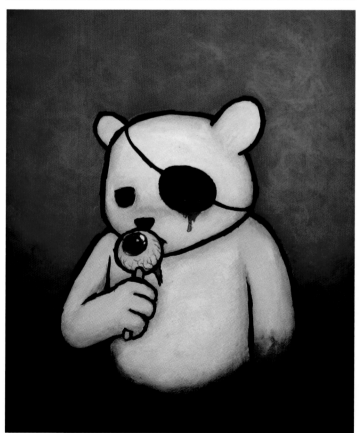

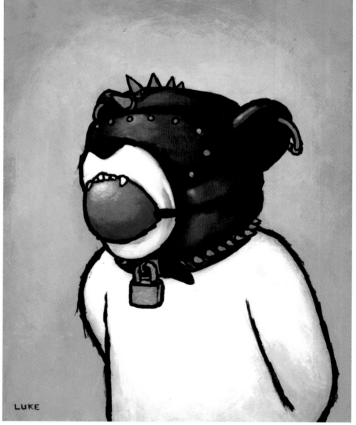

Lollipopeye
Acrylic and ink, 9 x 12 inches, 2008

Gimp
Acrylic and ink, 8 x 10 inches, 2008

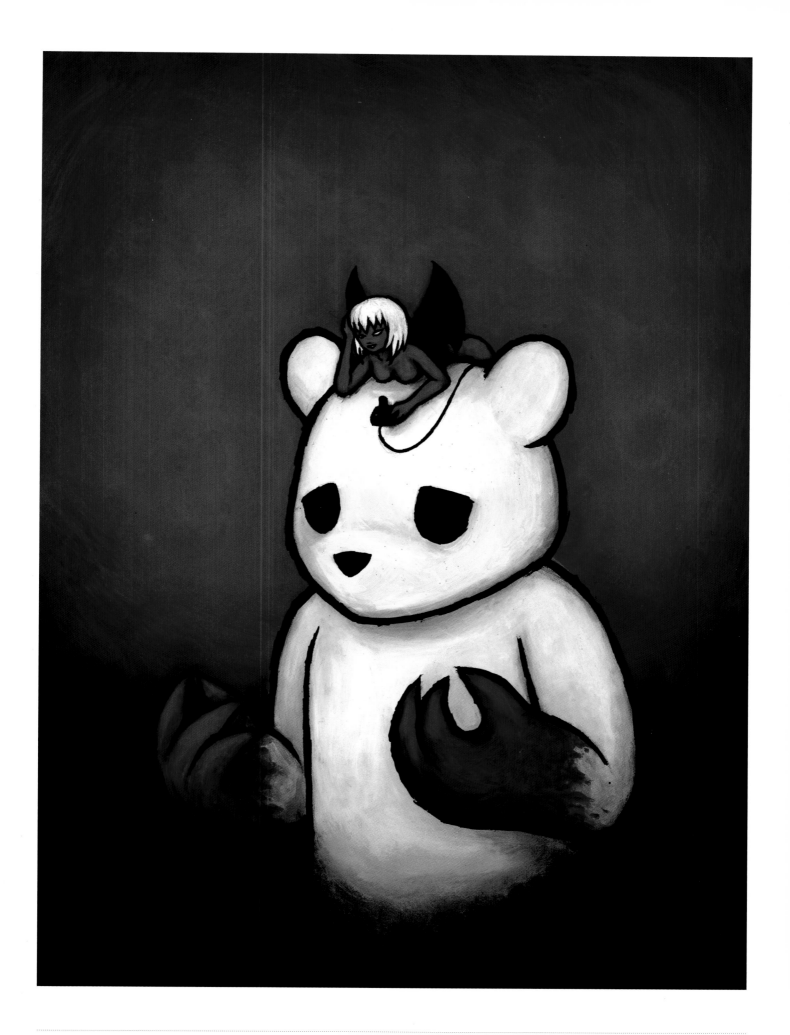

Possessed (Revisited)
Acrylic and ink, 18 x 24 inches, 2008

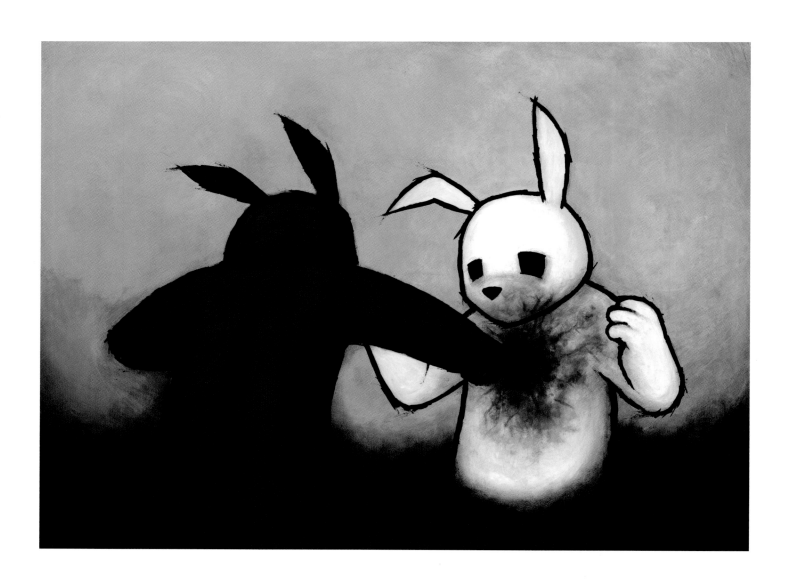

Just One Touch (Infected)
Acrylic and ink, 24 x 18 inches, 2008

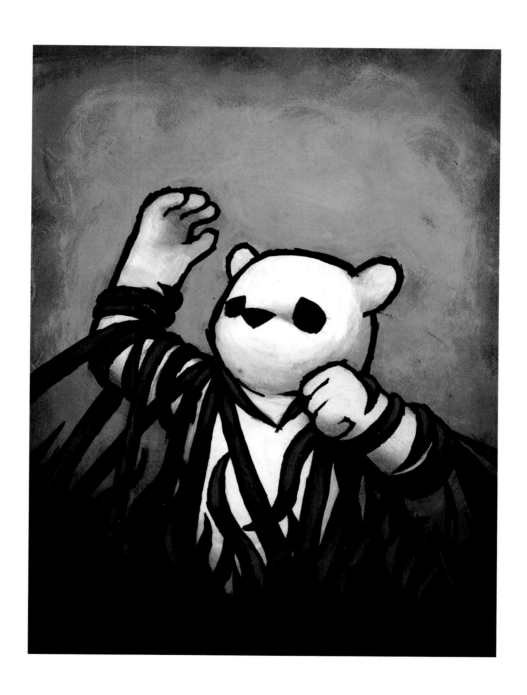

Bound (The Darkness – Simplified)
Acrylic and ink, 8 x 10 inches, 2008

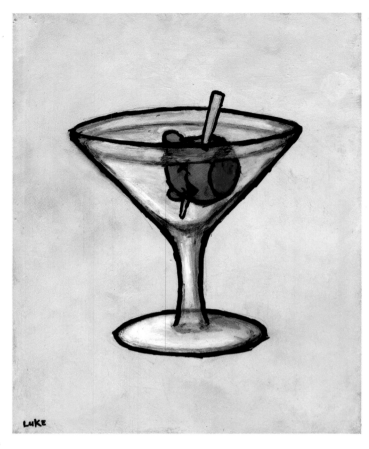

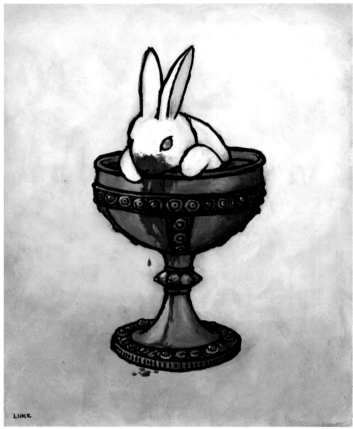

Dirty Martini
Acrylic and ink, 8 x 10 inches, 2008

Defender Of The Grail
Acrylic and ink, 11 x 14 inches, 2008

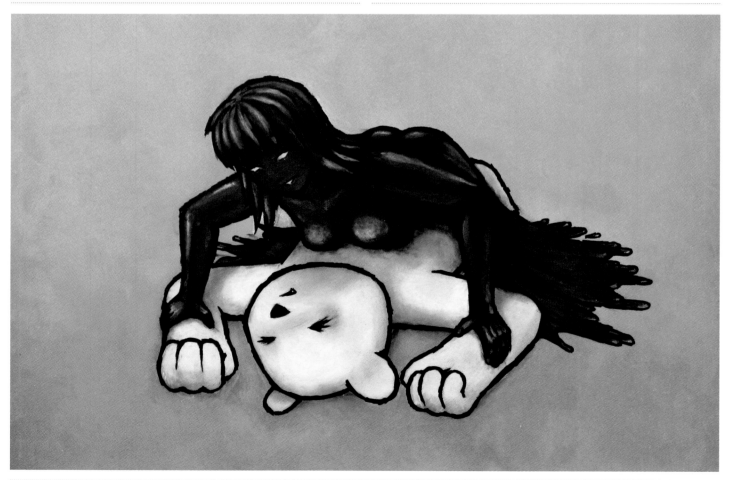

Tar Lady
Acrylic and ink, 20 x 16 inches, 2008

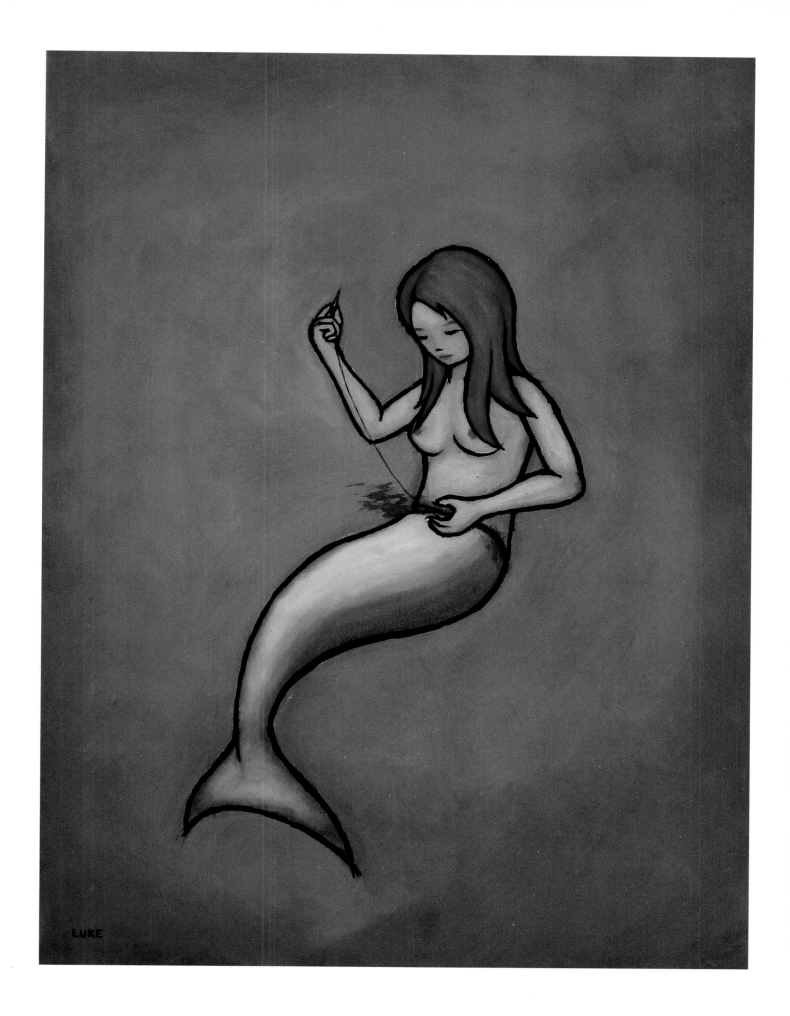

Mer-Made
Acrylic and ink, 12 x 16 inches, 2008

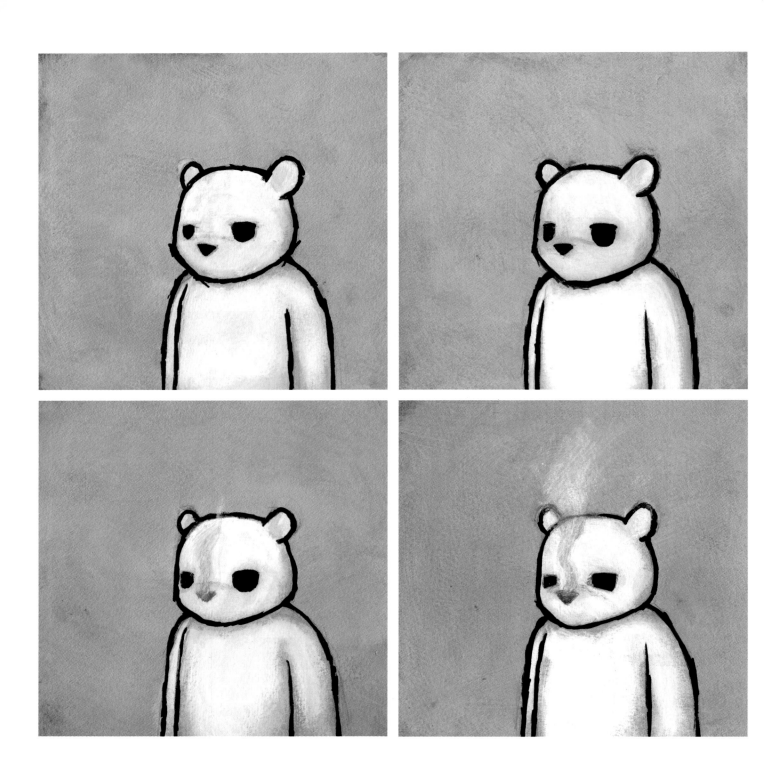

Spontaneous Combustion
Acrylic and ink, eight panels, 6 x 6 inches, 2008

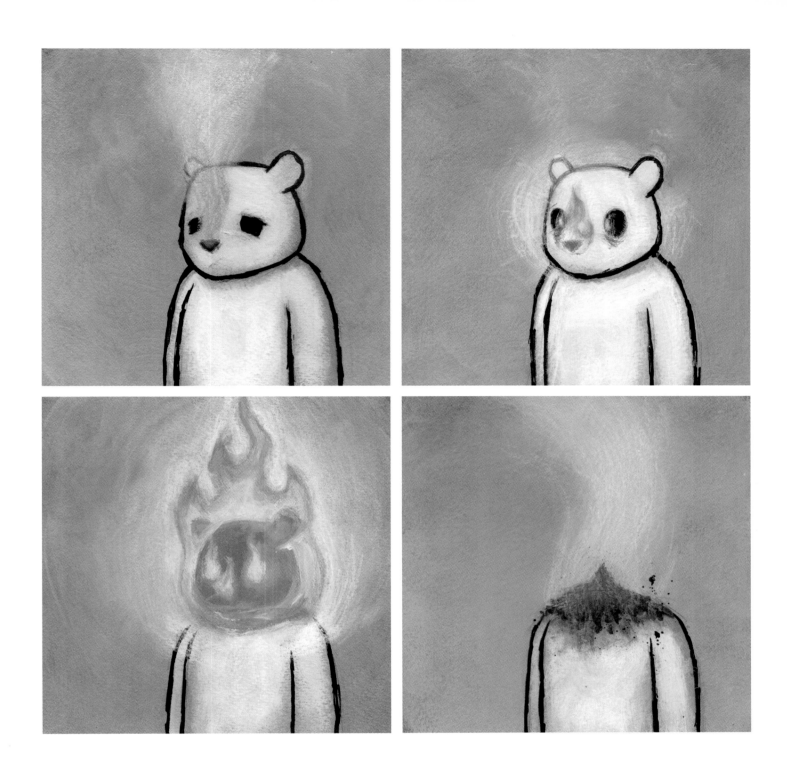

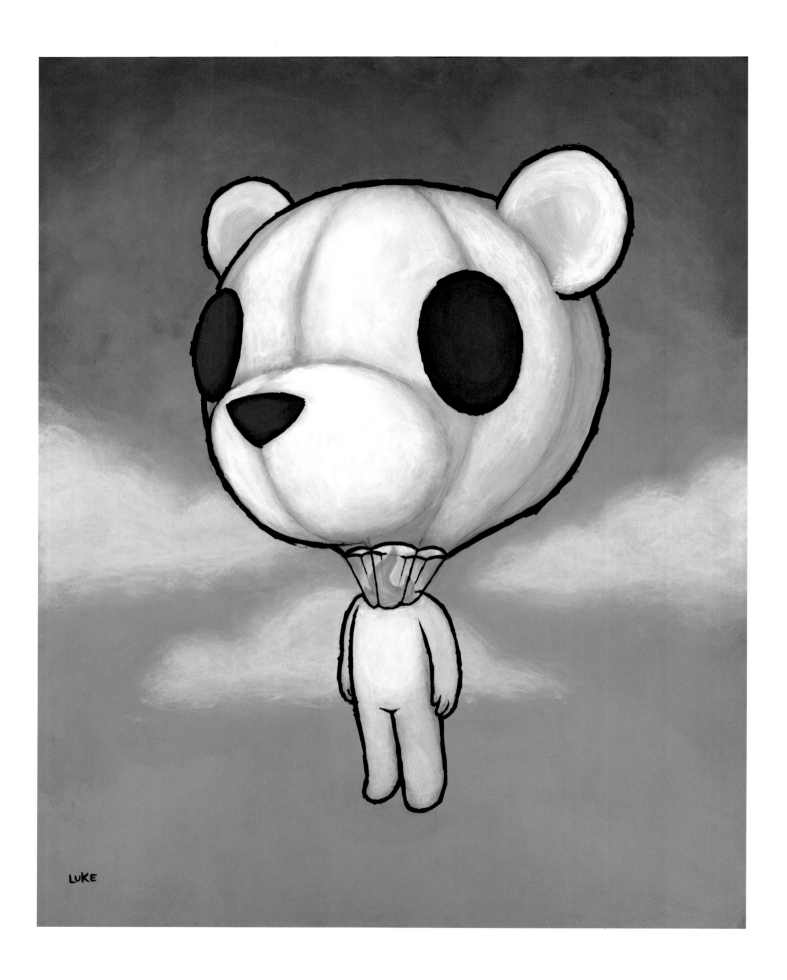

Balloonhead
Acrylic and ink, 24 x 30 inches, 2008

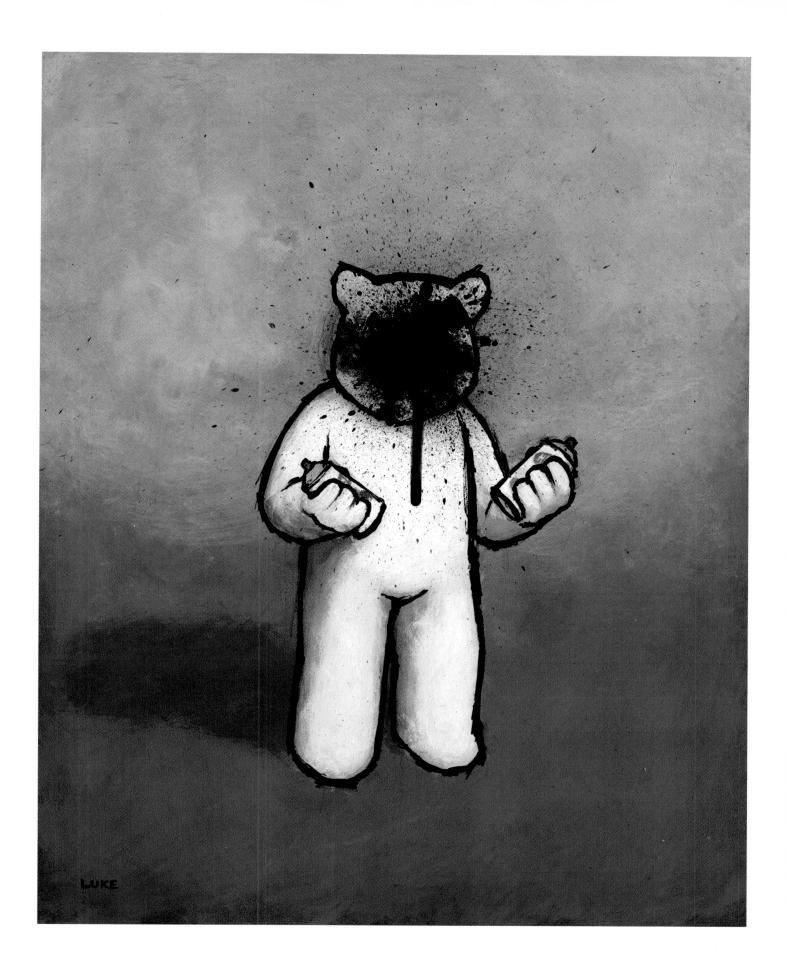

Graffiti (I Don't Do...)
Acrylic and ink, 11 x 14 inches, 2008

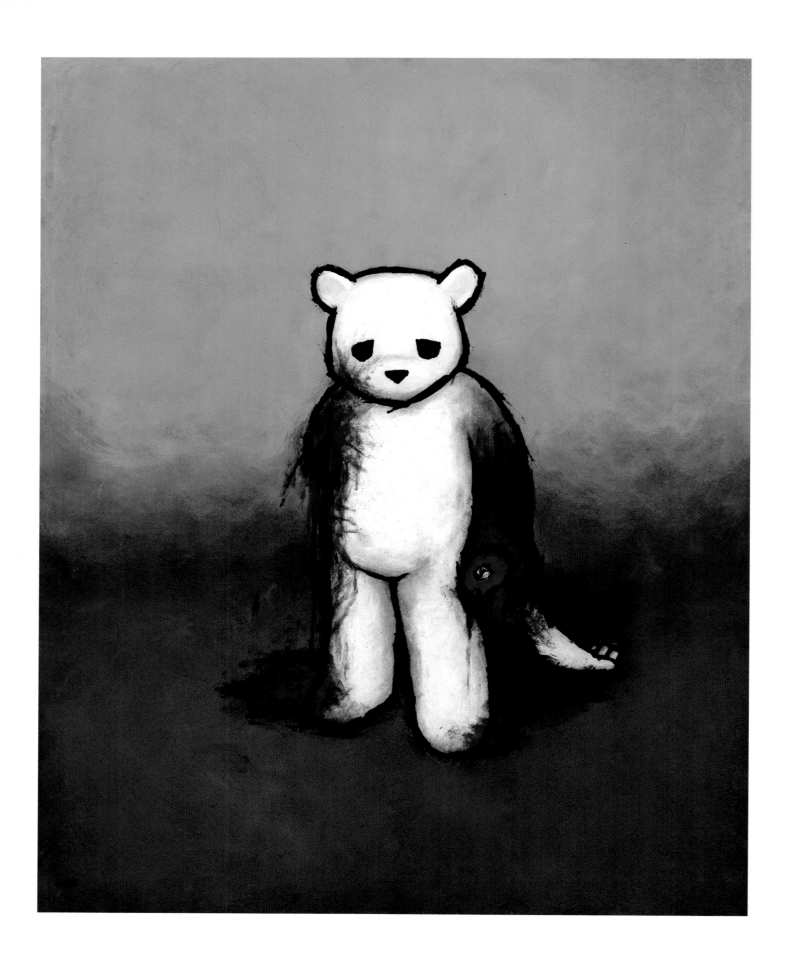

Southpaw (2008)
Acrylic and ink, 16 x 20 inches, 2008

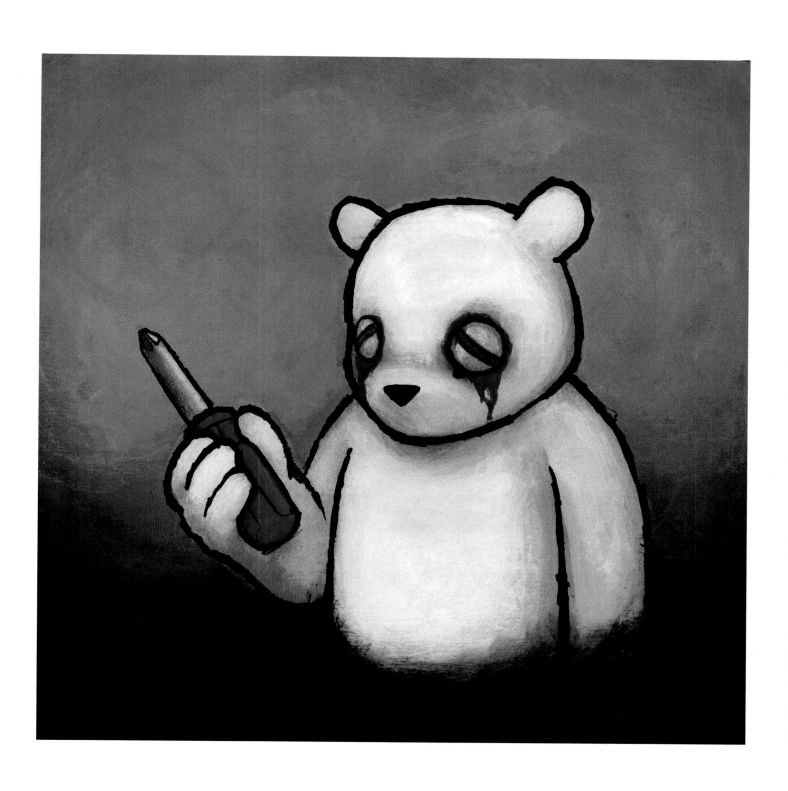

Screwed (2008)
Acrylic and ink, 10 x 10 inches, 2008

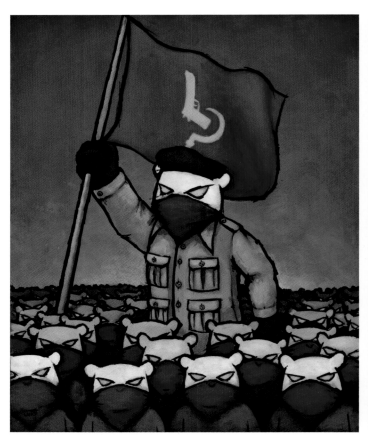

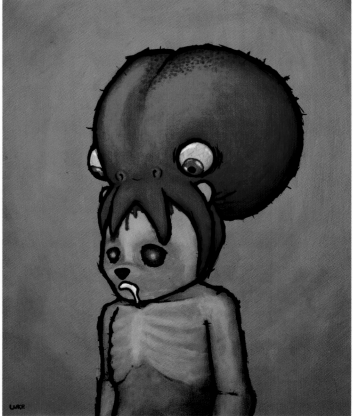

Linkin Park – Projekt Revolution
Acrylic and ink, 18 x 24 inches, 2008

Parasite (Sucking My Brains)
Acrylic and ink, 11 x 14 inches, 2008

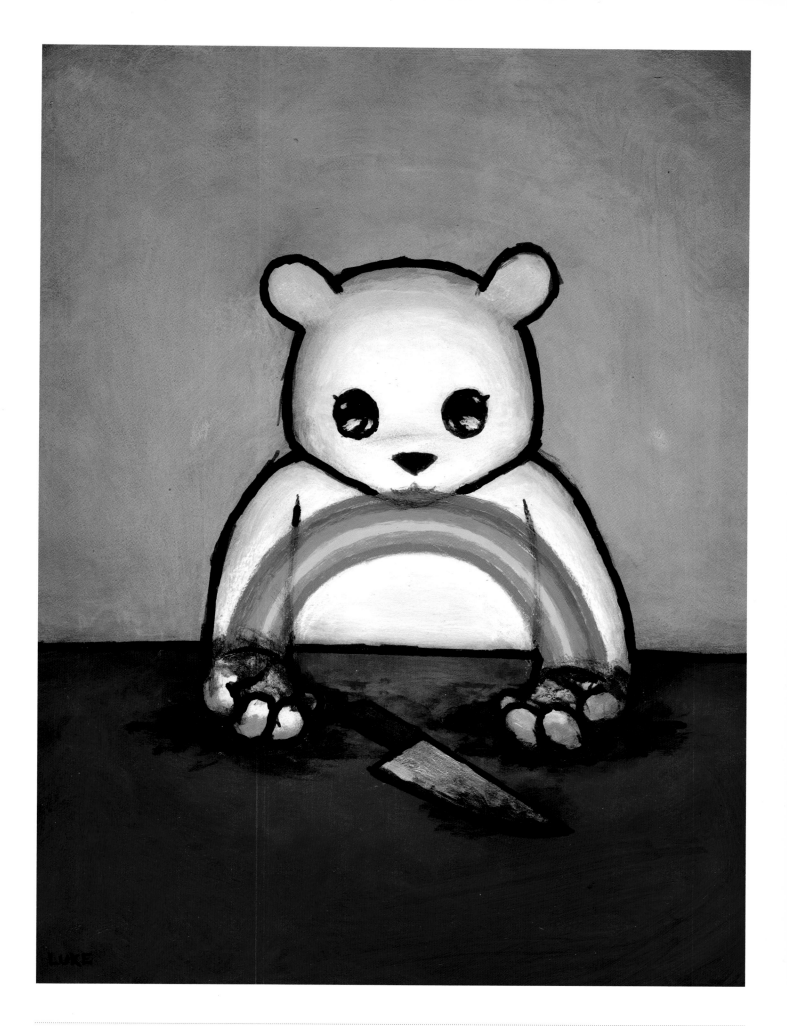

Rainbow Series 3
Acrylic and ink, 8 x 10 inches, 2008

Shedio R.I.P. (2003-2009)
Photo by Luke Chueh

2009

We were always impressed with the ability of Luke's art to connect with people. The bear suffered and the viewer suffered with it. During a long enjoyable dinner one night, we talked with Luke about art in general and his place in that world. Always humble, Luke denied his authority as an artist, but when talking about the style of contemporary art that intends to befuddle the audience by its inability to be understood – supposedly its claim to genius – Luke said, "If the audience can't understand what the artist is trying to communicate, doesn't it automatically fail?" That question may well define a great deal of the movement to which Luke belongs, inadvertently or not. This is an art movement of icons and relatability. And Luke has created some of the strongest icons of all.

Bruce & Jan Helford (Corey Helford Gallery)

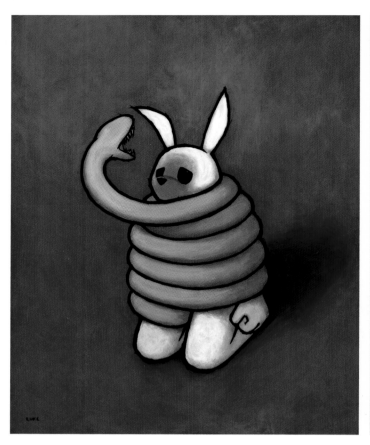

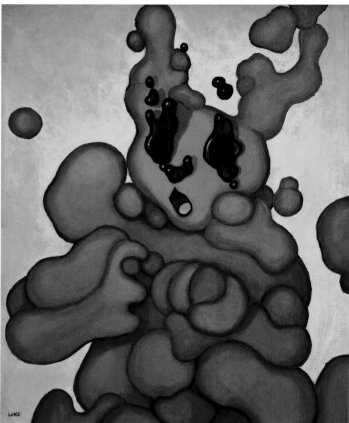

Serpentine
Acrylic and ink, 24 x 30 inches, 2009

Deliquescent
Acrylic and ink, 24 x 30 inches, 2009

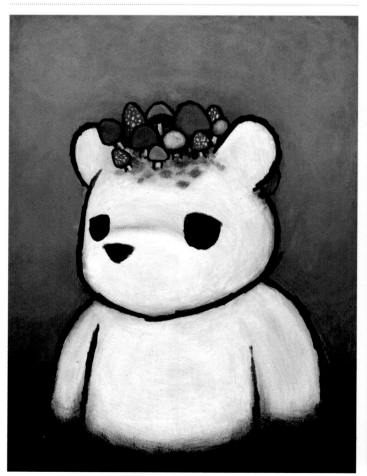

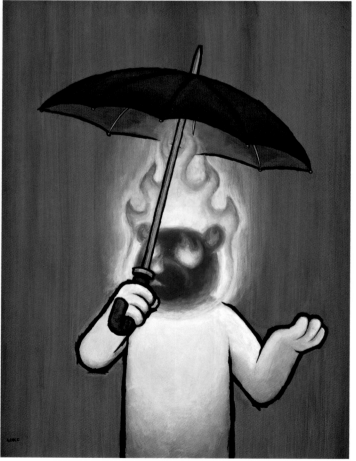

Mushroom Cap
Acrylic and ink, 6 x 8 inches, 2009

Rain Rain Go Away
Acrylic and ink, 18 x 24 inches, 2009

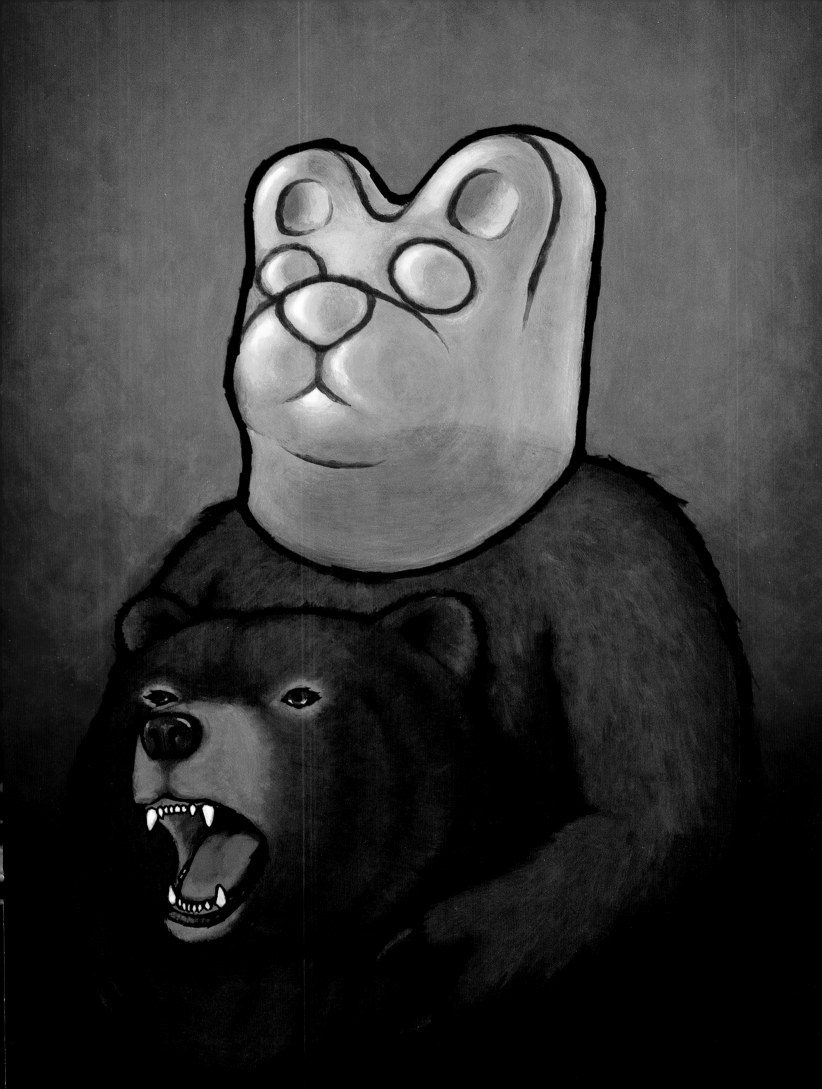

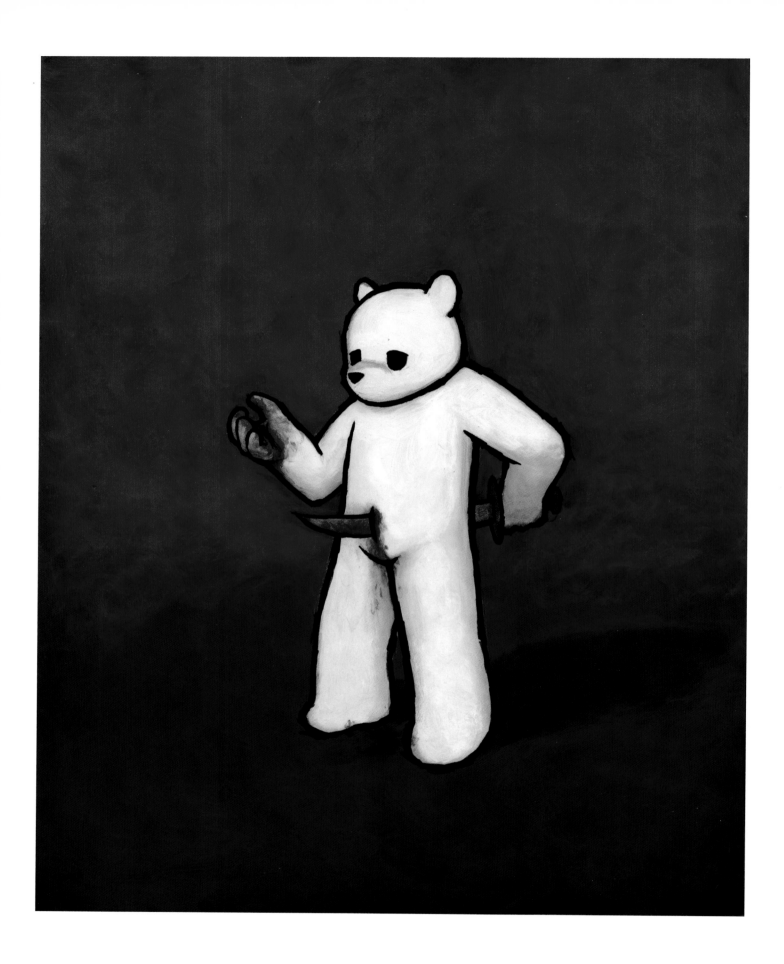

(Gummi) Bear In Mind
Acrylic and ink, 24 x 36 inches, 2009

The Sword
Acrylic and ink, 16 x 20 inches, 2009

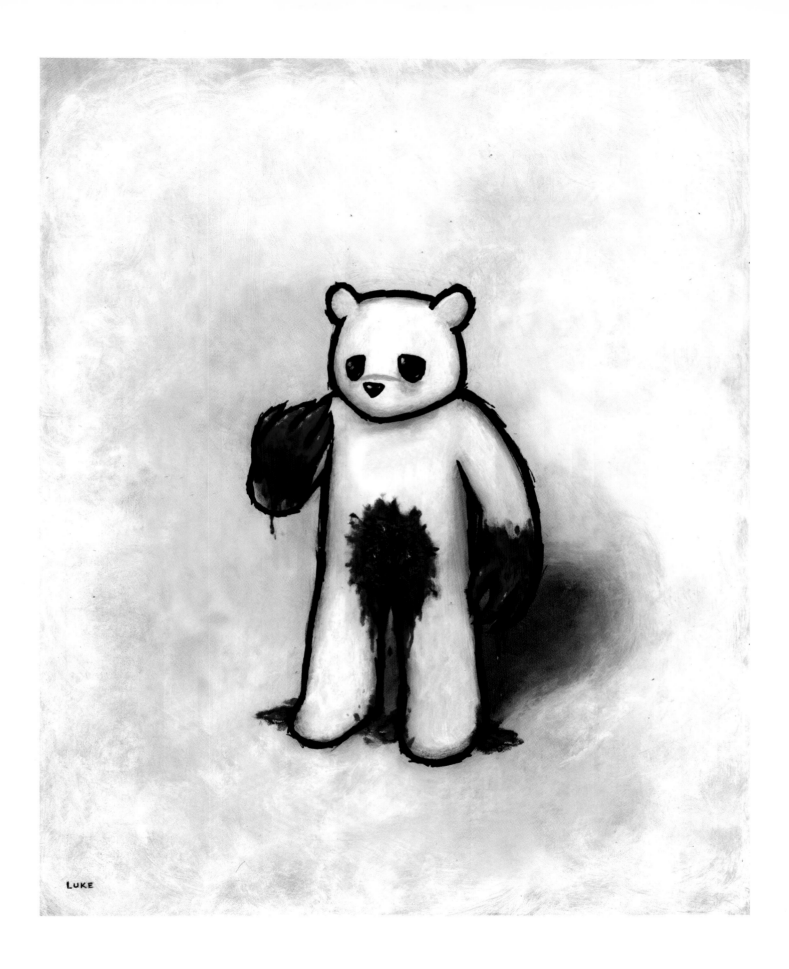

Crotch Shot
Acrylic and ink, 16 x 20 inches, 2009

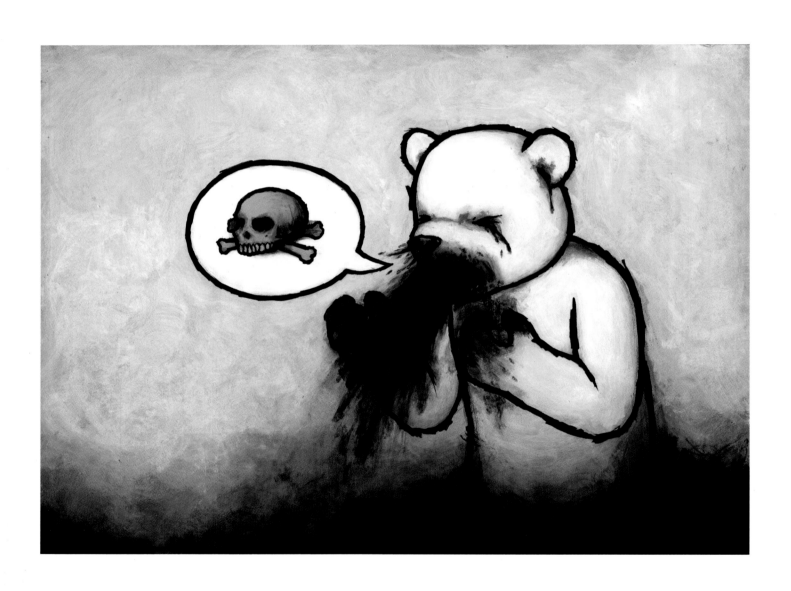

Vomito Negra (Revisited)
Acrylic and ink, 16 x 20 inches, 2009

Whitewash
Acrylic and ink, 36 x 48 inches, 2009

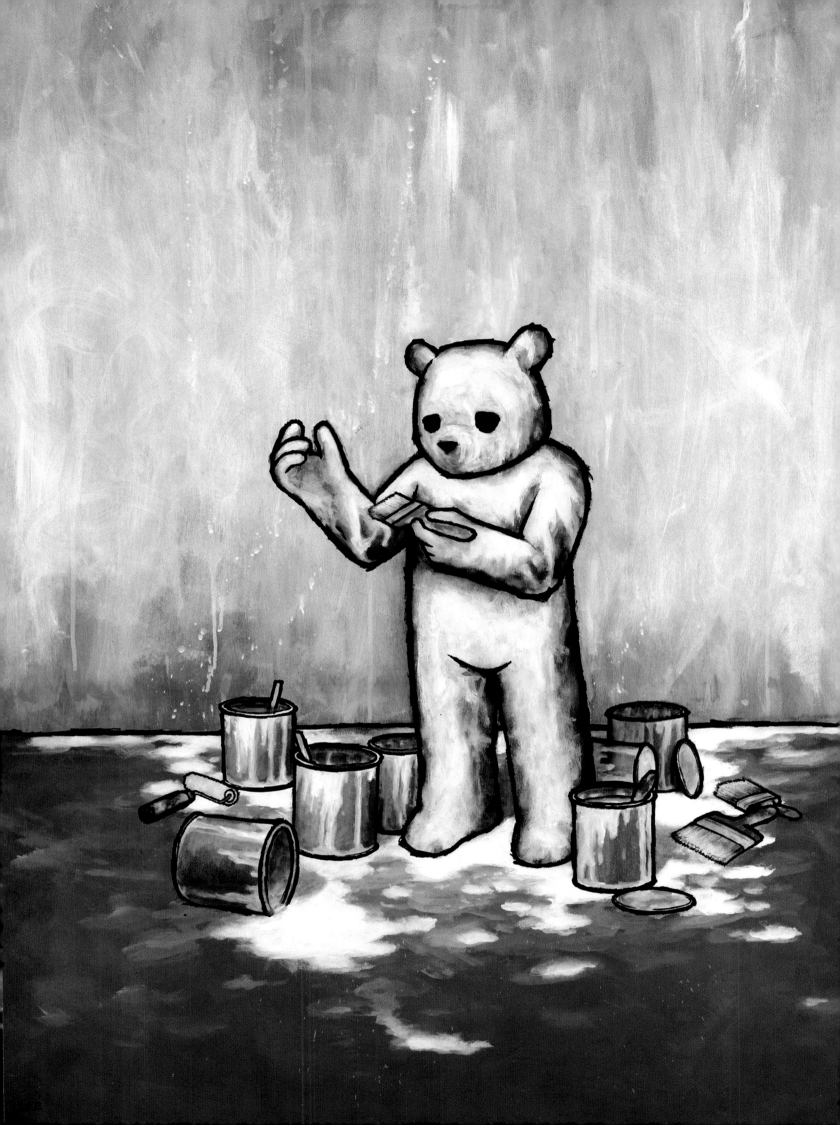

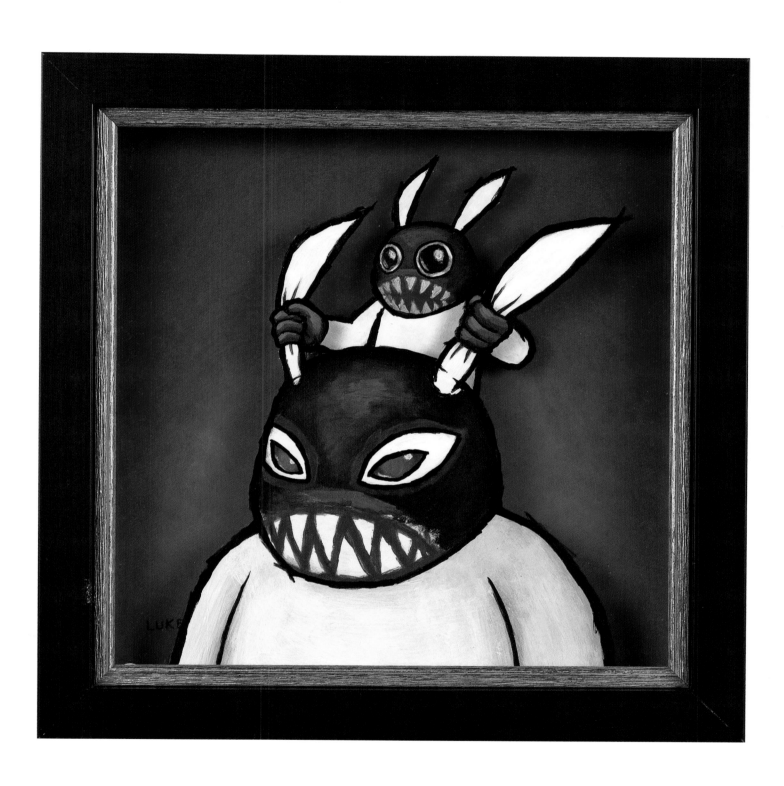

Master Blaster
Acrylic and ink on glass and wood, 12 x 12 inches, 2009

During my show "She's My Heroin(e)", I had one lone painting that didn't sell. It was one of the two paintings I created that didn't feature any of my typical animal characters. And being the 'glass half-empty' kind of guy I am, during the reception, rather than basking in the success of the sales, I fixated on the one piece that didn't. And it was while I was chatting with some friends about the unsold painting that I declared, "The Bear is my Ball & Chain!" This outburst became the genesis of the painting "My Ball & Chain".I truly believe most artists have love/hate relationships with the things that make them successful, only because those things can eventually become traps they'll spend the rest of their careers trying to escape.

But to be completely honest, I would never truly refer to any of my characters as a "ball & chain." To be so would mean that they were a burden, and I honestly love my creations. I can confidently say I don't foresee letting go of them any time soon.
Luke Chueh

Self Portrait 2009 / My Ball And Chain
Acrylic and ink, 24 x 36 inches, 2009

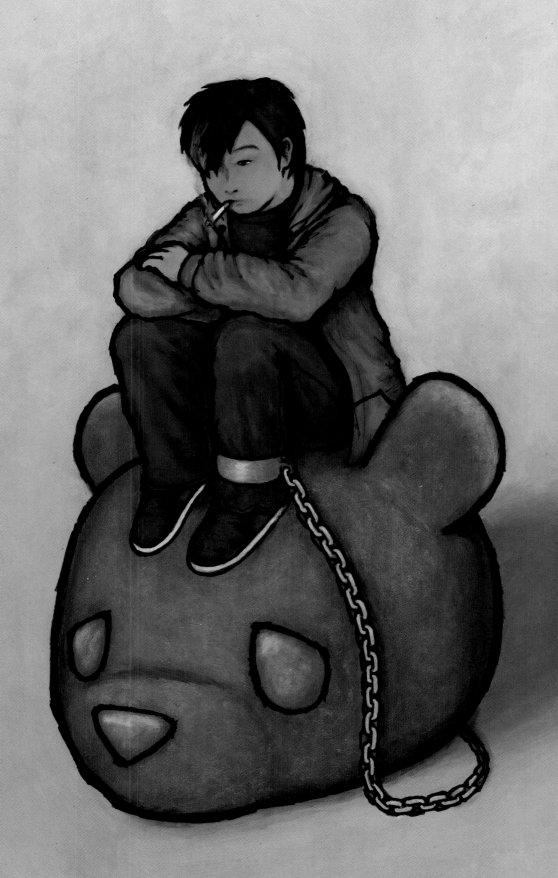

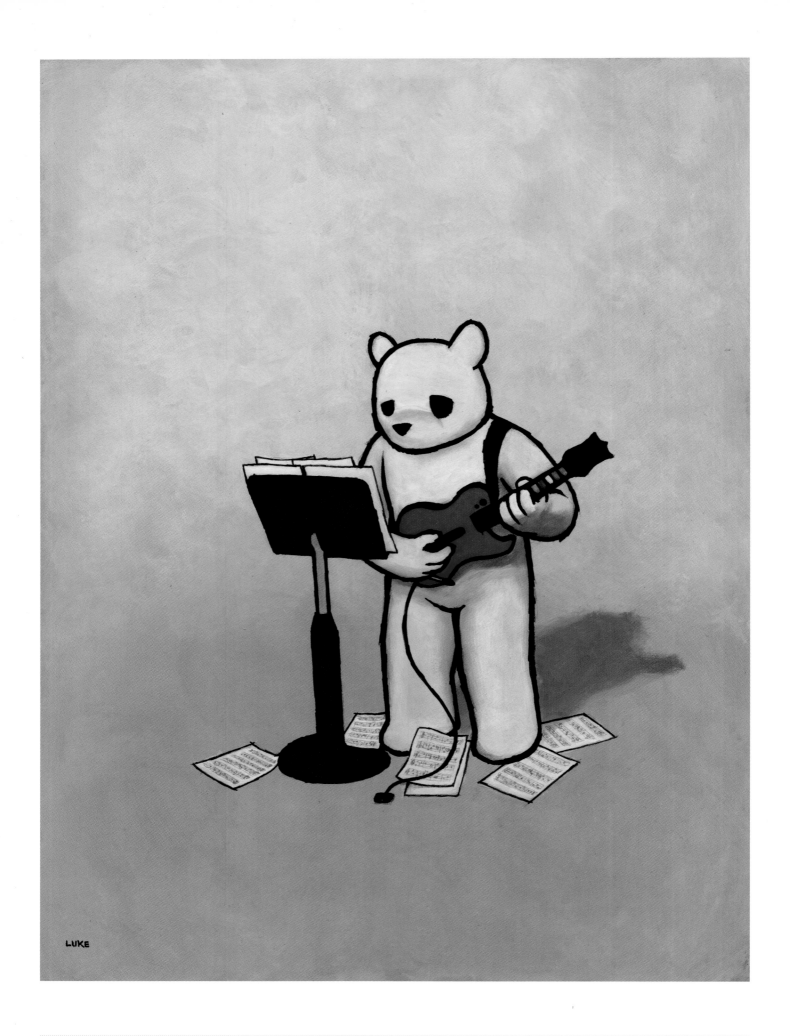

Guitar Hero
Acrylic and ink, 18 x 24 inches, 2009

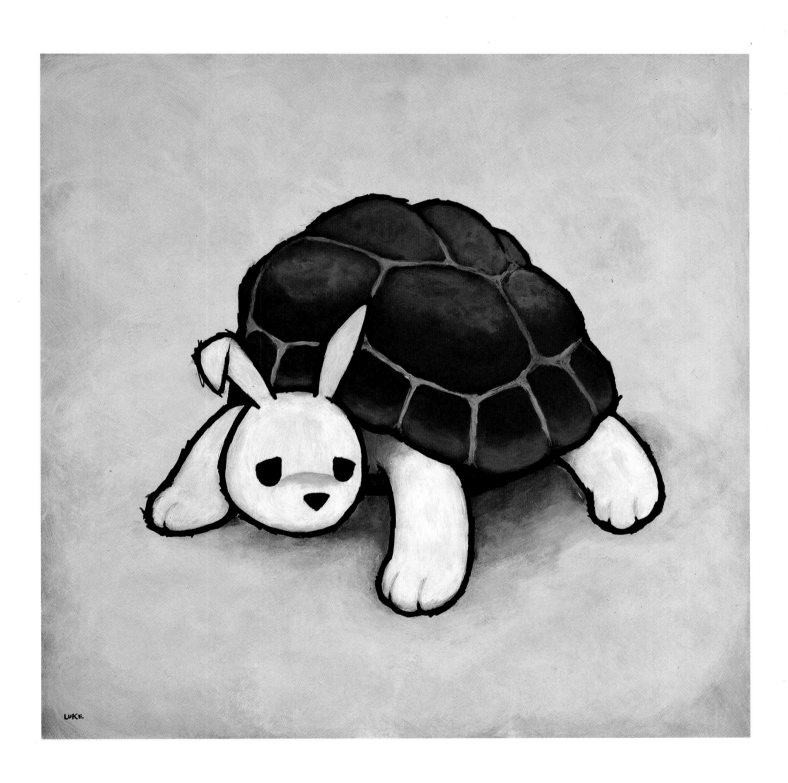

Rabbitoise
Acrylic and ink, 18 x 18 inches, 2009

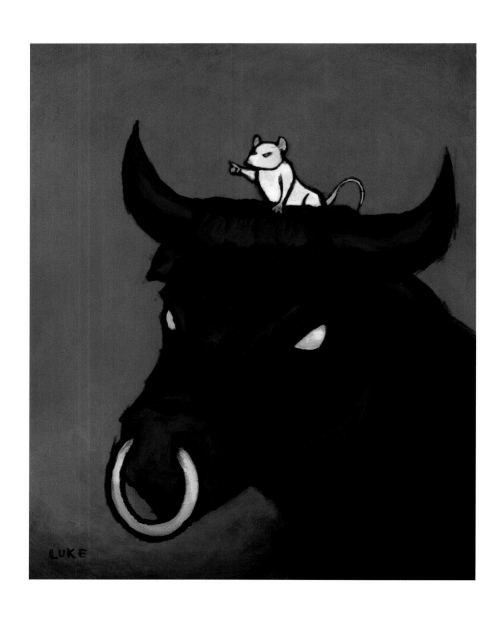

Mouse Over Matter
Acrylic and ink, 8 x 10 inches, 2007

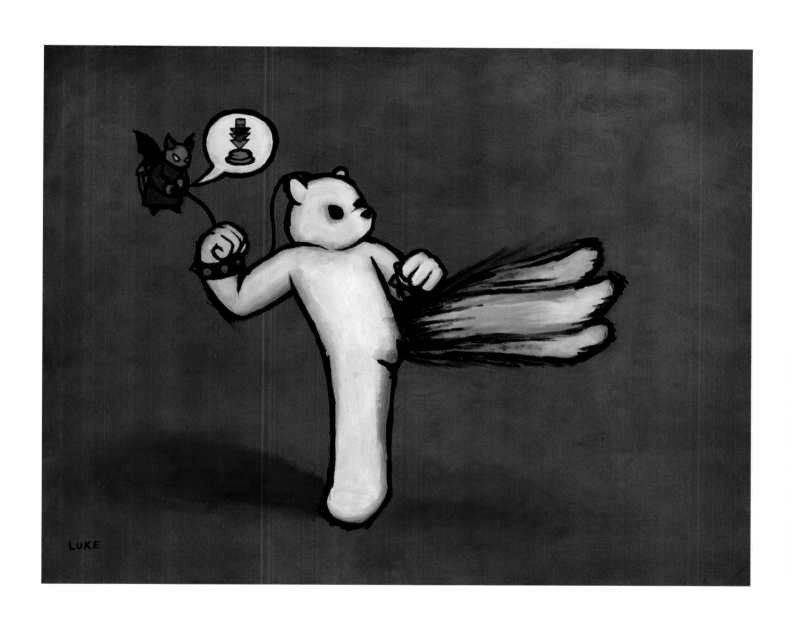

Street Fighter 2 – Hyakuretsu Kyaku (Lightning Kick)
Acrylic and ink, 14 x 11 inches, 2009

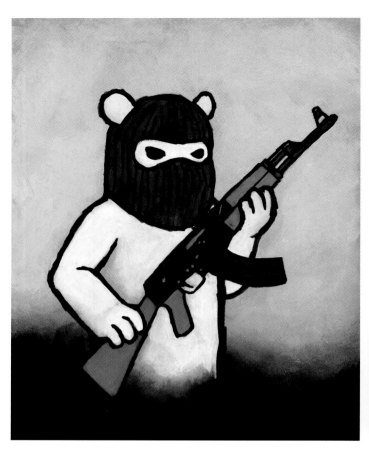

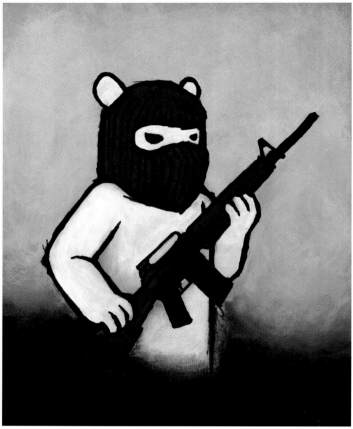

Assault Rifle Series – AK-47
Acrylic and ink, 8 x 10 inches, 2009

Assault Rifle Series – M-16
Acrylic and ink, 8 x 10 inches, 2009

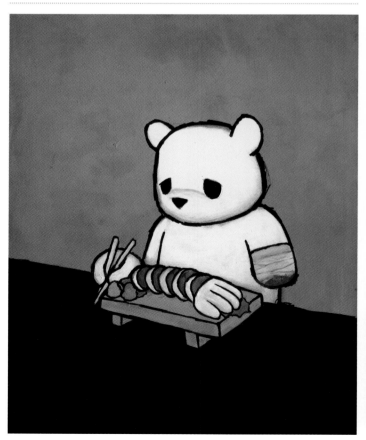

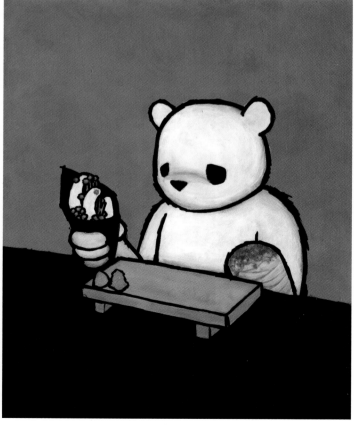

Sushi Series – Sashmi
Acrylic and ink, 11 x 14 inches, 2009

Sushi Series – Hand Roll
Acrylic and ink, 11 x 14 inches, 2009

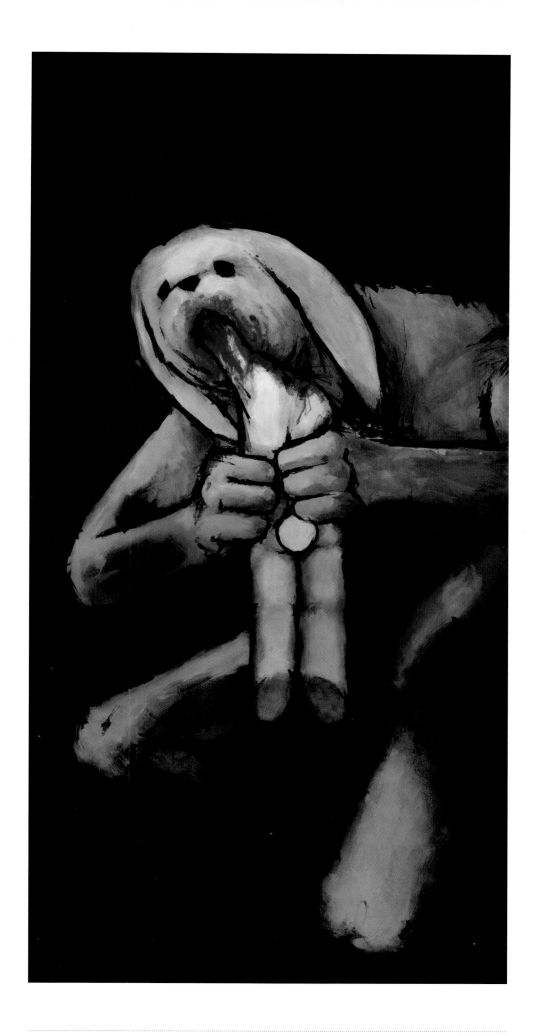

Francisco Goya: Saturn Devours His Son (Rabbid Remix)
Acrylic and ink, 18 x 36 inches, 2009

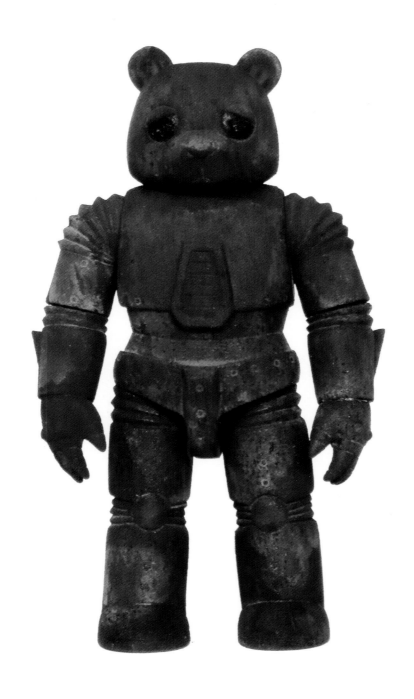

Mecha Sad Bear – Rusted
Mixed media, approx 7 inches, 2009

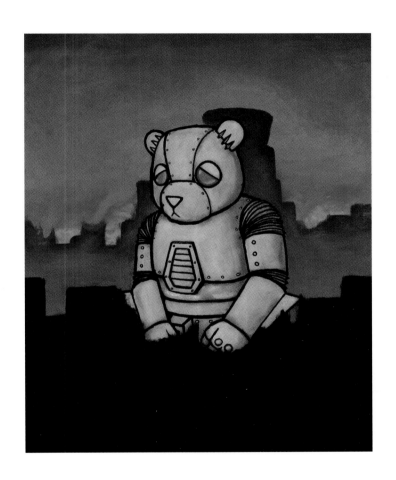

The Life & Times Of Mecha Sad Bear
Acrylic and ink, 16 x 20 inches, 2009

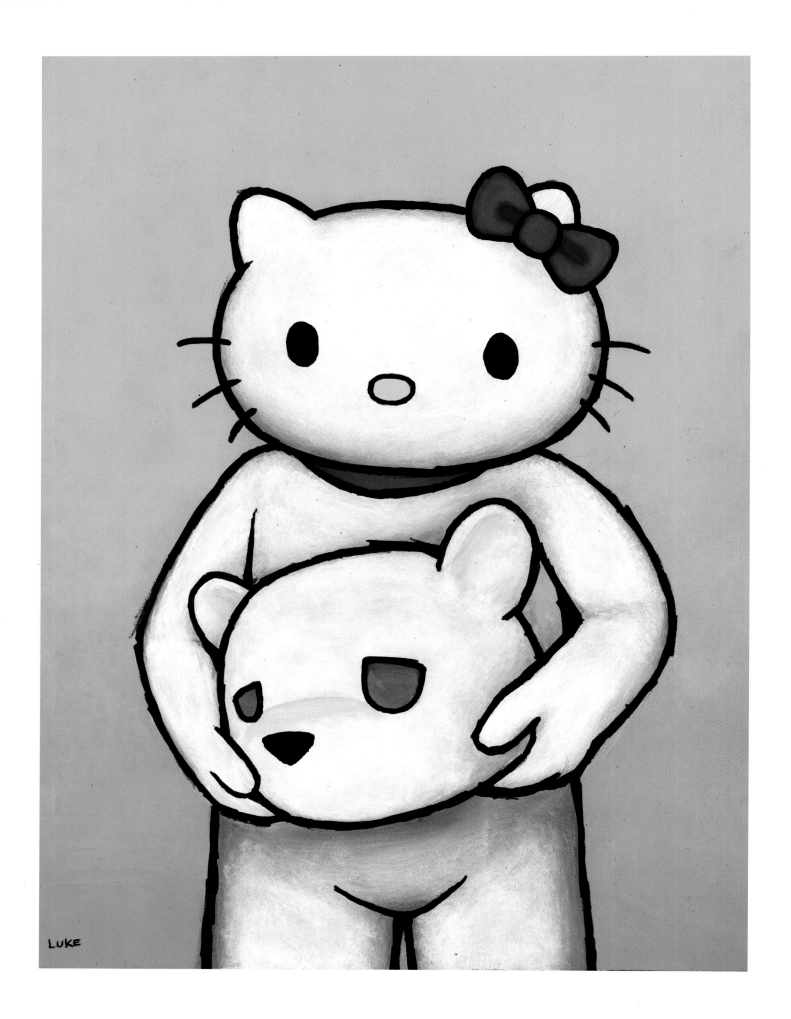

Hello, Kitty
Acrylic and ink, 12 x 16 inches, 2009

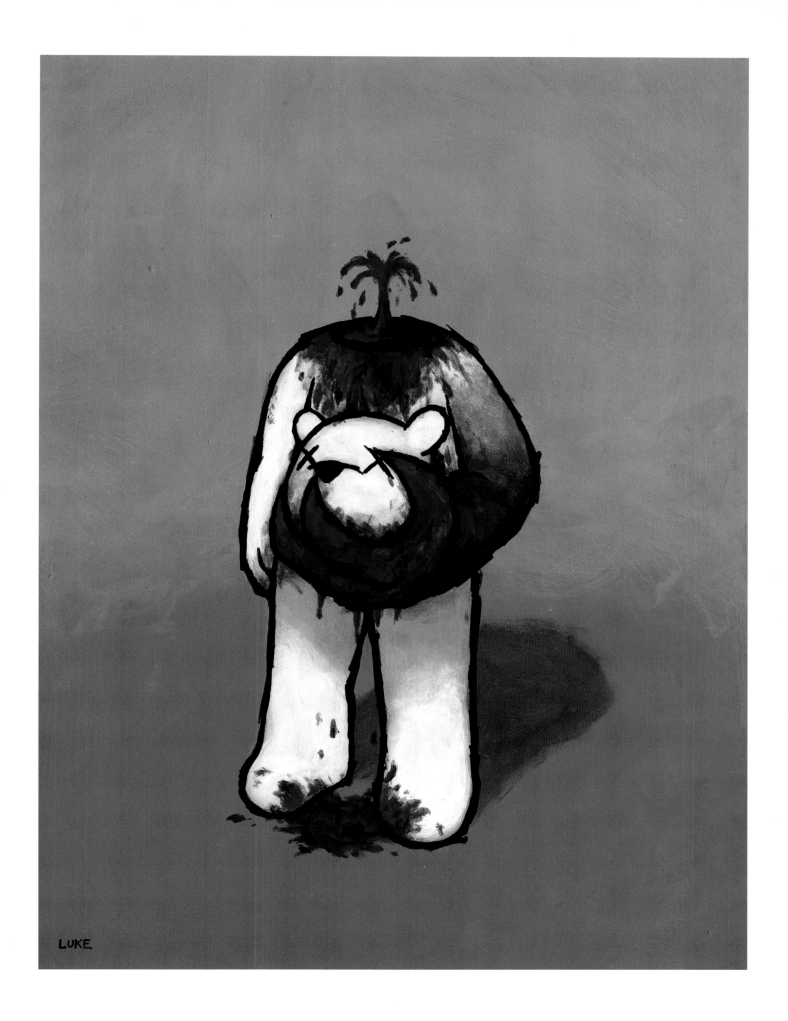

Southpaw 2009
Acrylic and ink, 11 x 14 inches, 2009

By the end of 2009, I was invited to contribute a painting in a show my friend and colleague Gary Baseman was curating. Entitled "True Self", we were asked to contribute a self-portrait, whether it be literal or metaphorical.

I took this opportunity to cement into a painting the kind of relationship I feel that I have with my characters, by diligently rendering my own features into the face of my bear.

This brings up a question I'm regularly asked: "Why a bear?" I decided on a bear because of a plethora of strange and embarrassing situations which led to me being referred to as a "bear" or a "panda". These titles were also used as pet names for me from previous girlfriends. When I was searching for a mascot to build a collection of paintings around, it was this history that led to my character.

Luke Chueh

My True Self
Acrylic and ink, 11 x 14 inches, 2009

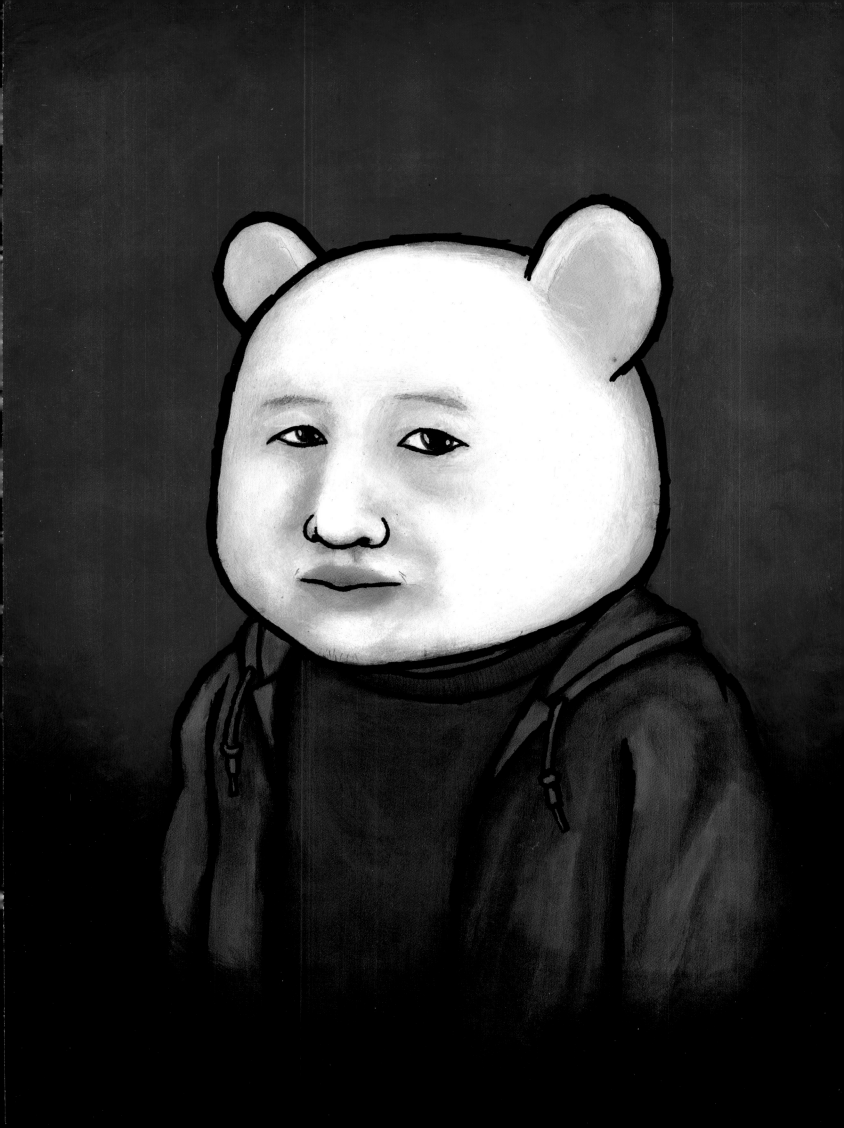

ACKNOWLEDGEMENTS

Luke Chueh would like to thank Wen & Margaret Chueh, Kim Chueh, Monica Blackburn & everyone at Syndrome Studios, L Croskey, Michele Waterman, Jensen Karp, Katie Cromwell & everyone at Gallery 1988, Patrick & Chanda Lam & everyone at Munky King, Gary Pressman, Greg Escalante, Jan Corey, Bruce Helford, Richard Scarry, Sherri Trahan & Everyone at Corey Helford Gallery, Joel & Josh Madden, Pete Wentz, Glenn Howard, Adam Newell & Everyone at Titan Publishing, Dave Bondi, Dave Pressler, Julie Beezy, Caro Buermann, Eric Nakamura & Everyone at Giant Robot, Ayumi Kim, Jaimie Alexander, Jenny Luu, Holly Worton, Alicia Ramos, Angie Hendrix, Joe Ledbetter, Thomas Han, Juan & Kat Muniz, Sterling Ball & Everyone at Ernie Ball Company, Bibiana Maltos Padilla, Ji Sook Lee & Black Market LA, Brett Wesley, Jeremy Lessem, Greg Blum, Jim Crawford, Emily Brough, Joan Ruggles, Mary LaPorte, Sky Bergmen, Anthony Ausgang, Gary Baseman, Travis Louie, Ishii Hitoshi, Jack Muramatsu, Dr. Hung Hei Yung and the Arrested Motion Crew, Spank Stokes, Andrew & Shawn Hosner, Gino Joukar, Bob Self & Everyone at Baby Tattoo, Jesse "J*Ryu" Yu, Aaron "Woebots" Martin, Sket One, Shane Jessup, Ritzy Periwinkle, Kano Kid, Rick Bains & Shashi Bains, Jason Valdez, Ben Zhu, Wade Buchanan, Jay & MiShell Naylor, Richard Mauger, Tina Ziegler, Beau & Christine LeBasse, Denise Grey, Pauly Simonetti, Paul Cruikshank, Jaime Mathis, Jonathan Cathey, Liz Ohanesian, Shannon Cottrell, Joanna Sieghart, Mark Murphy, Michael Watson, Mark Dugally, Rolf Vetter, Ashley Richards, Evan Armentrout, Brian McCarty, Adam & Jason Washburn, Daniel Zana, Attaboy & Annie Owens, Nathan Spoor, Lily Feliciano, Ayleen & George Gaspar, Ben Goresky, Dov & Sarah Jo Kelemer, Robert Haynes, Roman Cho, Scott Tolleson, Jamie Rivadeneira, J Salvador, Nancy Pham, Cory Lashever, Frank Schaefer, Jessica DiCicco, Wendy Jung, Mark Dugally, Doug Murphy, Johnny & Super Cooper Berella, and the many many more I've forgotten to name (my bad). This book wouldn't have been possible without all of you.